PETRARCH'S TWO GARDENS

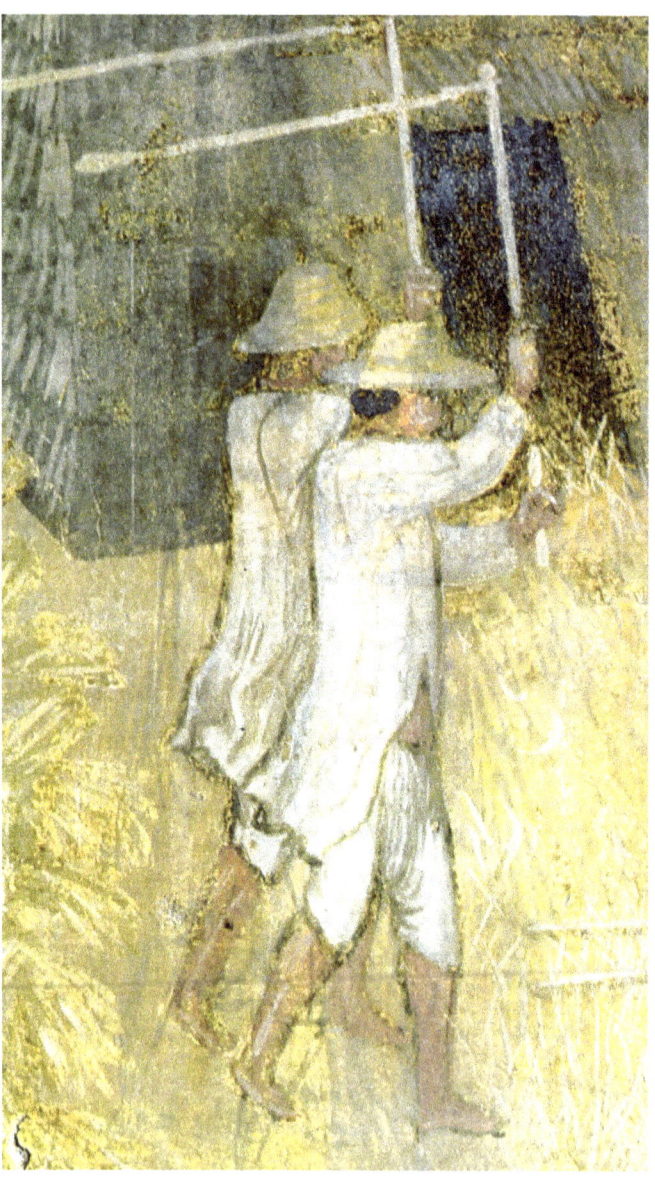

PETRARCH'S TWO GARDENS

LANDSCAPE AND THE IMAGE OF MOVEMENT

BY
WILLIAM TRONZO

ITALICA PRESS
NEW YORK
2014

Copyright © 2014 by William Tronzo

ITALICA PRESS, INC.
595 Main Street
New York, New York 10044
inquiries@italicapress.com

Italica Press Studies in Art & History

All rights reserved. No part of this publication may be reproduced, stored in a retrieval system, or transmitted, in any form or by any means, electronic, mechanical, photocopying, recording, or otherwise, without prior permission of Italica Press. For permission to reproduce selected portions for courses, please contact the Press at inquiries@italicapress.com.

Library of Congress Cataloging-in-Publication Data
Tronzo, William.
Petrarch's two gardens : landscape and the image of movement / by William Tronzo.
 pages cm
 Includes bibliographical references and index.
 ISBN 978-1-59910-271-9 (hardcover : alk. paper) -- ISBN 978-1-59910-272-6 (pbk. : alk. paper) -- ISBN 978-1-59910-273-3 (e-book)
 1. Gardens--Styles. 2. Gardens, Medieval. 3. Gardens, Renaissance. 4. Landscape gardening. I. Title.
SB458.35.T76 2013

712'.6--dc23
 2013040096

Cover art: Sketch of the Sorgue near Vaucluse, attributed to Petrarch, c.1351–59. From Pliny, *Historia naturalis*. Paris, Bibliothèque Nationale de France, MS lat. 6802, fol. 143v., detail.

For a Complete List of Italica Press Titles
Visit our Web Site at:
www.ItalicaPress.com

CONTENTS

ILLUSTRATIONS	vi
ACKNOWLEDGMENTS	x
PROLOGUE	1
Petrarch	4
Eden	6
The Unsettling of Tradition	11
Notes	13
ZISA AND CUBA IN PALERMO	25
Pavilions and Gardens	28
The Painted Ceiling of the Cappella Palatina	41
Function	46
Notes	57
PETRARCH ON THE BANK OF THE SORGUE	69
The Work	72
A Milieu	81
Notes	93
GOLD AND FLEECE: THE PARK AT HESDIN	99
Hesdin	101
The Golden Fleece	110
The Ghent Altarpiece	114
The Wool Trade	121
Notes	130
THE *CORTILE DELLE STATUE* IN ROME: COLLECTING FRAGMENTS, INDUCING IMAGES	143
Notes	174
EPILOGUE	183
Notes	187
BIBLIOGRAPHY	189
INDEX	221

ILLUSTRATIONS

Frontispiece: Ambrogio Lorenzetti, Allegory of Good Government, Countryside, detail, workmen with scythes. Siena, Palazzo Pubblico, Sala dei Nove. ii

1. Harvard Hannibal Master, Adam and Eve with the Creator in the Garden of Eden. Paris, Bibliothèque Nationale de France, MS fr. 247, fol. 3r. 8
2. St. Gall, Codex Sangallensis 1092. Plan of Monastery, detail, plan of cloister and adjacent buildings. 9
3. Cuba, Palermo. 19th-century English lithograph. Source: Caronia and Noto, *La Cuba di Palermo*. 24
4. Palazzo dei Normanni, Palermo. View of east facade with Torre Pisana. 26
5. Palermo, plan of city with location of gardens and pavilions (after Di Stefano, *Monumenti della Sicilia normanna*, pl. 133). 27
6. Zisa, Palermo. View of facade. Photo: author. 28
7. Zisa, Palermo, salsabil. Photo: author. 29
8. Rocco Lentini, reconstruction of Zisa and setting. 30
9. Zisa, Palermo, plan of first and second floor (after Caronia, *La Zisa di Palermo*, figs. 49 and 50). 31
10. Zisa, Palermo, second floor window with muqarnas hood looking onto salsabil. Photo: author. 32
11. Cuba, Palermo, muqarnas in fountain room. Photo: author. 33
12. Cuba, Palermo, plan (after Bellafiore, *La Zisa*, fig. 30). 34
13. Rocco Lentini, reconstruction of the Cuba and setting. 34
14. Palermo, Biblioteca Comunale, Miscellanea Qq C83, "Pianta dell'Aqua del Gabriele." 36
15. G.F. Ingrassia, *Informatione del pestifero*, Palermo, 1576, view of the Cuba. 37
16. Peter of Eboli, *Liber ad honorem Augusti*. Bern, Burgerbibliothek cod. 120 II, fol. 98r, view of Palermo with viridarium Genoard (upper left). 38
17. Juan Ruiz, view of Palermo from west. Palermo, Collezione Torta. 39
18. Cappella Palatina, Palazzo dei Normanni, Palermo, view of nave with royal throne platform to west. Photo: Alinari. 42

19. Cappella Palatina, Palazzo dei Normanni, Palermo, nave ceiling, detail of muqarnas. Photo: Gabrieli and Scerrato, *Gli Arabi in Italia*, fig. 86. 43
20. Cappella Palatina, Palazzo dei Normanni, Palermo, nave ceiling, detail of muqarnas. Photo: Gabrieli and Scerrato, *Gli Arabi in Italia*, fig. 60. 44
21. Cappella Palatina, Palazzo dei Normanni, Palermo, nave ceiling, shadirwan flanked by figures Photo: *La Capella Palatina a Palermo: Mirabilia Italiae*, fig. 607. 47
22. Zisa, Palermo, shadirwan. Photo: author. 47
23. Cappella Palatina, Palazzo dei Normanni, Palermo, nave ceiling, detail with women at windows. Photo: *La Cappella Palatina a Palermo: Mirabilia Italiae*, fig. 458. 48
24. Zisa, Palermo, window of second floor with muqarnas hood looking onto salsabil. 49
25. Pliny, *Historia naturalis*. Paris, Bibliothèque Nationale de France, MS lat. 6802, fol. 143v. 68
26. Pliny, *Historia naturalis*. Paris, BNF, MS lat. 6802, fol. 143v. Detail. 70
27. Petrarch, *Trionfi*, Dream of Petrarch. Vienna, Österreichische Nationalbibliothek, MS 2649, fol. 3v. 75
28. Ambrogio Lorenzetti, Allegory of Good Government. Siena, Palazzo Pubblico, Sala dei Nove. 82
29. Ambrogio Lorenzetti, Allegory of Good Government, Countryside. Siena, Palazzo Pubblico, Sala dei Nove. 83
30. Ambrogio Lorenzetti, Allegory of Good Government, Countryside, detail. Siena, Palazzo Pubblico, Sala dei Nove. 84
31. Limbourg Brothers, *Très riches heures of the Duc de Berry*, Calendar, June. Chantilly, Musée Condé ms. 65, fol. 6v. 86
32. Limbourg Brothers, *Très riches heures of the Duc de Berry*, Calendar, July. Chantilly, Musée Condé ms. 65, fol. 7v. 87
33. Ambrogio Lorenzetti, Allegory of Good Government, Countryside, detail, workmen with scythes. Siena, Palazzo Pubblico, Sala dei Nove. 88
34. Limbourg Brothers, *Très riches heures of the Duc de Berry*, Calendar, June, detail, workmen with scythes. Chantilly, Musée Condé, MS 65, fol. 10v. 89
35. Limbourg Brothers, *Très riches heures of the Duc de Berry*, Calendar, October, detail, workman sowing seeds. Chantilly, Musée Condé, MS 65, fol. 6v. 92

36. Ambrogio Lorenzetti, Allegory of Good Government, Countryside, detail, workman sowing seeds. Siena, Palazzo Pubblico, Sala dei Nove. 92
37. Map of the Burgundian Lowlands with Hesdin (after *Illuminating the Renaissance,* fig. on p. 5). 98
38. Hesdin plan, after Van Buren, "The Park of Hesdin," *Medieval Gardens,* fig. 2. 101
39. Copy of painting attributed to Jan van Eyck purportedly showing the Park at Hesdin. Versailles, Musée du Chateau. 104
40. Table fountain. Cleveland, Cleveland Museum of Art. 107
41. Jean Mansel, *La fleur des histoires,* Jason and the Argonauts, 1446–51. Brussels, Royal Library, MS 9231, fol. 109v. 111
42. Hubert and Jan van Eyck, Altarpiece, detail, St. Anthony. Ghent, St. Bavo. 115
43. Hubert and Jan van Eyck, Altarpiece. Ghent, St. Bavo. 117
44. Hubert and Jan van Eyck, Altarpiece, view closed. Ghent, St. Bavo. 118
45. Hubert and Jan van Eyck, Altarpiece, detail, Adoration of the Lamb. Ghent, St. Bavo. 119
46. Hubert and Jan van Eyck, Altarpiece, detail, Adam and Eve. Ghent, St. Bavo. 120
47. Hubert and Jan van Eyck, Altarpiece, detail, John the Baptist. Ghent, St. Bavo. 122
48. Robert Campin, Merode Altarpiece, detail, Virgin of Annunciation. New York, Metropolitan Museum of Art, The Cloisters. 128
49. Claus Sluter, Pleurant, Tomb of Philip the Bold. Dijon, Chartreuse de Champmol. 129
50. Roger van der Weyden, Descent from the Cross, detail. Madrid, Prado. 129
51. Hendrick III van Cleve, *Cortile delle statue* from view of Vatican, 1589. Brussels, Musées Royaux des Beaux Arts de Belgique. 142
52. Marten van Heemskerck, *Cortile delle statue,* c. 1532. London, British Museum. 143
53. Duveen Gallery with Parthenon marbles. London, British Museum. 146
54. Parthenon, Athens. Photo: Alison Frantz. 146
55. After Marten van Heemskerck, Old and New St. Peter's, 1538–42. Berlin, Kupferstichkabinett, 79.D.2, vol. 1, fol. 15r. 148
56. Reconstruction of Bramante's plan for the Vatican (after Frommel, "I tre progetti," *Il Cortile delle statue,* fig. 7). 148

ILLUSTRATIONS

57. *Cortile delle statue,* Vatican. Modern view. 149
58. *Cortile delle statue,* Vatican. Reconstruction of site in the 16th c. (Brummer, *The Statue Court in the Vatican Belvedere,* pl. II). 149
59. Laocoon, from the *Cortile delle statue.* Vatican Museums. 150
60. Antonio da Sangallo the Elder (attr.), Niche for Laocoon in *Cortile delle statue.* Vienna, Albertina, Inv. 48v. 151
61. Perugino and Filippino Lippi, Deposition. Florence, Galleria dell'Accademia. 158
62. After Marten van Heemskerck, Garden of the Galli, 1532–37. Berlin, Kupferstichkabinett, 79.D.2, vol. 1, fol. 72. 160
63. After Federico Zuccari, Taddeo Zuccari drawing in the *Cortile delle statue.* Florence, Uffizi, Gab. Disegni. 161
64. Titian, Resurrection Altarpiece, detail, Christ triumphant, Brescia, Ss. Nazaro e Celso. 162
65. Apollo Belvedere, from the *Cortile delle statue.* Vatican Museums. 163
66. Raphael, School of Athens. Vatican Palace. 164
67. St. Peter's in the Vatican, view of interior to west. 165
68. Belvedere Torso, from the *Cortile delle statue.* Vatican Museums. 169
69. Titian, Adam and Eve. Madrid, Prado. 169
70. Marten van Heemskerck, Hercules and Antaeus from the *Cortile delle statue.* Berlin, Kupferstichkabinett, 79.D.2, vol. 1, fol. 59r. 170
71. Michelangelo, Flood, detail. Sistine Chapel, Vatican Palace. 170
72. Baccio Bandinelli or Battista Naldini, the Nile, from the *Cortile delle statue.* Lisbon, Museu Nacional de Arte Antigua, inv. no. 1072. 171
73. Michelangelo, Creation of Adam, detail, God the Father. Sistine Chapel, Vatican Palace. 171
74. Cleopatra (now identified as Ariadne), from the *Cortile delle statue.* Vatican Museums. 172
75. Lorenzo Ghiberti, bronze doors, Nativity, detail, Virgin. Florence, Baptistery of S. Giovanni. 172
76. Venus Felix, from the *Cortile delle statue.* Vatican Museums 173
77. Raphael, Madonna of the Meadow. Vienna, Kunsthistorisches Museum. 173
78. Robert Campin, Merode Altarpiece, Virgin of Annunciation. Detail. New York, Metropolitan Museum of Art, The Cloisters. 188

ACKNOWLEDGMENTS

I HAD BEEN THINKING OF A BOOK like this for quite some time, and then two opportunities arose that prompted me to begin. One was an invitation from Tom Crow to direct a workshop at the Getty Research Institute in 2006 in conjunction with the theme year, "The Persistence of Antiquity," which helped me organize my thoughts on the Cortile delle Statue. The other was my year long term as the Marta Sutton Weeks Faculty Fellow at the marvelous Stanford Humanities Center in 2006–7, where I was able to devote myself full time to research. I would like to thank both institutions and their extraordinary staffs for all manner of assistance as well as the chance to benefit from truly wonderful scholarly communities. I was able to pursue my work with fellowships at the Huntington Library in San Marino and the Sterling and Francine Clark Art Institute in Williamstown, in the summer and fall of 2007 respectively, for which I am also deeply grateful. I have presented different parts of my text at Columbia University, Tulane University, the Claremont Colleges, Dumbarton Oaks Center for Landscape Studies, the Università degli Studi di Parma, Lecce, Roma Tre and "La Sapienza," Northwestern University, the University of Colorado at Boulder, the J. Paul Getty Museum and the University of California at Berkeley, Santa Cruz, Los Angeles and San Diego, and have profited from the discussions that ensued.

Among those who played a role in the genesis of this book, I would like to single out Therese O'Malley, who has quietly but profoundly shaped the present-day field of landscape studies and whose friendship and support have been much appreciated. George Gorse and Michel Conan were available at several key points for some useful conversations and interchanges, and John Dixon Hunt gave an incisive reading of my manuscript.

ACKNOWLEDGMENTS

Friends and colleagues generously shared with me their knowledge and insight in numerous conversations: Ann Jensen Adams, Maria Andaloro, Liliana Barroero, Caroline Bruzelius, Barbara Cinelli, S. Hollis Clayson, Giovanna Cesarani, Anthony Cummings, Caecilia Davis Weyer, Martin Donougho, Judson J. Emerick, Marina Falla Castelfranchi, Claire Farago, Sharon Farmer, Maria Luisa Fobelli, Marisa Galvez, Roland Greene, Jack Greenstein, Christina Kiaer, Richard Kieckhefer, Michael Kuczynski, Johanne Lamoureux, Michael Lewis, Ruggero Longo, Claire Lyons, John Marino, Mark Meadow, Maureen C. Miller, J. Nicholas Napoli, Valentino Pace, Roberta Panzanelli, Arturo Carlo Quintavalle, Serena Romano, Avinoam Shalem, Maddalena Signorini, Claudia Swan, Alice Mary Talbot, Teresa Toulouse, Caterina Volpi, Martha Wolff and Jan Ziolkowski. I would also like to acknowledge a debt of the more distant past, to Ernst Kitzinger, for instilling in me a desire to understand twelfth-century Palermo.

The Foundation for Landscape Studies graciously awarded this book support in the form of a David R. Coffin Publication Grant. My publishers at Italica Press, Ronald G. Musto and Eileen Gardiner, have been, throughout the process of publication, just simply perfect.

Chapter 5 was presented at the Getty Research Institute in May 2006 and published in the volume, *The Fragment: An Incomplete History,* ed. William Tronzo (Los Angeles: The Getty Research Institute, 2009), 39-59, and I am grateful for permission to include a revised version of it here.

This book is dedicated to my favorite gardeners, Gail and Phoebe, with hearty thanks.

PROLOGUE

"The garden flew round with the angel,
The angel flew round with the clouds."
—Wallace Stevens, "The Pleasures of Merely Circulating," 1934

THE FOUR ESSAYS that make up this book take as their subject gardens of the Middle Ages and Renaissance whose traces are still visible, in varying degrees, at sites in Italy and France: Palermo and Rome, the Vaucluse and Hesdin. Traces only, as these gardens have long since been emptied of the life whose insistent motion gave them shape and in the intervening years have been transformed in such a way as to entangle and obscure significant moments of their past. Yet these moments were also refracted in other media — images and texts — that may be used to bring the past into focus again in the landscape itself. In the pages that follow I shall attempt precisely this. I would like to think of my modus operandi as an experiment, crossing the constitutive acts of the discipline of archaeology — excavation and reconstruction — with the protocols of the history of art, as it will involve, in a continuous circuit, both the identification and the interpretation of salient witnesses of the past.

This experiment may derive from archaeology and the history of art, but its subject belongs to the field of landscape studies, which has truly burgeoned in recent years under the auspices of a provisional and yet ever-widening constituency of disciplines and initiatives, including garden history, cultural geography and environmental science, as well as anthropology and the histories of art and architecture, literature, material culture and performance.[1] As landscape has become an increasingly independent field of inquiry, however, it has tended to take on the character of an autonomous form like that of the arts, whose methods of theory and criticism have become ensconced in the academy.[2]

This book will take a different path. The landscape it seeks to narrate, in four discrete episodes, stands not alone, as an independent and integral creation, but as an installation within a more enduring environment in much the same way that temporary "ambient architecture" — the architecture of the stage set, the showroom and the festival — stands within the framework of building and city.[3] It will be argued here that this landscape functioned as a kind of staging ground or laboratory of experiment, in which new social, political and cultural forms could be imagined, realized, developed and manipulated virtually simultaneously and without the burden of a commitment to their permanent implementation, and in ways that involved both complicity with and critique of the existing order; indeed, that it was this precise modality of landscape — serving, mediating, instrumentalizing — that made it a critical space of change in the era between the medieval and early modern worlds.[4] Seeing the four gardens in light of the larger prerogatives and practices of the societies in which they are embedded is thus the necessary condition of the present endeavor. What will hold this point in focus, and indeed the thread that links these studies, is the meaning of the garden as made manifest in movement.

Much of what I have come to see as significant in the four gardens is predicated on a concept of bodily movement, which is understood here as both an experiential and an imaginative act. As a manifestation of the past, this movement takes shape in historical documents — images and texts. But I would like to think that it can also be sensed in the landscape itself, almost phenomenologically, as a kind of a cursive script formed by the body freely circumambulant in space, the installation of which is as consequential as any tree or stone. The significance of this script lies in the way in which it congers up a narrative, much in the manner of the *ductus* or the momentum through a medieval text instilled stylistically by the author and absorbed

by the reader, to which Mary Carruthers has drawn attention.[5] My goal in each of the following essays will be to elucidate the narratives instilled in the historical landscape by bodily movement as conveyed in relevant images and texts.

At the same time, this book has benefited from directions taken in previous work in the field of landscape studies, at whose intersection, in a sense, it stands. The description of Piero de' Crescenzi (1233–1321) of the garden as a thing seen is almost a programmatic statement for the subsequent development of landscape design in plans and views.[6] It is also a paradigm for the study of gardens, and landscape, as visual phenomena; it leads directly to thinking about their taxonomy and symbolism, their genealogies, traditions and political affiliations, and in the guise of visuality, their social framework and implications.[7] Functional considerations have been another important issue in the field, embracing the role of the audience and reflecting an engagement with reception.[8] Performance studies have usefully called into question the efficacy of the production/reception divide and have raised important questions about the conceptualization of space, motion and time.[9] There is also an analogy in architectural studies in the use of liturgy (embodied in texts) to interpret churches and other religious spaces, or in the use of ritual and ceremony in the secular and civic arena, which has expanded our frame of reference in writing about the past. But this analogy is only a partial one.[10] What is at issue is not simply a problem of mimesis. It is the problem of the material traces of phenomena by which historically resonant acts are made manifest.

As I make more explicit below, my effort to formulate the matter in these terms also signals a debt, if not in the letter at least in the spirit of my enterprise, to the work of Aby Warburg. This scholar's interest in the interconnection of words, images and movement led him to a conception of culture as a dynamic composition of energies — of needs and anxieties, of

forms and ideas — that exist not in isolation but as currents in courses, pathways or circuitries that bind them together as they move in multiple directions, forward and back.[11] The challenge posed by this model has been felt here, and it may be expressed in the following terms: in order to apprehend any individual form, such as landscape, it is incumbent upon the historian to reach out widely into the culture as a whole and to attempt to extract from it, in the various material traces that it has left, the relevant witnesses to a particular moment, or the relevant circuitries, that are both real and fragile at the same time.

Petrarch

THE THREAD INTERTWINING the two phenomena, gardens and movement, that generated these studies can be traced back to a single moment and one text: a letter of Petrarch's written to a friend, Franceso Nelli, in 1352, in which there is an arresting description of the poet's beloved residence in the Vaucluse:

> Here I have acquired two small gardens perfectly suited to my skills and taste. To attempt a description for you would be too long. In short, I believe that no similar spot exists in all the world, and, to confess my unmanly fickleness, I regret only that it is not in Italy. I customarily call it my transalpine Helicon. The one garden is very shady, suitable only for study and sacred to our Apollo. It overhangs the source of the Sorgue, and beyond it lies nothing but ravines and cliffs, remote and accessible only to wild beasts or birds. The other garden, near the house, appears more cultivated, and is a delight to Bacchus. This one, astonishing as it may seem, is in the midst of the very beautiful and swift-running river. Nearby, divided from it by a very small bridge on the further side of the house, hangs a curved vault of native rock that now provides shelter against the summer heat. It is a place that inspires studies, and I suspect is not too dissimilar to the little hall where Cicero used to declaim his orations, except that his did not have a Sorgue flowing alongside. Under this vault, therefore, I spend my afternoons, and my mornings on the

hillsides; the evenings I spend in the meadows or in my less cultivated garden at the source where my efforts have conquered nature and cleared a spot under the high cliff in the midst of the waters, narrow indeed but very inspiring, in which even a sluggish mind can rise to the noblest thoughts.[12]

What struck me immediately in reading this text was how Petrarch imagined his gardens: not as an abstract space endowed with the properties of extensibility and tangible contours, but as a sequence of events guided and shaped by purposive action. The term "space," in fact, seemed inadequate to convey the significance of the scene, nor was temporality the key.[13] This was a scenario in the pure staging of motion, whose content derived from its form and whose form embraced the landscape. In a sense, this narration bears some resemblance to the poet's famous description of his ascent of Mount Ventoux — long thought to be the mirror of an experiential reality and now understood as a beautiful poetic fiction — but with a clearer and more compact structure.[14]

The composition takes the shape of a crescendo. It is in the poet's devotion to the new activity of secular learning, it is in his innovative use of the classical as an affective frame, but above all it is in his restless movement in the landscape between the two gardens, the cultivated and the wild, between reason and passion, that Petrarch creates a powerful and prescient image. At a later point in time this amalgamation of reason and passion would be enacted imaginatively in the scholar's study, the secular version of the monastic cloister, but at this moment and for Petrarch, it is landscape that serves to lay bare the perceived mechanism of the new learning, in its relentless oscillation in nature between these two poles. Movement thus becomes a way of apprehending landscape, as landscape becomes a way of understanding culture.

Part of the significance of the text was as a parable whose key ingredients foreshadowed my historical narrative: the site and its representation (the two gardens and their dedications

respectively to Apollo and Bacchus); the animation of the site in the form of bodily movement (the daily passage of the author from one place to the other); and the expression of resolution in a culturally significant act (learning).[15] But the text also had a more immediate impact in the degree to which it enabled me to articulate a historical distinction. These gardens were not just simply another instance of the ancient and venerable theme of the *locus amoenus*.[16] Petrarch's movement itself was an act of creation: the creation of a world in which he could come into being as a poet. This world stood apart from the one in which he lived, epitomized by his house, his dwelling. Perhaps more accurately, this new world issued forth from another, more primordial point as the poet himself issued forth each day from his house in order to perform his duties. His performance entailed the unfurling of this world, which supplemented the one that had previously sustained him. His movements and their manifold implications, therefore, did not stand alone but in relationship to a prior and ongoing existence from which he had to depart. In other words, the import of this passage, the dynamism of the imagined experience, derives as much from the movement to the garden as from the movement in the garden. As such, the passage conspicuously juxtaposes itself to another garden narrative, one that had also involved a momentous movement and which for ages had been a profoundly influential cultural artifact.

Eden

THE MOST IMPORTANT GARDEN in the Middle Ages — the best known and most deeply resonant — was not a place at all, but an act of the imagination: the Garden of Eden.[17] This garden, also known as the terrestrial paradise, was described in the book of Genesis. Out of it humanity's common ancestors, Adam and Eve, were ultimately driven, to their consternation,

in a series of events commonly known as the Fall. The story is colossal, although it is told in the first few chapters of Genesis with an often frustrating terseness, which makes no exception for important details of locale, including the garden:

> When the Lord God made earth and heaven, there was neither shrub nor plant growing wild upon the earth, because the Lord God had sent no rain on the earth; nor was there any man to till the ground. A flood used to rise out of the surface of the earth and water all the ground. Then the Lord God formed a man… (and)… planted a garden in Eden away to the east, and there he put the man whom he had formed. The Lord God made trees spring from the ground, all trees pleasant to look at and good for food; and in the middle of the garden he set the tree of life and the tree of the knowledge of good and evil. There was a river flowing from Eden to water the garden, and when it left the garden it branched into four streams.… The Lord God took the man and put him in the Garden of Eden to till it and care for it. He told the man, "You may eat from every tree in the garden, but not from the tree of the knowledge of good and evil. [Gen. 2:9–17]

To those who dared to visualize this magical place, the biblical passage provided some conspicuous points of reference: the existence of a center occupied by two portentous trees, which also in turn implied the existence of a periphery, not to mention the other trees "pleasant to look at" and the winding river, which divided into four when it left the garden. Taken in a literal sense, these features became a kind of template that made the Garden of Eden one of the most conventional images of the Middle Ages. The template emphasized the garden's perfection and regularity, its utter detachment from the realm of change. It is interesting to observe that this quality adhered to Eden as much in its visualizations as in its uses as metaphor.

With regard to images, one might single out as exemplary the suave rendering of the fifteenth-century Harvard Hannibal Master (Fig. 1), whose relationship to tradition nonetheless is

revealed in juxtaposition to other, earlier representations, as for instance in the twelfth-century *Liber floridus* of Lambert of Saint-Omer.[18] These images show the garden to be as civilized a piece of nature as one could imagine, beautifully regular in the disposition of its parts and filled with nourishment for the eye and body. No simple swath of uncultivated land could be so replete.

As to the symbolic use of Eden, on the other hand, a case in point is the monastic cloister. The cloister became an important component of the monastery sometime in the early Middle Ages; its definitive shape of four porticoes enclosing an open central space marked by paths that converged on a tree or a fountain, is attested in the early-ninth century St. Gall Plan (Fig. 2).[19] Thereafter, the

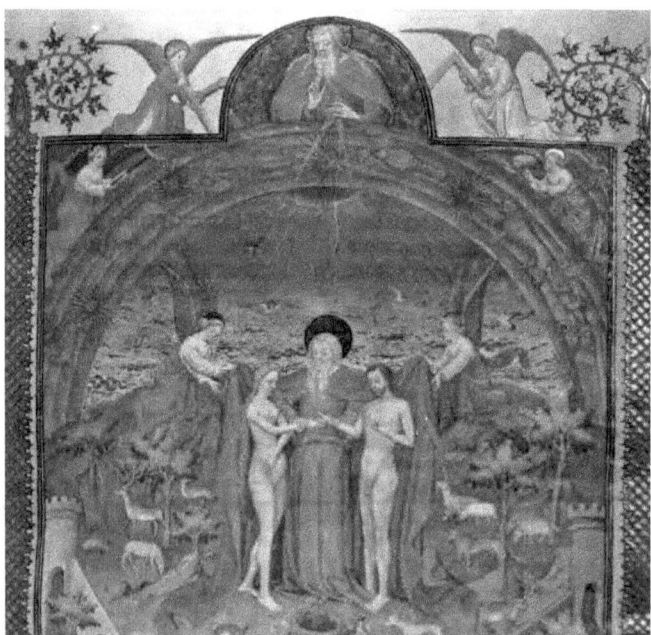

Fig. 1. Harvard Hannibal Master, Adam and Eve with the Creator in the Garden of Eden. Paris, Bibliothèque Nationale de France, MS fr. 247, fol. 3r.

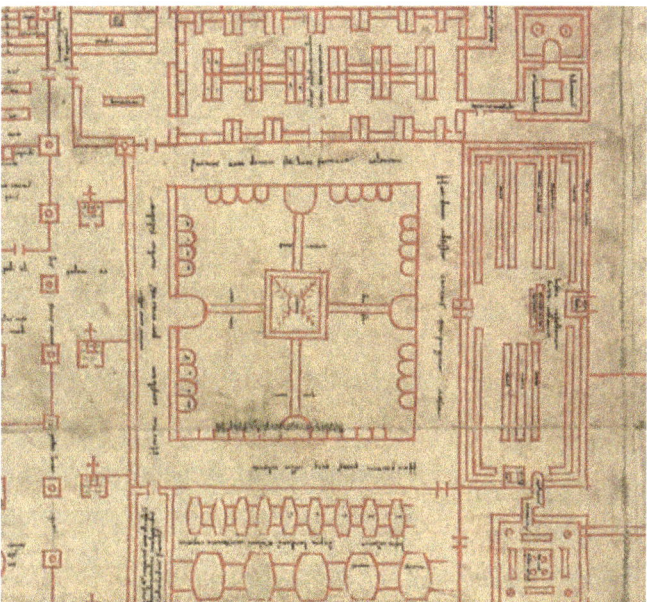

Fig. 2. St. Gall, Codex Sangallensis 1092. Plan of Monastery, detail, plan of cloister and adjacent buildings.

cloister appears with some consistency in medieval monasteries, particularly in the West. This is doubtless a testimony to its functional importance but also to its symbolic significance. Among its various meanings and uses, the cloister (as both the architectural structure of the courtyard and the monastery as a whole) was understood as paradise, to which monks laid special claim because of their spiritual avocation. In the words of William Durandus in the thirteenth century, "Just as the church building symbolizes the Church Triumphant, so is the *claustrum* a symbol of the paradise where we will live together with one heart.... This image of paradise is given to them who dwell within the cloister."[20] The equilateral form of the courtyard gave architectural shape to the perfection of the place by dimensionalizing the stasis of an unwavering symmetry.

But this is the conundrum. The Eden of Genesis was not simply the paragon of stasis. It was also the epicenter of change, perhaps the most catastrophic and far-reaching that humanity had ever imagined experiencing; through it the entire human race passed from one state of existence into another. This passage was filled to its extremities with passion whose own essential expression was movement. In a sense the movement began with the fateful reach for the fruit of the tree, but it crystallized and then culminated decisively in expulsion at the hand of God, ratified by an angel with a fiery sword:

> So the Lord God drove him out of the garden of Eden to till the ground from which he had been taken. He cast him out and to the east of the garden of Eden. He stationed the cherubim and a sword whirling and flashing to guard the way to the tree of life. [Gen. 3:23–24]

All of human endeavor and almost all of human culture precipitated immediately. Adam and Eve's exit was preceded by the invention of clothing, undertaken by God Himself, but followed by the institution of the family, by agriculture and husbandry, by emotion and strife, by society, cities and boundaries, all of which were the fabrications, the innovations, the improvisations of humanity. These projects were the events that filled the story of humanity, a story heretofore devoid of incident, pushing it time and again to a breaking point (i.e., the Flood), as the fragile vessel that envelopes a vacuum is endangered by a breach that allows the natural world of substance once again to fill it. All of the things that then rushed in — stories, histories, events, cultures, activities, interactions, thoughts and feelings — were the result of one fateful move: the move from within the garden to without. In this respect to call the first seven days of Genesis a narrative of the story of creation is perhaps to place the accent on the wrong syllable. Admittedly these days witnessed considerable accomplishment, but the world of

humanity, the story of humanity — tumultuous, tortured and infinitely complex — was the direct result of one moment above all: the exit of Adam and Eve.[21]

The Unsettling of Tradition

THAT PETRARCH'S TEXT puts the generative movement in reverse is precisely the point. Adam and Eve expanded the world by leaving their garden — Petrarch, by entering his. With the exit of Adam and Eve, Eden was emptied of movement to become a perfect and indeed beautiful void. Its primary purpose from that point on was as a thing viewed, almost as if it were a receptacle of symbols, an object, burdened by an allegory that rendered it almost inert. Petrarch moved from human agency to nature and in so doing opened the possibility of a new world of endeavor that constituted his work. His gardens were like a force field, given shape and heft by the energy of movement, which was in effect the continuous unfolding of potential. Petrarch's gardens were not simply objects, but events, and with this conceptualization one senses a shift in the terms of the discourse, an unsettling, of tradition, which would seem to resonate with a change that is perceptible in landscape itself.

That the later Middle Ages and early Renaissance witnessed an enormous expansion in the role of landscape from the immediately preceding centuries is borne out by numerous sources and histories: by the famous gardens of Palermo, Naples, Hesdin and Rome, for example, or by the poetry of the *Roman de la Rose*, Dante, Boccaccio and the *Hypnerotomachia Poliphili*, or by the images in S. Francesco in Assisi, the Palazzo Pubblico in Siena, the *Très riches heures of the Duc de Berry* and the Castello del Buonconsiglio in Trent.[22] All of these have been described by learned commentators at one or more points in their *fortuna critica* as revolutionary, unprecedented

or strikingly new.²³ To read these commentaries is to marvel at the imbalance between past and present imputed to these works, which implies in turn the perception of a profound change in the culture as a whole. One might almost suspect that some massive and yet unseen force holding landscape in check had suddenly disappeared. That this was not simply the case is clear. The landscape of the earlier Middle Ages was not devoid of formal variety, nor was it constrained by a single symbology.²⁴ But it might seem so at times in contrast to the dynamic complexity of the landscapes that followed.

I would like to suggest that movement is the story of Petrarch's gardens and in addition, in the essays that follow — episodically and across a broad arc of time — that movement is the story of other gardens, from which it has, for different reasons, been strangely disassociated. The gardens on which I would like to focus, moreover, are actual sites whose very nature as physical space sets them apart immediately from a purely narrative realm, like that of Eden, to the extent that one might wonder whether a story of movement could be told at all. The philosophical and methodological issues raised by this problem will lay out the path that I would now like to pursue.

Notes

1. The recent publications of the Dumbarton Oaks Center for Landscape Studies, for example, give some sense of the range of approaches currently applied to the study of the historical landscape. See *Garden History: Issues, Approaches, Methods*, ed. John Dixon Hunt (Washington, DC: Dumbarton Oaks, 1992); *Landscape Design and the Experience of Motion*, ed. Michel Conan (Washington, DC: Dumbarton Oaks, 2003); *Performance and Appropriation: Profane Rituals in Gardens and* Landscapes, ed. Michel Conan (Washington, DC: Dumbarton Oaks, 2007); *Sacred Gardens and Landscapes: Ritual and Agency*, ed. Michel Conan (Washington, DC: Dumbarton Oaks, 2007); *Gardens and Imagination: Cultural History and Agency*, ed. Michel Conan (Washington, DC: Dumbarton Oaks, 2008); *Cleo in the Garden: Twenty-First Century Studies in Historical Methods and Theoretical Perspectives*, ed. Mirka Beneš and Michael G. Leo (Washington, DC: Dumbarton Oaks, 2011). In addition, see Denis Cosgrove, *The Palladian Landscape: Geographical Change and Its Cultural Representation in Sixteenth-Century Italy* (Leicester: Leicester University Press, 1993); idem, *Geography and Vision: Seeing, Imagining and Representing the World* (London: I.B. Tauris, 2008); John Dixon Hunt, *Greater Perfections: The Practice of Garden Theory* (Philadelphia: University of Pennsylvania Press, 2000); idem, *The Afterlife of Gardens* (Philadelphia: University of Pennsylvania Press, 2004); Martin Warnke, *Political Landscape: The Art History of Nature* (Cambridge, MA: Harvard University Press, 1995); *Iconography of Landscape: Essays on the Symbolic Representation, Design, and Use of Past Environments,* ed. Denis Cosgrove and Stephen Daniels (Cambridge: Cambridge University Press, 1988); *The Meaning of Gardens: Idea, Place and Action,* ed. M. Francis and R.T. Hester Jr. (Cambridge, MA: MIT Press, 1989); *Pensare al giardino*, ed. Paola Capone, Paola Lanzara and Massimo Venturi Ferriolo (Milan: Angelo Guerini, 1992); *Landscape and Power*, ed. W.J.T. Mitchell (Chicago: University of Chicago Press, 1994); *Landscape Theory*, ed. Rachael DeLue and James Elkins (New York: Routledge, 2008); Jacob Wamberg, *Landscape as World Picture: Tracing Cultural Evolution in Images*,

trans. Gaye Kynoch, 2 vols. (Aarhus: Aarhus University Press, 2009); John Dixon Hunt, *A World of Gardens* (London: Reaktion Books, 2012); and John Aberth, *An Environmental History of the Middle Ages: The Crucible of Nature* (London: Routledge, 2012). See also now *A Cultural History of Gardens*, ed. Michael Leslie, John Dixon Hunt et al., 6 vols. (London: Bloomsbury, 2013) with volumes devoted to antiquity and to the Middle Ages.

2. A fundamental premise of the scholarship of David R. Coffin, John Dixon Hunt and Elisabeth Blair MacDougall, each of whom has played a critical role in the development of the field of landscape studies, is the garden as a work of art. See, for example, the collected studies of David R. Coffin, *Magnificent Buildings, Splendid Gardens* (Princeton: Princeton University Press, 2008); Elisabeth Blair MacDougall, *Fountains, Statues and Flowers: Studies in Italian Gardens of the Sixteenth and Seventeenth Centuries* (Washington, DC: Dumbarton Oaks, 1994); and the works by Hunt cited in n. 1.

3. A case in point is the study of Alessandra Anselmi, "Theaters for the Canonization of Saints," in *St. Peter's in the Vatican*, ed. William Tronzo (New York: Cambridge University Press, 2005), 244–69.

4. On this issue, see Wolfgang Iser, *The Fictive and the Imaginary: Charting Literary Anthropology* (Baltimore: The Johns Hopkins University Press, 1993). For Iser, what embraces the complexity of fiction is the process of doubling, by which is meant an extension of reality, its dimensionalization and spatialization, so that it may serve as a platform on which a new world of performance may be staged. See also the collected essays devoted to the critical assessment of Iser's book in *New Literary History* 31 (2000); and Hans Belting's *Bild-Anthropologie: Entwürfe für eine Bildwissenschaft* (Munich: W. Fink, 2001), with a discussion of Iser's work.

5. Mary Carruthers, "Rhetorical *Ductus*, or Moving through a Composition," *Acting on the Past: Historical Performance across the Disciplines*, ed. Mark Franko and Annette Richards (Hanover, NH: Wesleyan University Press, 2000), 99–117.

6. Petrus de Crescentiis (Pier de' Crescenzi), *Ruralia commoda: Das Wissen des vollkommenen Landwirts um 1300).* Erster Teil: Einleitung mit Buch I–III, ed. Will Richter and Reinhilt Richter-Bergmeier (Heidelberg: C. Winter, 1995). See also *Pier de' Crescenzi (1233–1321): Studi e documenti,* ed. Tommaso Alfonsi, Roberto Bozzelli et al. (Bologna: Licinio Cappelli Editore, 1933); Robert G. Calkins, "Piero de' Crescenzi and the Medieval Garden," in *Medieval Gardens,* ed. Elisabeth MacDougall (Washington, DC: Dumbarton Oaks, 1986), 155–73, with bibliography; Johanna Bauman, "Tradition and Transformation: The Pleasure Garden in Piero de' Crescenzi's *Liber Ruralium Commodorum,*" *Studies in the History of Gardens and Designed Landscapes* 22 (2002): 99–141.

7. Denis Cosgrove, "Prospect, Perspective and the Evolution of the Landscape Idea," *Transactions of the Institute of British Geographers* n.s. 10 (1985): 45–62. See the introduction by D. Fairchild Ruggles and Elizabeth Kryder-Reid, "Vision in the Garden," *Journal of Garden History* 14 (1994): 1–2; *Visuality Before and Beyond the Renaissance: Seeing as Others Saw,* ed. Robert S. Nelson (Cambridge: Cambridge University Press, 2000); and Jens E. Kjeldsen, "Talking to the Eye: Visuality in Ancient Rhetoric," *Word & Image* 19 (2003): 133–37.

8. A striking case is the recent study of Versailles, which takes as its point of departure garden itineraries composed by Louis XIV. See Robert W. Berger and Thomas Hedin, *Diplomatic Tours in the Gardens of Versailles under Louis XIV* (Philadelphia: University of Pennsylvania Press, 2008). In another vein entirely, see the discussion of ekphrasis and movement in Ruth Webb, "The Aesthetics of Sacred Space: Narrative, Metaphor, and Motion in *Ekphraseis* of Church Buildings," *Dumbarton Oaks Papers* 53 (1999): 59–74.

9. See, for example, Victor Turner, *The Anthropology of Performance* (New York: PAJ Publications, 1986); *Secular Ritual,* ed. Sally F. Moore and Barbara G. Myerhoff (Amsterdam: Van Gorcum, Assen, 1977); *Performativity and Performance,* ed. Andrew Parker and Eve Kosofsky Sedgwick (New York: Routledge, 1995); *Picturing Performance: The*

Iconography of the Performing Arts in Concept and Practice, ed. Thomas F. Heck (Rochester, NY: University of Rochester Press, 1999); and Franko and Richards, *Acting on the Past*. See also Jennifer Nevile, "Dance and the Garden: Moving and Static Choreography in Renaissance Europe," *Renaissance Quarterly* 52 (1999): 805–36. Conversely, the analysis of a garden feature may prompt interesting observations on movement. See Martine Paul, "Turf Seats in French Gardens of the Middle Ages (12th–16th centuries)," *Journal of Garden History* 5 (1985): 3–14; Malgorzata Szafranska, "Place, Time and Movement: A New Look at Renaissance Gardens," *Studies in the History of Gardens and Designed Landscapes* 26 (2006): 194–208; Robin Veder, "Walking through Dumbarton Oaks: Early Twentieth-Century Bourgeois Bodily Techniques and Kinesthetic Experience of Landscape," *Journal of the Society of Architectural Historians* 72 (2013): 5–27.

10. To cite one example: Sible de Blaauw, *Cultus et Decor: Liturgia e architettura nella Roma tardoantica e medievale. Basilica Salvatoris, Sanctae Mariae, Sancti Petri* (Vatican City: Biblioteca Apostolica Vaticana, 1994).

11. There has been an outpouring of research on Aby Warburg in recent years (as well as new editions of his own publications), among which the following are worthy of note: Peter Schmidt, *Aby M. Warburg und die Ikonologie, mit einem Anhang unbekannter Quellen zur Geschichte der Internationalen Gesellschaft für Ikonographische Studien von Dieter Wuttke* (Bamberg: Stefan Wendel Verlag, 1987); E.H. Gombrich, *Aby Warburg: An Intellectual Biography*, 2nd ed. (Chicago: University of Chicago Press, 1986); Dieter Wuttke, *Aby M. Warburgs Methode als Anregung und Aufgabe, mit einem Briefwechsel zum Kunstverständnis*, 4th ed. (Wiesbaden: Otto Harrasowitz, 1990); *Aby Warburg: Akten des internationalen Symposions, Hamburg 1990*, ed. Horst Bredekamp, Michael Diers and Charlotte Schoell-Glass (Weinheim: VCH, 1991); Dieter Wuttke, *Dazwischen: Kulturwissenschaft auf Warburgs Spuren* (Baden-Baden: Valentin Koerner, 1996); Matthew Rampley, "From Symbol to Allegory: Aby Warburg's Theory of Art," *The Art Bulletin* 79 (1997): 41–55; Christiane Brosius, *Kunst als Denkraum: Zum Bildungsbegriff*

von Aby Warburg (Pfaffenweiler: Centaurus-Verlagsgesellschaft, 1997); *Photographs at the Frontier: Aby Warburg in America 1895–1896*, ed. Benedetta Cestelli Guidi and Nicholas Mann (London: Merrell Holberton Publishers, The Warburg Institute, London, 1998); Georges Didi Huberman, *L'image survivante: Histoire de l'art et temps des fantômes selon Aby Warburg* (Paris: Éditions de Minuit, 2002); Spyros Papapetros, "The Eternal Seesaw: Oscillations in Warburg's Revival," *Oxford Art Journal* 26 (2003): 169–76; Philippe-Alain Michaud, *Aby Warburg and the Image in Motion*, trans. Sophie Hawkes (New York: Zone Books, 2004); Karen Lang, *Chaos and Cosmos: On the Image in Aesthetics and Art History* (Ithaca, NY: Cornell University Press, 2006); Charlotte Schoell-Glass, *Aby Warburg and Anti-Semitism: Political Perspectives on Images and Culture*, trans. Samuel Pakucs-Willcocks (Detroit: Wayne State University Press, 2008); Spyros Papapetros, *On the Animation of the Inorganic: Art, Architecture, and the Extension of Life* (Chicago: University of Chicago Press, 2012).

12. Petrarch, *Epistolae Familiares* XIII 8. The latest, standard edition is *Le familiari*, ed. Ugo Dotti, 3 vols. (Rome: Archivio Guido Izzo, 1991). For the English translation see *Letters on Familiar Matters*, trans. Aldo S. Bernardo, 3 vols. (New York: Italica Press, 2005), 2:204–6. See also Ernst Hatch Wilkins, *Studies in the Life and Works of Petrarch* (Cambridge, MA: The Mediaeval Academy of America, 1955), 81–181; and idem, *Petrarch at Vaucluse: Letters in Verse and Prose* (Chicago: University of Chicago Press, 1958), 122–23. See also Lucia Battaglia Ricci, "Gardens in Italian Literature during the Thirteenth and Fourteenth Centuries," *The Italian Garden: Art, Design and Culture*, ed. John Dixon Hunt (New York: Cambridge University Press, 1996), 6–33; R. Fabiani Giannetto, "Writing the Garden in the Age of Humanism: Petrarch and Boccaccio," *Studies in the History of Gardens and Designed Landscapes* 23 (2003): 231–57, included in Fabiani Giannetto, *Medici Gardens: From Making to Design* (Philadelphia: University of Pennsylvania Press, 2008), 99–131; Louis Cellauro, "Le case di campagna e i giardini di Petrarca a Valchiusa

(Vaucluse) e ad Arquà," in the exh. cat., *Andrea Palladio e la villa veneta da Petrarca a Carlo Scarpa,* ed. Guido Beltramini and Howard Burns (Padua: Marsilio, 2005), 204–5; J.B. Trapp, "Petrarchan Places: An Essay in the Iconography of Commemoration," *Journal of the Warburg and Courtauld Institutes* 69 (2006): 1–50. For a recent scholarly overview of Petrarch and his work see *Petrarch: A Critical Guide to the Complete Works,* ed. Victoria Kirkham and Armando Maggi (Chicago: University of Chicago Press, 2009).

13. The avidity with which the concept of space has been scrutinized in recent years from a variety of literary, historical and anthropological perspectives is striking. See, for example, Bill Hillier and Julienne Hanson, *The Social Logic of Space* (Cambridge: Cambridge University Press, 1984); Henri Lefebvre, *The Production of Space,* trans. Donald Nicholson-Smith (Oxford: Blackwell, 1991); *Architecture and Order: Approaches to Social Space,* ed. Michael Parker Pearson and Colin Richards (London and New York: Routledge, 1994); Stephen C. Levinson, *The Body in Space: Cultural Differences in the Use of Body-Schema for Spatial Thinking and Gesture* (Nijmegen: Cognitive Anthropology Research Group at the Max Planck Institute for Psycholinguistics, 1996); *Signs & Space = Raum & Zeichen: An International Conference on the Semiotics of Space and Culture in Amsterdam,* ed. Ernest W.B. Hess Lüttich, Jürgen E. Müller and Aart van Zoest (Tübingen: G. Narr, 1998); *Medieval Practices of Space,* ed. Barbara A. Hanawalt and Michael Kobialka (Minneapolis: University of Minnesota Press, 2000); *The Anthropology of Space and Place: Locating Culture,* ed. Setha M. Low and Denise Lawrence-Zuñiga (Oxford: Blackwell Publishing, 2003); David Summers, *Real Spaces: World Art History and the Rise of Western Modernism* (London: Phaidon, 2003); *Cultural Geography: A Critical Dictionary of Key Concepts,* ed. David Sibley, Peter Jackson, David Atkinson and Neil Washbourne (London: I.B. Tauris, 2005), esp. 3–88, "Space, Knowledge and Power"; and Lars Maraussen, *The Architecture of Space/The Space of Architecture* (Copenhagen: The Danish Architectural Press, 2008).

14. Giuseppe Billanovich, *Petrarca e il primo umanesimo* (Padua: Antenore, 1996), 168–84. See also B. Martinelli, "Del Petrarca e il Ventoso," *Studi in onore di Alberto Chiari* II (Brescia: Paideia, 1973), 768–834; Robert Durling, "The Ascent of Mt. Ventoux and the Crisis of Allegory," *Italian Quarterly* 18 (1974): 7–28; Thomas M. Greene, *The Light in Troy: Imitation and Discovery in Renaissance Poetry* (New Haven: Yale University Press, 1982), 104–11; Michael O'Connell, "Authority and the Truth of Experience in Petrarch's 'Ascent of Mount Ventoux'," *Philological Quarterly* 62 (1983): 507–20; Jill Robbins, "Petrarch Reading Augustine: 'The Ascent of Mont Ventoux'," *Philological Quarterly* 64 (1985): 533–53; Albert Russell Ascoli, "Petrarch's Middle Age: Memory, Imagination, History and the 'Ascent of Mount Ventoux'," *Stanford Italian Review* 10 (1991): 5–43; and Allen S. Weiss, *The Wind and the Source: In the Shadow of Mount Ventoux* (Albany: State University of New York Press, 2005). In addition, see: Marjorie Hope Nicolson, *Mountain Gloom and Mountain Glory: The Development of the Aesthetics of the Infinite* (New York: W.W. Norton, 1959); *La montagne dans le texte médiéval: Entre mythe et réalité*, ed. Claude Thomasset and Danièle James-Raoul (Paris: Presses de l'Université de Paris-Sorbonne, 2000); and *Les Montagnes de l'esprit: Imaginaire et histoire de la montagne à la Renaissance. Actes du Colloque International Saint-Vincent (Vallée d'Aoste) les 22–23 novembre 2002*, ed. Rosanna Gorris Camos (Aosta: Musumeci Éditeur, 2005). The prevailing interpretation of the passage on the ascent had been epitomized by Jacob Burckhardt's *Die Cultur der Renaissance in Italien: Ein Versuch* (Basel: Schweighauser, 1860); see also *The Civilization of the Renaissance in Italy*, trans. S.G.C. Middlemore (London: George G. Harrap, 1929), 293–97.

15. In this regard see also John Dixon Hunt's study, *The Figure in the Landscape: Poetry, Painting, and Gardening during the Eighteenth Century* (Baltimore: The Johns Hopkins University Press, 1989).

16. See the classic study of E.R. Curtius, *European Literature and the Latin Middle Ages,* trans. Willard R. Trask, Bollingen Series 36 (Princeton: Princeton University Press, 1973), 185–202. Also,

Nathaniel B. Smith, "In Search of the Ideal Landscape: From 'Locus Amoenus' To 'Parc du Champ Joli' in the 'Roman de la Rose'," *Viator* 11 (1980): 224–43.

17. Reinhold Grimm, *Paradisus coelestis, paradisus terrestris: Zur Auslegungsgeschichte d. Paradieses im Abendland bis zum 1200* (Munich: Fink, 1977); Colleen McDannell and Bernhard Lang, *Heaven: A History* (New Haven: Yale University Press, 1988); Jean Delumeau, *History of Paradise: The Garden of Eden in Myth and Tradition* (New York: Continuum, 1995); Ursula Frühe, *Das Paradies ein Garten – der Garten ein Paradies: Studien zur Literatur des Mittelalters unter Berücksichtigung der bildenden Kunst und Architektur* (Frankfurt am Main: Lang, 2002); and Alessandro Scafi, *Mapping Paradise: A History of Heaven on Earth* (Chicago: University of Chicago Press, 2006).

18. *Lamberti S. Audomari Cononici, Liber Floridus: Codex autographus Bibliotecae Universitatis in commemorationem diei natalis*, ed. Alberto Derolez (Ghent: Story-Scientia, 1968), 1, fig. on 105 (fol. 52r).

19. Walter Horn and Ernst Born, *The Plan of St. Gall*, 3 vols. (Berkeley: University of California Press, 1979). See also Wolfgang Sörrensen, "Gärten und Pflanzen im Klosterplan," Studien zum St. Galler Klosterplan (= *Mitteilungen zur vaterländischen Geschichte herausgegeben vom Historishcen Verein des Kantons St. Gallen*, XLII) (St. Gall: Fehr, 1962). Raymond Rey, *L'art des cloîtres romans: Étude iconographique* (Toulouse: Édouard Privat, 1955); *Gesta* 12 (1973) (issue devoted to the monastic cloister); Jacques Bousquet, "Problèmes d'origines des cloîtres romans: Histoire et stylistique. De l'époque carolingienne à Aurillac, Conques et Moissac," *Les Cahiers de Saint-Michel de Cuxa* 7 (1976): 7–33; Marcel Durliat, "Les cloîtres historiés dans la France méridionale à l'époque romane," *Les Cahiers de Saint-Michel de Cuxa* 7 (1976): 61–74; Franco Cardini, "Il giardino monastico nelle 'Sententiae' di Bernardo di Clairvaux," in *Protezione e restauro: Il giardino storico*, ed. Pier Fausto Bagatti Valsecchi (Florence: Regione Toscana, Giunta Regionale, 1987), 92–95; *I giardini dei monaci*, ed. Maria Adriana Giusti (Lucca: M. Pacini Fazzi, 1991); Rolf Legler, *Der Kreuzgang: Ein*

Bautypus des Mittelalters (Frankfurt am Main: Peter Lang, 1989). With regard to cloister fountains, see Willibald Sauerländer, "Art antique et sculpture autour de 1200," *Art de France* 1 (1961): 47–56 (cloister of S. Denis); Xavier Barral i Altet, "Fontaines et vasques provenant de cloîtres méridionaux: Problèmes de typologie et d'attribution," *Les cahiers de Saint Michel de Cuxa* 7 (1976): 123–25; *Tuinen in de Middeleeuwen*, ed. R.E.V. Stuip and C. Vellekoop (Hilversum: Uitgeverij Verloren, 1992); Franco Cardini, "L'acqua come simbolo nel giardino toscano tardomedievale," *L'eau dans la société médiévale: Function, enjeux, images. Mélanges de l'École Française de Rome* 104.2 (1992): 545–53.

20. Jean Leclerq, "Le cloître est-il un paradis?" *Le message des moines à notre temps: Mélanges offerts à Don Alexis, Abbé de Boquen*, ed. Cardinal Fumasoni Biondi (Paris: A. Fayard, 1958), 141–59; Paul Meyvaert, "The Medieval Monastic Claustrum," *Gesta* 12 (1973): 53–59; idem, "The Medieval Monastic Garden," in MacDougall, *Medieval Gardens*, 23–53; Cardini, "Il giardino monastico"; Giusti, *I giardini dei monaci*; Françoise Michaud-Fréjaville, "Images et réalités du jardin médiéval," *Jardins du Moyen Age*. Centre de l'Enluminure et de l'Image Médiévale, Abbaye de Noirlac (Paris: Le Léopard d'Or, 1995), 39–62 for Durandus.

21. Adam and Eve moved from the garden to a stage on which the sum total of the effort to return to stasis could be enacted, in a series of experiments that combined both disastrous failures and apparent, partial successes. The subsequent history of Eden is shot through with the poignant desire for return. In the early Christian period, Eden was imagined as distant, although not unimaginably so. With time and effort it was believed that it might actually be reached; conversely, the beneficence of its nourishing waters could flow directly into the inhabited lands of the earth through the rivers of the Tigris, Euphrates and the Nile. The sense of a palpable, physical connection, however, diminished with the centuries, and by the later Middle Ages the path from this world to Eden is no longer discernible. See Henry Maguire, "Paradise Withdrawn," *Byzantine Garden Culture*,

ed. Antony Littlewood, Henry Maguire and Joachim Wolschke-Bulmahn (Washington, DC: Dumbarton Oaks Research Library and Collection, 2002), 23–35. What came to replace the garden as the ultimate goal of human striving was the heavenly Jerusalem, a city whose terrible perfection of gold and jewels was manufactured, in contravention of nature. The circuitry of history thus realigned itself around an arc of movement from garden to city, from nature to the human construct. See William Alexander McClung, *The Architecture of Paradise: Survivals of Eden and Jerusalem* (Berkeley: University of California Press, 1983).

22. For a discussion of these works and relevant bibliography, see chaps. 2–5.

23. For example: Terry Comito, *The Idea of the Garden in the Renaissance* (New Brunswick, NJ: Rutgers University Press, 1978); Franco Cardini, "Il giardino del cavaliere, il giardino del mercante: La cultura del giardino nella Toscana tre-quattrocentesca," *Mélanges de l'École Française de Rome, Moyen Age, Temps modernes* 106.1 (1994): 259–73; Giorgio Bertone, *Lo sguardo escluso: L'idea di paesaggio nella letteratura occidentale* (Novara: Interlinea SRL, 2000), in addition to the discussions of the following chapters. See also the remarks of McDannell and Lang, *Heaven: A History*, 111–43.

24. Dieter Hennebo, *Gärten des Mittelalters* (Hamburg: Broschek Verlag, 1962); Derek Pearsall and Elizabeth Salter, *Landscapes and Seasons of the Medieval World* (Toronto: University of Toronto Press, 1973); Teresa McLean, *Medieval English Gardens* (New York: Viking Press, 1980); Marilyn Stokstad and Jerry Stannard, *Gardens of the Middle Ages*, exh. cat. (Lawrence, KS: Spencer Museum of Art, 1983); MacDougall, *Medieval Gardens*; *Le Jardin médiéval: Colloque, concert et exposition. Les Cahiers de l'Abbaye de Saint-Arnoult* (Warluis: Adama, 1990); John Harvey, *Mediaeval Gardens* (London: B.T. Batsford, 1990); Françoise Piponnier, "À la recherché des jardins perdus: Vestiges et traces archéologiques des jardins médiévaux," *Mélanges de l'École Française de Rome. Moyen Age* 106 (1994): 229–38; Cardini, "Il giardino del

cavaliere"; Centre de l'Enluminure et de l'Image Médiévale, Abbaye de Noirlac, *Jardins du Moyen Age* (Paris: Le Léopard d'Or, 1995); *Inventing Medieval Landscapes: Sense of Place in Western Europe*, ed. John Howe and Michael Wolfe (Gainesville: University Press of Florida, 2002); Sylvia Landsberg, *The Medieval Garden* (Toronto: University of Toronto Press, 2003); Oliver H. Creighton, *Designs upon the Land: Landscapes of the Middle Ages* (London: Boydell, 2009); and Ellen F. Arnold, *Negotiating the Landscape: Environment and Monastic Identity in the Medieval Ardennes* (Philadelphia: University of Pennsylvania Press, 2012). With regard to issues of symbolism and meaning, see D.W. Robertson, "The Doctrine of Charity in Medieval Literary Gardens: A Topical Approach through Symbolism and Allegory," *Speculum* 26 (1951): 24–49; Colette Beaune, "Le Language symbolique des jardins médiévaux," *Jardins du Moyen Age*, 63–75; Henry Maguire, *Earth and Ocean: The Terrestrial World in Early Byzantine Art* (University Park: Pennsylvania State University Press, 1987); and idem, *Nectar and Illusion: Nature in Byzantine Art and Literature* (New York: Oxford University Press, 2012). See also the remarks of McDannell and Lang, *Heaven*, 143–44, on motionlessness and the transition from a medieval to Renaissance concept of the paradise garden in heaven.

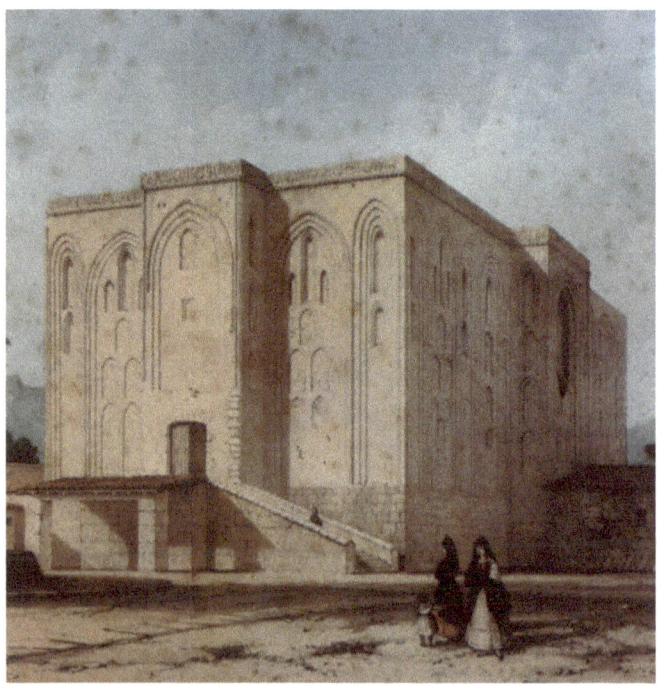

Fig. 3. Cuba, Palermo. 19th-century English lithograph. Source: Caronia and Noto, La Cuba di Palermo.

ZISA AND CUBA IN PALERMO

> Over esplanades, through doors, and across royal courts they led us, gazing at the towering palaces, well set piazzas and gardens, and the ante-chambers given to officials. All this amazed our eyes and dazzled our minds. — Ibn Jubayr, *Travels*

WHEN I FIRST VISITED that exquisite fragment of Norman Sicilian architecture called the Cuba (Fig. 3), a pavilion in one of the two gardens in Palermo whose intertwined fortunes form the subject of this chapter, I had to enter it through a private residence on the Corso Calatafimi (the continuation of the Corso Vittorio Emmanuele outside of the walls of the old city), with the gracious permission of the aged occupants of the house. At that time the Cuba seems to have been directly connected to the house by a corridor, although this may just have been a figment of my imagination. What I can confirm is that the Cuba was used as a laundry room. At some point in the course of its long history, after having passed from one princely family to another and having served a variety of noble purposes, the Cuba had fallen on hard times.

It is unlikely that this occurred before the middle of the fourteenth century. Giovanni Boccaccio used the Cuba as the setting for one of the tales of the *Decameron,* the sixth story of the fifth day, where the edifice housed a young maiden named Restituta. Restituta had been kidnapped from Ischia by pirates who then gave her as a gift to King Federigo of Sicily.[1] The king happened to be recovering from an illness at the time and so had the young woman lodged "in some beautiful buildings in a garden of his called the Cuba" ("in certe case bellissime d'un suo giardino il quale chiamavan la Cuba"). But before he could pay attention to her, she was found by a lover from her island home, which enraged the king. He was on the verge of having the couple killed when he was dissuaded from doing so

by his admiral, Ruggieri dell'Oria, and the story had a happy ending. The very names of this story — Restituta (as in the patron saint of Naples), Federigo (as in the Hohenstaufen emperor) and Ruggieri (as in the first king of Sicily) — betray knowledge of the South, though somewhat tangled and oblique. However, there is no ambiguity about the Cuba. The ascription of beauty to the ensemble attests to the fame of the edifice and its garden as a work of art.

The twelfth century witnessed an extraordinary cultural efflorescence in Sicily based on the wealth of the Norman kings, which was reflected above all in changes to the environment of the island that fundamentally shaped the experience of it even up to today.[2] The process began with preceding generations of Norman princes in the South, who were essentially peripatetic, but it took a new turn in the middle of the twelfth century with the first king, Roger II, who chose Palermo as his capital and built a royal residence there ("in loco, qui dicitur Galea"), the *Palatium novum* (Fig. 4).[3]

Medieval Palermo was not a unified urban fabric as it is today, but divided decisively into three zones by the wide beds of an inlet, the Papireto, and a seasonal river or torrent, the Kemonia

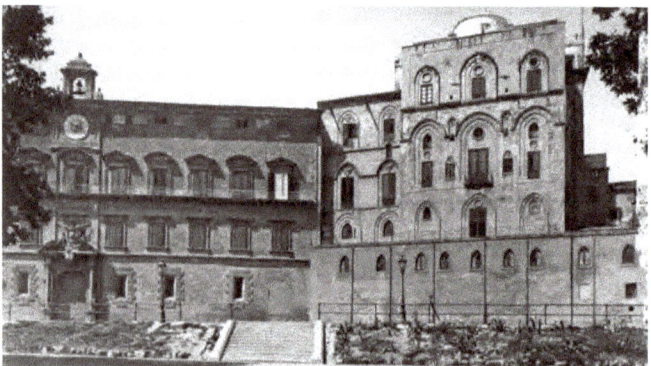

Fig. 4. Palazzo dei Normanni, Palermo. View of east facade with Torre Pisana.

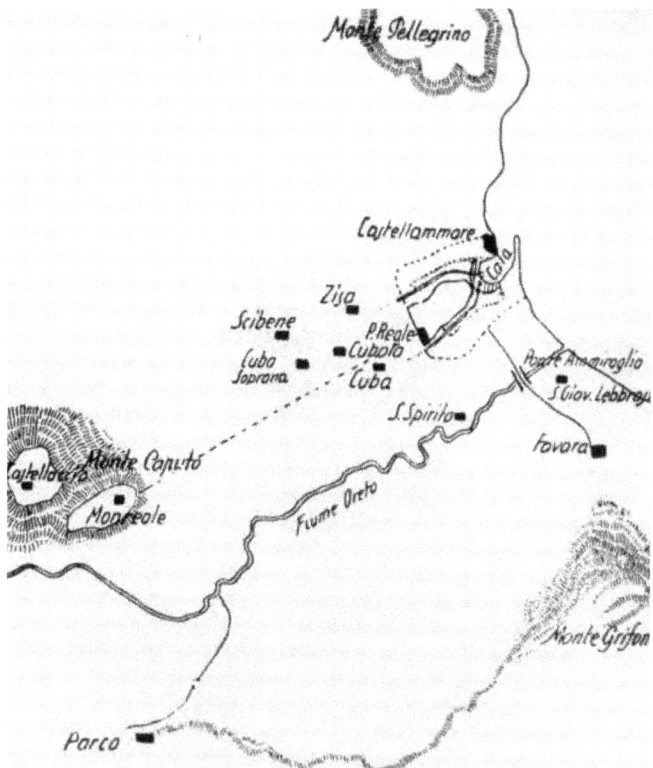

Fig. 5. Palermo, plan of city with location of gardens and pavilions (after Di Stefano, Monumenti della Sicilia normanna, pl. 133).

(Fig. 5). The highest area of the middle zone or Cassaro — the Galca — was dominated by the palace complex. Large tracts of land on the outskirts of the city outside of the walls were absorbed by royal prerogative and turned into designed landscapes or gardens. Although the name of only one of these gardens has come down to us, *viridarium Genoard,* there are many structures throughout the area that survive from this royal habitation, such as the Favara or Maredolce, the Scibene and the Cubula.[4] But two clearly stand out. One is the Cuba;

the other, closely related though slightly earlier in date, is now called the Zisa (Fig. 6).⁵

These buildings are pendants, Zisa and Cuba, and together they constitute one of the most spectacular manifestations of the designed landscape that we possess from the ample and well documented culture of twelfth-century Sicily. The following discussion will be devoted to exploring the interconnected circumstances of space, function and above all movement that they map, in the midst of which a relationship will emerge — with a set of images to which the buildings have never been directly connected before — that will allow a critical category of analysis to come into focus for the first time in their context.

Pavilions and Gardens

THE ZISA IS LOCATED to the west of the royal palace, slightly to the north of the main thoroughfare that connects the city with the

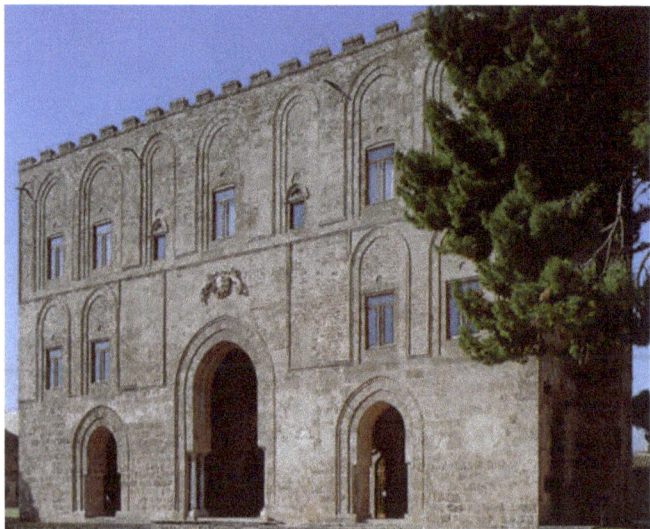

Fig. 6. Zisa, Palermo, view of facade. Photo: author.

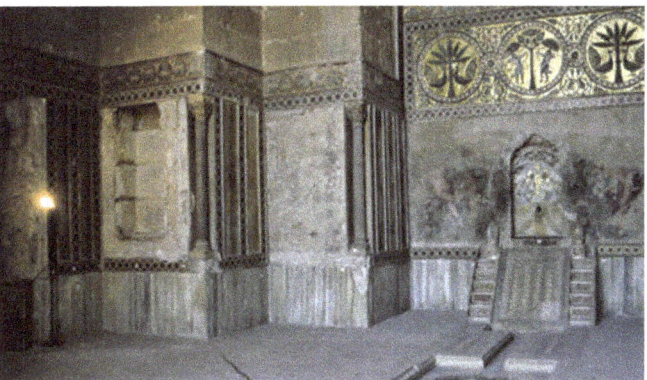

Fig. 7. Zisa, Palermo, salsabil. Photo: author.

cathedral and monastery of Monreale. Its construction is attributed to William II, the grandson of the first of the Norman kings, Roger II, although it may have been begun under William II's predecessor, William I (d. 1166). Its name derives from an Arabic inscription on the facade, which calls the building *al-'Aziz,* the magnificent or glorious edifice.[6] This is one clue, among many, that illuminates the derivation of the building from the Islamic world, as scholarship has exhaustively shown.

The building — massive and cubic — has a dramatic bearing that derives in part from its remarkable state of preservation, but also from the restorations following a recent earthquake, which have smoothed and regularized almost all of its surfaces. It is three stories in height, with an emphasis decidedly on the central bay of the ground floor. This bay contains a magnificent vaulted chamber, two stories high — the room of the fountain or *salsabil* — clearly discernible from the outside through an immense opening in the facade (Fig. 7).[7] A water channel runs down the center of the floor from a *shadirwan*, the inclined plane of a water chute in the rear wall of the room. This channel once emptied into a pool that stood in front of the building. The remains of a platform, which also once probably contained a small pavilion, have been found in the center of the

pool, leading to a reconstruction of the ensemble along the lines of the one executed by Rocco Lentini in 1935 (Fig. 8).[8] This sketch gives a reasonable impression of the Zisa and its environs in the mid-twelfth century.

The large central chamber was once lavishly outfitted with marble and mosaic. The walls had a high marble dado with bands of opus sectile and mosaic ornament, and the water channel too was decorated with mosaic and opus sectile. There was a figurative mosaic panel above the stepped fountain and large stretches of muqarnas in the area of the vaults, which were once covered with stucco. But perhaps the functional rationale of the room reveals itself most clearly in its plan.

On ground level, the room is flanked on both sides by sets of corridors and rather unassuming subsidiary spaces, several possibly for service or other provisional functions (Fig. 9). The flanking rooms above, on the second floor, are more majestic, but also include a pair of chambers directly adjacent to the double-storied ground-floor room, which open onto it

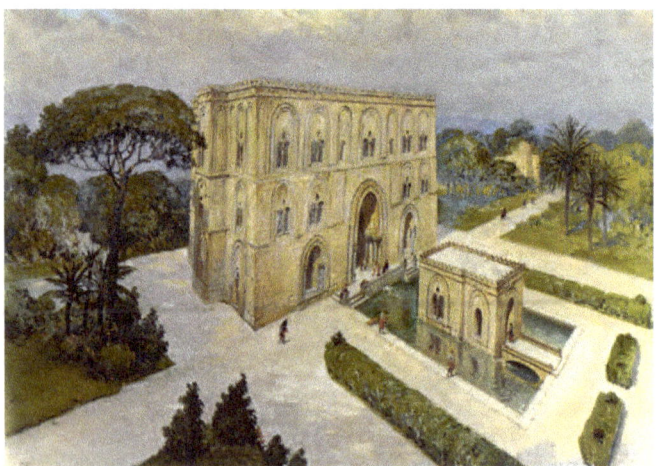

Fig. 8. Rocco Lentini, reconstruction of Zisa and setting.

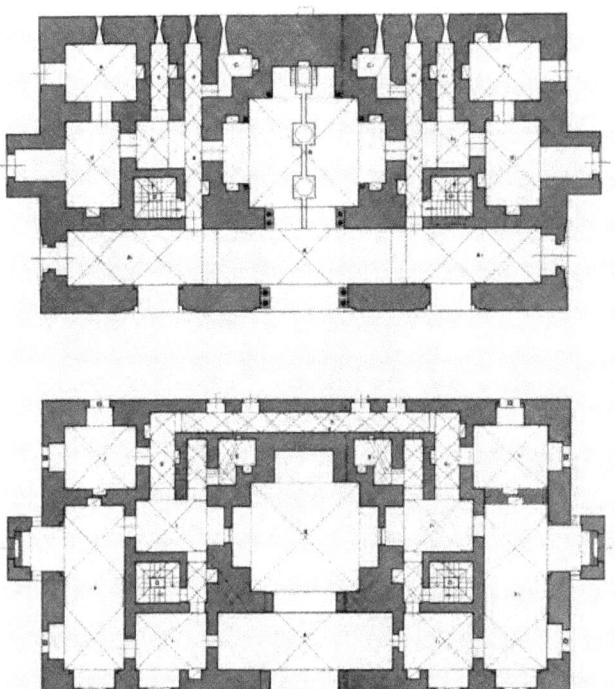

Fig. 9. Zisa, Palermo, plan of first and second floor (after Caronia, La Zisa di Palermo, figs. 49 and 50).

through windows. The windows, whose importance is indicated by the presence of muqarnas vaults above them, enabled the viewing of activities below from the vantage point of the occupants of the second floor (Fig. 10). The configuration of the third floor mirrors that of the second. It is centered on a court, which was once open with a pool in the center. To look at the building from the outside is to see it as vast and complex, but when we penetrate its plan, it simplifies itself. It settles into alignment as the coalescence, the crystallization of space around the grand ground-floor room, the "fulcro dell'architettura del Palazzo," in the words of Ursula Staacke.[9]

The glistening surfaces and chromatic splendor of this room are thus the proper expression of the idea.

It is possible to think of the Cuba, whose name derives from the Arabic word for dome, as a later, simpler and somewhat smaller version of the Zisa.[10] But in the end this is insufficient to characterize a relationship, which is more properly understood in terms of the impact of the interior: the quality of grandeur, which is present in the Zisa especially in the ground-floor

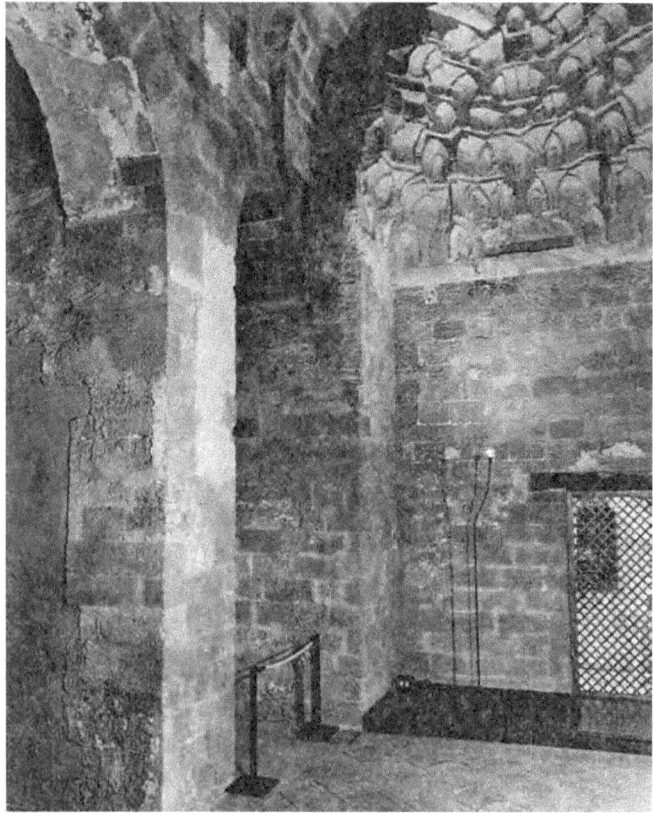

Fig. 10. Zisa, Palermo, second floor window with muqarnas hood looking onto salsabil. Photo: author.

room, has been accentuated in the Cuba. What makes it more difficult to grasp, however, is the poorer state of preservation of the building as a whole. The central space is a ruin, made all the more poignant by the traces of muqarnas vaults in the upper reaches of the large rectangular niches in each of the room's side walls (Fig. 11). The stucco fragments of muqarnas, as well as the other traces of stucco revetment on the walls, bear witness to the magnificence of the original decorative scheme.

Fig. 11. Cuba, Palermo, muqarnas in fountain room. Photo: author.

The central space is square in plan (Fig. 12). There are column bases in each of the four corners. Arches that once projected from the wall to converge at the points of the columns are visible in the southwest corner. The existence of these elements has led to the conjecture that the space was vaulted, with subsidiary vaults in the four corners and a dome over the central square carried by the four columns (Fig. 13).[11] This reconstruction is a hypothesis, however, and other solutions are possible. It may have been the case that the central room was covered with a wooden ceiling, or it may have been only partly covered and partly left open.

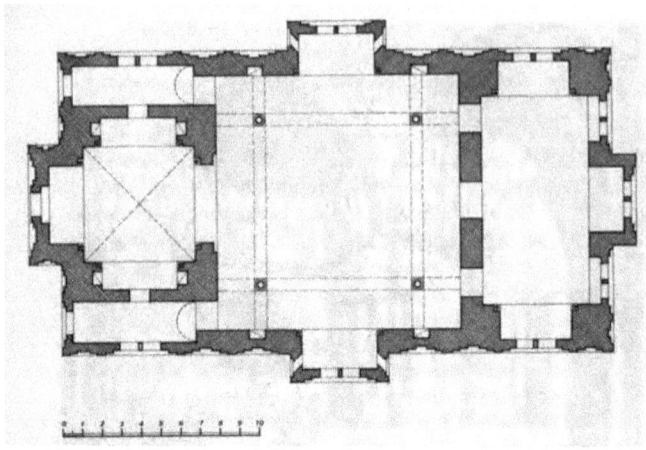

Fig. 12. Cuba, Palermo, plan (after Bellafiore, La Zisa, fig. 30).

The center of the room contains a large square pool, much like an ancient Roman *impluvium* — stepped, shallow and decorated with a star-shaped pattern in relief that would have been clearly visible beneath the surface of the water. Enough

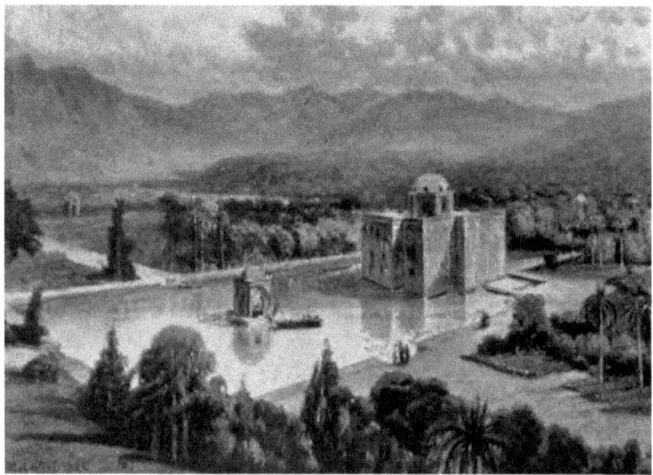

Fig. 13. Rocco Lentini, reconstruction of the Cuba and setting.

of the hydraulic system that fed the pool has survived to suggest that it also contained a fountain. The pool and fountain made the prime space of the center of the room unusable. The functional part of the room must have been essentially the periphery, like the colonnades of a cloister.

On the east side is a narrow rectangular room set at a right angle to the main axis of the building and opening onto the large central room through three doors; on the west side is a chamber, accessible from the main room by a single large opening. This room, which is nearly square in shape, has sets of rectangular niches in its side walls and an opening to the outside in its rear wall. It is interesting to observe that it is also flanked by two narrow spatial units, corridor-like in form, and clearly essentially service-oriented in function. The building is axial, sequential and hierarchical, and one definitely senses a flow of space and function from vestibule to terminating chamber, with the grand, stage-like space of the central room in between.[12]

Critical to the function of both buildings was water. The systems by which the fountains, channels and pools were provisioned in the main spaces of the two buildings have been at least in part recovered. These, however, must have been connected to a larger system of water distribution throughout the zone, which also allowed for agricultural endeavors, such as the ones that have been analyzed in the work of David Abulafia and Henri Bresc.[13] The plan of a system from the early modern period, now in the collection of the Biblioteca Comunale of Palermo, cannot be held to be accurate for the twelfth century, but it is suggestive, especially given the deeply traditional nature of the undertaking (Fig. 14).[14] That the two buildings themselves were surrounded by water is certain. The form of a pool has been partly recovered in the area in front of the Zisa. The physical evidence is more meager in the case of the Cuba,

but it is complemented by a sixteenth-century view of the building engraved by Ingrassia, which shows a courtyard structure whose foundation is believed to incorporate the retaining wall that once formed the perimeter of the twelfth-century

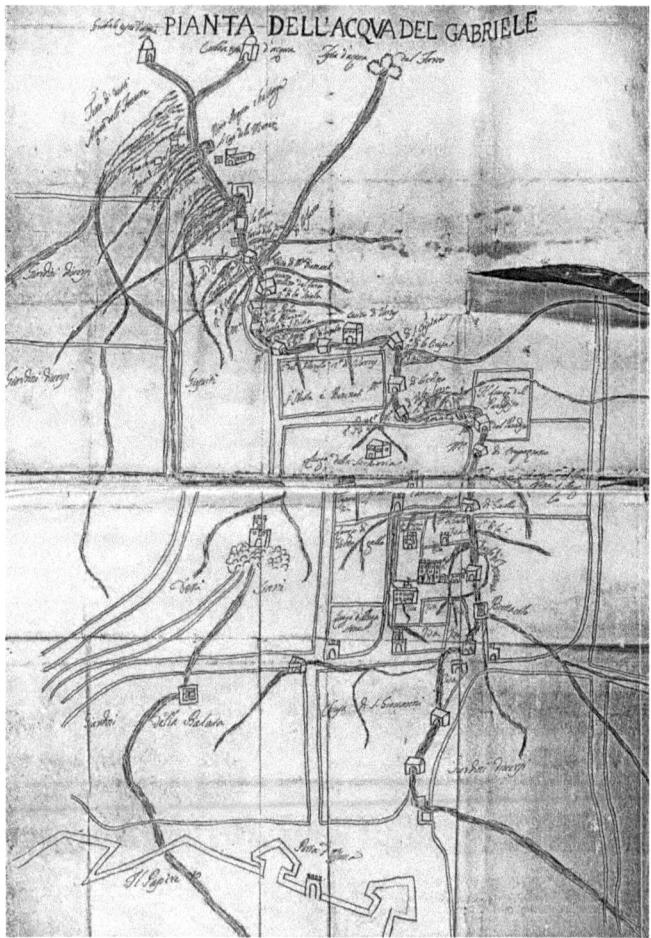

Fig. 14. Palermo, Biblioteca Comunale, Miscellanea Qq C83, "Pianta dell'Aqua del Gabriele."

pool (Fig. 15).¹⁵ Retaining walls covered with hydraulic plaster are preserved around the Favara; they indicate that this type of construction was well known in the Norman environment.¹⁶

The survival of these buildings in tangible, material form is clearly essential to our perception of them, but perhaps no

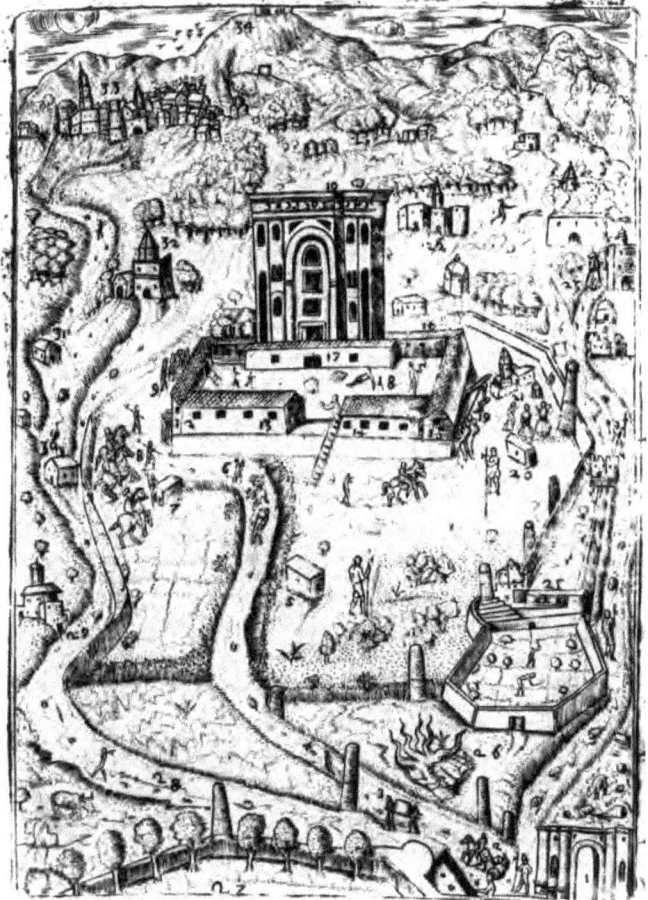

Fig. 15. G.F. Ingrassia, Informatione del pestifero, *Palermo, 1576, view of the Cuba.*

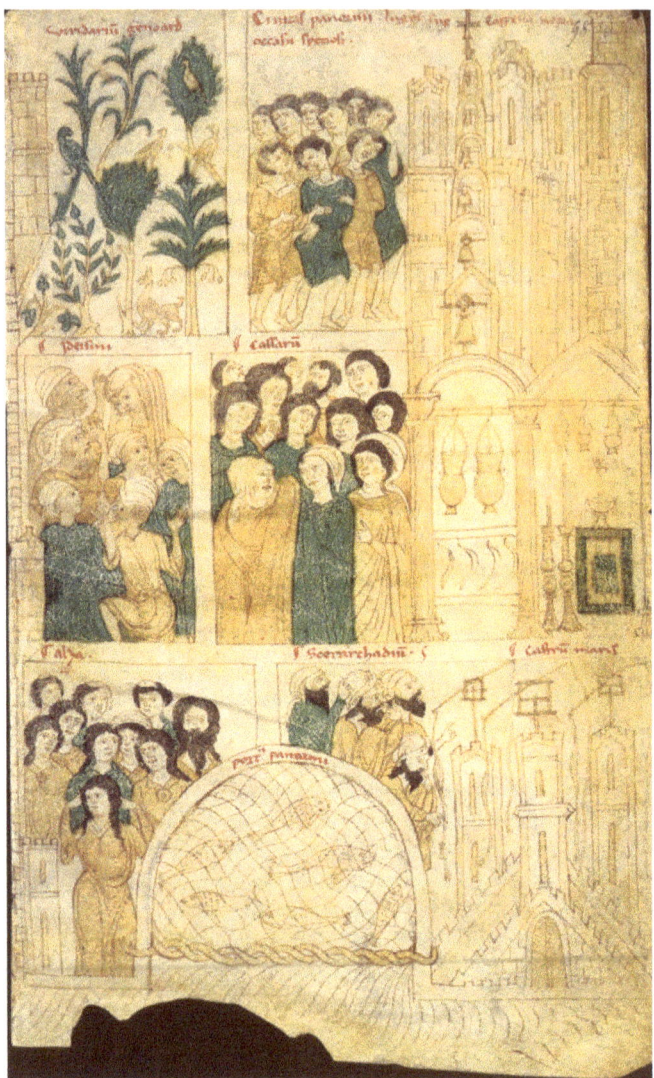

Fig. 16. Peter of Eboli, Liber ad honorem Augusti. *Bern, Burgerbibliothek cod. 120 II, fol. 98r, view of Palermo with viridarium Genoard (upper left).*

more so than their survival in another sense: as mediated by the various traditions of images and texts. The fact that the late twelfth century illustrated version of Peter of Eboli's poem on Henry VI includes the *viridarium Genoard* (from the Arabic, *gennat-al-ard* or paradise on earth) in an intricate constellation of images that form an illustration of the city of Palermo bears witness to the importance of the area in a contemporary interpretation of the urban environment (Fig. 16).[17] Giuseppe Bellafiore has called this image the first "landscape portrait" in the history of Western art, that is to say, the first portrayal of an actual as opposed to imaginary garden.[18] Its few elements can hardly be taken as portraiture in the conventional sense; nonetheless they suggest the tone or character of the place as a natural environment, overarched with noble trees, including one ornamental and highly iconographic species, the palm, as well as birds and the figure of an animal, either canine or feline, which may be related to the theme of the royal hunt. The theme of the hunt is reiterated in the mosaic above the stepped fountain in the great room of the Zisa, in the paired figures of archers. The natural richness of this zone is indicated by later images as well, such as the mid-eighteenth-century depiction of the Palermitan plain, the Conca d'Oro, by Juan Ruiz now in the Collezione Torta (Fig. 17). Embedded in the urban sprawl that is now the modern city, the Zisa and the Cuba survive in isolation as precious relics of the past. In the

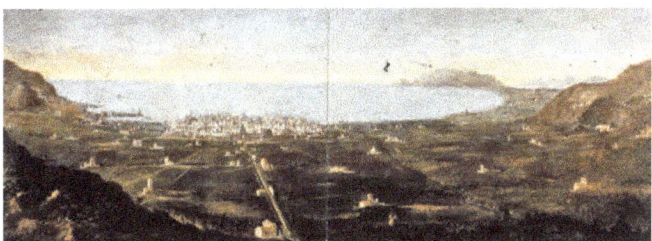

Fig. 17. Juan Ruiz, view of Palermo from west. Palermo, Collezione Torta.

twelfth century, however, they stood in a natural landscape of considerable density and beauty.

With regard to medieval and early modern texts, in addition to Boccaccio's *Decameron*, there is Leandro Alberti's extended description of the Zisa based on his visit to Palermo in 1526, not to mention references in the increasingly popular genres of antiquarian literature, guidebooks and histories of the city.[19] The situation changes rather dramatically in the modern period, however, when these buildings become objects of study in the rapidly evolving disciplines of the history of architecture and art. It is not our purpose here to summarize this often excellent research but to use the broader trajectory it follows in order to sharpen our perception of the historical issues that these buildings and their sites raise.

The modern scholarly discourse began in earnest with the publication of Adolf Goldschmidt's synthetic overview of the Norman palaces in 1890, and it has continued up to the present with the equally synthetic, although considerably ampler and more detailed overview of Hans Rudolf Meier.[20] Even though the discussion has been conducted across the years, it is striking how laden it is with an analysis of sources, which has led to the delineation of a primary context for the buildings and their gardens in the Islamic world. From the form of the buildings, to the shape of particular rooms, to the individual elements of furnishings — such as the fountains, water channels and pools — and decorations, such as the muqarnas and wall revetments in stucco, almost every element of form has been correlated with examples drawn from the geographic range of the Islamic world, from Spain and North Africa to Egypt and Mesopotamia.[21] In addition, there are parallels in the Islamic world to the large reflecting pools flanked by shrubbery and enclosing small islands that occur here.

What is notable about this form of scholarly argumentation is the degree to which it functions in aggregate. It derives its

force, not from the single case, but from the volume of evidence generated: even though the parallels and analogies are compelling, they occur in pieces. The fact is there is nothing elsewhere entirely like either building in its totality. Nor is there an analogy in terms of place, in the sense of the spatial arrangement in Palermo — the clustering of suburban pavilions around an urban palace as center — although this may be more a function of the vagaries of survival than anything else. Both medieval Cairo and Constantinople had multiple garden pavilions of princely patronage.[22] Nonetheless the thrust of the scholarly discussion is to denaturalize the buildings of Palermo, to make them strange in their own environment. They have become almost place-less in the degree to which they have been atomized and distributed to other contexts. What is called for is some recognition of the forces that once worked in the opposite direction: that led to the emergence of these gardens and their pavilions precisely here.

The Painted Ceiling of the Cappella Palatina

MOVING FROM THE OUTSKIRTS of the city back to the center, to the royal palace, and in particular to the royal chapel, the Cappella Palatina, that formed its heart, I would like to draw upon a set of images that decorate the ceiling of its nave in order to address the theme of movement, which is at the core of this chapter (Fig. 18).[23] The chapel was begun and indeed finished under Roger II, although important work on it was executed under his successors, William I and William II, both of whom were patrons of Norman gardens. The Cappella Palatina is a true chapel but unlike any other, in the degree to which it adjudicates between two presences, that of Christ and that of the king. Presenting the two as pendants, the heavenly and earthly rulers, was the point of the edifice. The east end is devoted to Christ, complete with dome and mosaics like a

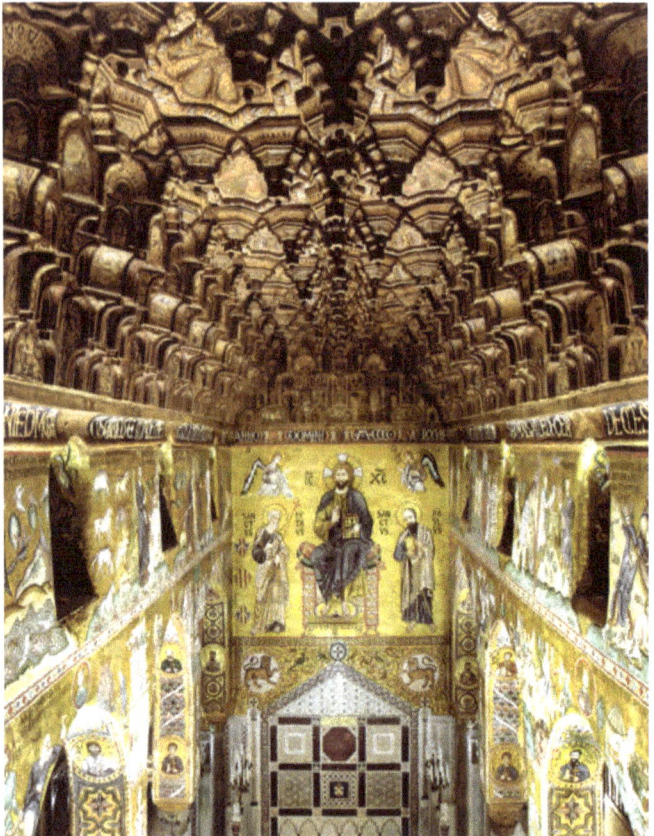

Fig. 18. Cappella Palatina, Palazzo dei Normanni, Palermo, view of nave with royal throne platform to west. Photo: Alinari.

Byzantine church, as it houses the site of the liturgy, the altar, where he was believed to have been made materially manifest.

The king was meant to dominate the west end of the chapel, however, from the vantage point of a grand throne platform that spanned the west wall of the nave.[24] Unfurled above him and the members of the court assembled around him, was the undulating expanse of a magnificent muqarnas ceiling, whose multiple facets

Figs. 19. *Cappella Palatina, Palazzo dei Normanni, Palermo. Nave ceiling, detail of muqarnas.* Photo: Gabrieli and Scerrato, Gli Arabi in Italia, fig. 86.

were decorated with figures and scenes set in the leafy world of a garden (Fig. 19).[25] Although its precise origins are still debated, muqarnas became a signature element of medieval Islamic architecture.[26] There is no surviving example of muqarnas in Sicily from the period of the Arab domination of the island, and this fact, coupled with the perfection of the rendering in the Cappella Palatina, which could only have been the result of an extraordinarily high level of skill, strongly suggests the presence of practitioners from abroad, imported into Palermo by royal prerogative to execute this master work in the chapel of the king. The closest parallel to the muqarnas of the Cappella Palatina occurs in a mid-twelfth century mosque in Fez.[27] What appears to be unprecedented is the painted decoration of the vault. No earlier and indeed no later muqarnas preserves such an elaborate painted and gilded decoration.[28]

The decoration is dominated by intensely animated figures — drinkers, dancers and, above all, music makers — beautifully dressed in what could only be described as the finery of court (Fig. 20). These figures enact their pleasures, not in the stuffy confines of regal audience hall or drafty church, but outside, in pavilions surrounded by landscape and in the garden. In fact the landscape moves from image to image, interweaving the parts into a whole quite literally as a leafy vine scroll that winds its way through the borders and other interstices of

Figs. 20. *Cappella Palatina, Palazzo dei Normanni, Palermo. Nave ceiling, detail of muqarnas. Photo: Gabrieli and Scerrato,* Gli Arabi in Italia, *fig. 60.*

the ceiling, and around and across some of the figures in the vignettes.

The salient features of the decoration are the following: the individual figures and scenes are separate from one another; there is a considerable amount of repetition but no readily apparent sequence discernible in them; but there is the garden setting; and there is a decided accent on pleasure, particularly in the form of drinking, and an extraordinary emphasis on another activity: music. David Gramit's meticulous study of the representation of musical instruments in the ceiling has revealed a couple of startling facts.[29] There is a remarkably wide range of instrumentation depicted — embracing string, percussion and wind, and including such items as the 'ud, or Arabic lute, the long-necked lute, the rabab, the harp, the qasaba or end-blown flute, the round-frame drum, the hourglass-shaped drum and the idiophone or clapper. These instruments are realistically rendered, if occasionally generalized but with no significant mistakes or misunderstandings. And as an aggregation, this group of images is the earliest and by far the richest set of depictions of music making anywhere, in Islam, Byzantium or the West.

Scholarship has conducted a lively discussion of these images, revolving around an apparent range of questions — "religious or secular?", "indigenous or imported?", "meant to be seen or not seen?" — although sharing essentially the same underlying

assumption: that these are simply representations. This discourse assumes that the imagistic world of the muqarnas ceiling was intended to occupy the same level of reality as any of the other images in the chapel, such as the narratives of Christ and the saints, that is, that these are imaginings of another world, pushed back from our own both temporally and spatially, and thus, having been set at a comfortable distance, without the capacity to affect us directly. But a different view of the matter emerges when another component of the decoration is taken into account.

Besides figures and vine scrolls, the ceiling is also filled with inscriptions.[30] These are in Arabic, in kufic script, positioned in the frames of the star-shaped compartments of the central section of the ceiling. They are composed of words or pairs of words, both nouns and adjectives, many of which have a distinct resonance in the Qur'ān: "riches," "health," "prosperity," "strength," "happiness," "joy," "magnificence," "complete or total," "rising" and "persevering."[31] Although there is no specific subject stated, the question has arisen as to whether we should take these terms as descriptors. Recently Jeremy Johns has put forth an interpretation based in part upon the fact that the inscriptions have a distinct resonance in the Qur'ān.[32] Johns argues that they were composed by the Arabic-speaking eunuchs of the court, whose adherence to the Muslim religion prompted them to fashion a critique of the king in these texts. Johns infers the critique by a reading of selected passages from the Qur'ān in which certain of the terms occur. But this interpretation is too convoluted to stand. The type of reading that it imputes to the eunuchs — fraught with research in a decidedly modern sense and profoundly reflective — is anachronistic.[33]

The fact that the inscriptions are non-narrative and that they repeat frequently within a given frame and often across the central section of the ceiling — as if they were following the cursus

of some unarticulated ritual or as if their very intonation were magical, like an incantation — suggests that they were intended to do more than simply passively indicate: they were designed actively to invoke. They are like a litany that embraces the dimensions of both supplication and thanksgiving, thus endowed with the capacity — or perhaps more accurately, the desire — to conjure something into being. Rather than descriptive, therefore, it is more accurate to think of them as possessing a performative dimension.[34] Their very presence renders the space in which they are situated honorific. Given the context, not to mention the range of qualities and characteristics invoked, this could only have had to do with the king, or perhaps more precisely with a condition of being — perfected physically and hyperbolically pleasurable — that exists in the presence of the king.[35]

I would suggest that the adjacent and accompanying images on the ceiling are to be understood in similar terms. These images are not representational but performative: they fill the space around the king, as he ostentatiously occupies the magnificent throne platform that dominates the nave (Figs. 18 and 19), with a performance that acts out the condition called forth in words by the inscriptions. Thus the nave space is to be imagined as pulsating with activity, teeming with life, which does not simply passively record, but actively celebrates, the quality and nature of life with this king. Concomitantly, it is also to be imagined as both interior and exterior at once, the interior of the chapel having been overlaid by the garden imagery of the ceiling, which shifts the scene to the immensely pleasurable natural world.

Function

IT IS INTERESTING to observe the degree to which the images relate to the gardens of the Cuba and the Zisa. They do so on an obvious level, as garden activities immersed in a garden

setting. But they also reach out more pointedly to the gardens surrounding the city of Palermo, drawing them into their orbit, thus suggesting that a more direct connection may have been intended. For example, the image of the two music makers beside the shadirwan could easily have been a portrayal "contrefait al vif," to quote the famous Gothic draftsman Villard de Honnecourt, "from life," of the fountain court of the Zisa (Figs. 21 and 22).[36] And the same large room also has viewing windows in the upper portion of its walls, so that occupants of rooms on the second floor could look down on the activities that were taking place below them, much like the image of a figure looking out of a window in the muqarnas ceiling of the chapel (Figs. 23 and 24).[37] The hypothesis that may be advanced is the following: that the chapel paintings actually model the life of the gardens, that is to say, they bring this environment to life in an ensemble of movements. They model these gardens as a performative space and in precisely the terms in which they themselves operate, in terms of a condition of being — physically perfected and hyperbolically

Fig. 21 Cappella Palatina, Palazzo dei Normanni, Palermo, nave ceiling, shadirwan flanked by figures. Photo: La Cappella Palatina a Palermo: Mirabilia Italiae, fig. 607.

Fig. 22. Zisa, Palermo, shadirwan. Photo: author.

Fig. 23. Cappella Palatina, Palazzo dei Normanni, Palermo, nave ceiling, detail with women at windows. Photo: La Cappella Palatina a Palermo: Mirabilia Italiae, fig. 458.

pleasurable — that exists in the presence of the king.

By connecting garden and image, we have acquired not only a new vantage point from which to view them but also the capacity to move between them, forward and back, in order to generate new meanings and hypotheses. One of the unanswered questions about the two buildings has to do with their function. What were their rooms used for? What was the rationale behind their particular configuration? Moving from image to building prompts a series of suggestions.

The analysis of the buildings has pointed out the degree to which, spatially speaking, they are both an arrangement around a grand hall on the ground floor, which, in the case of the Cuba, may have been open to the elements from above and, in the case of the Zisa, certainly open to the outside from the front and including, within the compass of its enframement, a set of rooms on the second floor that look out onto it by means of windows. There is something distinctly stage-like, theatrical about these spaces. It is interesting to think about these in terms of the Arabic poetry that Henri Bresc, Yasser Tabbaa and Karla Mallette have cited in conjunction with the garden culture of Norman Sicily.[38] At the same time, it is interesting to think about this poetry in the context of these rooms, and particularly with regard to the cavernous spatiality of the Zisa, which has distinctive acoustical properties like other vaulted spaces of

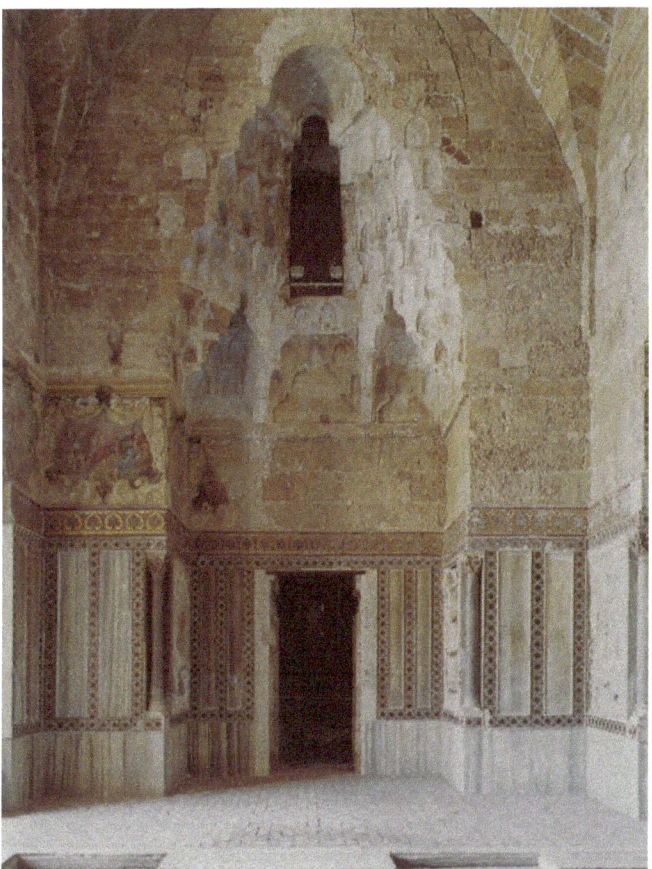

Fig. 24. Zisa, Palermo, window of second floor with muqarnas hood looking onto salsabil.

a similar size and shape. One might also then consider the rooms and the poetry in the context of the ceiling paintings of the Cappella Palatina that provide a pointed clue to the performative in the overwhelming emphasis they place on the experience of music, including the detailed cataloguing of its means and its effects. All of these observations come to-

gether in the suggestion that these magnificent rooms housed performances accompanied by music that were meant to be witnessed by a circle of audiences, including those positioned above looking down upon the room from the second floor. That is to say, their meaning lay in the most evanescent of the senses — hearing — inextricably bound up with sight.

A second theme of the ceiling paintings suggests the milieu in which a performance of music may have occurred. Drinking was a component of dining, whose magnificence in the twelfth century is amply attested in the sources. The high standard of hospitality in the Italian South of the twelfth century is implicit in John of Salisbury's casual anecdote on a contemporary dinner that he inserted into a longer disquisition drawn mainly from ancient history and literature:

> I myself recall having been present at a dinner given by a certain rich man in Apulia which lasted from the ninth hour of the day until almost the twelfth hour of the night, and that too about the time of the summer solstice. This host of Canosa loaded his board with delicacies from Constantinople, Babylon, Alexandria, Palestine, Tripoli, Syria, and Phoenicia, as though Sicily, Calabria, Apulia and Campania were not capable of providing a banquet with delicacies. Abundant means, discipline of servants, attentive service, courtesy of host are characteristics which are better and more fully exemplified in a man of unique eloquence who excels all whom I have ever seen in the elegance of his use of the three tongues.[39]

The royal standard, set by the richest kingdom in the twelfth century, is described by Alexander of Telese in his account of a feast that accompanied the coronation of Roger II on Christmas day, 1130, whose lavish display, replete with silk-covered serving dishes, silk-draped servers and dinnerware of gold and silver, stupefied all observers.[40] This short summary, full of breathless enthusiasm, follows directly on a description of the palace, whose walls were magnificently draped in silk

and whose floors were covered with precious carpets, so that the whole shined in splendor.[41] One could almost imagine the vibrant decoration of the large room in the Zisa as having been modeled on such an enterprise.

We are admittedly centuries away from the time in which expenditures for such celebrations were recorded *in extenso*, thus giving us a detailed picture of the event as a whole, or even better still, when such celebrations were captured in images, such as the great ducal feast portrayed in the Limbourg Brothers' *Très riches heures*.[42] The twelfth century is the era of rising troubadour culture in Occitania and elsewhere, whose early history is shrouded in mystery, although scattered throughout it are tantalizing glimpses into lavish events, such as the festival of Henry II at Beaucaire in 1174 in which 100,000 sous were given away.[43] These events, as well as the more customary and mundane princely feasts, were the natural place for troubadour performance of poetry and music, whose popularity increased rapidly in the twelfth century, and against the backdrop of which the pleasure practices of the Norman court may be seen.[44] It is difficult to believe that the Norman kings were unaware of these, among the most exuberant and original manifestations of courtly culture in the western Mediterranean world, and it is tempting to see the rising curve of suburban habitation in Palermo, in the various pavilions in the landscape from Roger II to William II, as the decidedly Norman-Sicilian response to bettering them.[45]

The intended effects on the recipients of this royal beneficence are spelled out in Alexander of Telese's account: wonder and awe. It is interesting to observe that a reaction along precisely these lines is recorded by a twelfth-century Spanish visitor to Palermo, Ibn Jubayr:

> After the morning prayers, we bent our way to al-Madinah (Palermo). On arrival we made to enter, but were stopped and

directed to a gate near the palace of the Frankish king — may God relieve the Muslims of his dominance. We were then conducted to his commissioner that he might question us as to our intentions, as they do in the case of all strangers. Over esplanades, through doors, and across royal courts they led us, gazing at the towering palaces, well set piazzas and gardens, and the antechambers given to officials. All this amazed our eyes and dazzled our minds, and we remembered the words of Almighty and Glorious God: "But that mankind would become one people (i.e., infidels), we would have given those who denied merciful God silver roofs for their houses, and stairways to mount them" (*Quran* XLIII, 33, gold and silver having no value in the sight of God). Amongst the things that we observed was a hall set in a large court enclosed by a garden and flanked by colonnades. The hall occupied the whole length of that court, and we marveled at its length and the height of it belvederes. We understood that it was the dining-hall of the king and his companions, and that the colonnades and the ante-chambers are where his magistrates, his officials, and his stewards sit in presence.[46]

The last reference here has been interpreted as part of the *Palatium novum*, the royal palace, and perhaps the garden courtyard known as the "aula regia" or "sala viridis," which has been connected with an image in Peter of Eboli's poem on Henry VI now in Bern labeled "Teatrum imperialis palacii."[47] This reading is based on the assumption that the compass of Ibn Jubayr's peregrination was small, and that it embraced essentially the area within the walls of the city, centered on the palace itself. But if we imagine the situation differently, and see Ibn Jubayr moving within a broader sphere, which is at least implied by the multiplicity of the sights to which he alludes, then it is possible to see the Zisa or Cuba emerge as candidates for his visit.

All of which brings us to the larger context of the two edifices. Beyond the water features with which they were both associated, little actually can be reconstructed of the landscape, unless of course we lend credence to the post-medieval

accounts, such as a text of 1581 that describes the area immediately around the Zisa as filled with fragrant fruit trees, and thus cultivated, with a surrounding zone farther out that was given over to hunting, which must have been wild. But the point is that almost the entire area stretching outward from the walls of the city was occupied with royal gardens and hunting parks, punctuated with pavilions like the Zisa and the Cuba (although on a smaller scale). As individual entities they were clearly devoted to the protocols of royal pleasure, but in aggregate they must have created an aura of royal presence in the zone, an aura that literally surrounded and embraced the city itself. The titles given the Norman kings on their coins — "he who glories in the power of God," for Roger II; "he who rules justly by the grace of God," for William I; and "he who has become powerful in God," for William II — convey the idea of them as guides and protectors of the kingdom of the highest rank.[48] As such, the royal presence manifest in the green zone surrounding the city may be read as an iteration of the protective power of the surrounding walls, or a doubling of their potency.

Thus the gardens; what about the ceiling? If we reverse course by moving now from garden to image, we can offer some thoughts on a question that has continued to vex historians: how is it possible that the pleasures of the flesh could have been celebrated so forthrightly in an edifice dedicated to the Christian liturgy? The fact is that these courtly pleasures had a valence in the Islamic world, lacking in the West, which the Norman kings may have wished to play off against and to exploit. They figured the blissful afterlife, which was conceived in Muslim imaginary in terms of the concrete physical enjoyments of drink and dance; on earth this afterlife was prefigured nowhere more concretely than in the ruler's court.[49] In a Muslim visual culture otherwise deeply averse to rendering

the human form not only was the court a primary locus for the depiction of earthly pleasures, but the court was also elaborated as a spatial construct to enhance these pleasures.

Both images and landscapes may have played this role in the Norman context as well. They formed a true hapax, a cultural enterprise brought in from another context (the Islamic world) where they possessed a unique status as the evocation of a sacred realm of sensual delight. Indeed, it was precisely because of the status of these images that the Norman kings could have been emboldened to place them on the ceiling of the Christian liturgical space of their palace chapel, as well as to incorporate them without reproach into the functioning of their court.

Returning to the phenomenon of dining, it is interesting to observe the diversity of sources for the constituent elements of the Apulian feast described by John of Salisbury: "Constantinople, Babylon, Alexandria, Palestine, Tripoli...." One cannot help but see them against the backdrop of Alexander of Telese's response to the royal coronation feast of Roger II: *"stupor vehementissimus."* In other words, one cannot help but connect the two texts in a single trajectory that begins with the composed or "mixed" object (i.e., the feast), since the very essence of its nature is composite, and ends with its effect, wonder.[50] *Mixta* and *mira*, as Caroline Bynum has observed, were intimately linked in medieval thinking, "Wonder was associated with paradox, coincidence of opposites; one finds *mira* (wondrous) again and again in the texts alongside *mixta* (mixed or composite things), a wonder that evokes the hybrids and monsters also found in the literature of entertainment."[51]

I would like to suggest that the composite nature of John of Salisbury's dinner party was intended to produce the effect that is so vividly described in Alexander of Telese's account. In so doing this ephemeral festivity also aligned itself with the more

permanent manifestation of the composite in the visual culture of Norman Sicily.[52] I have argued elsewhere that the vivid juxtapositions in Norman architecture — as for instance between the vault of the sanctuary and the ceiling of the nave of the Cappella Palatina — were intended to produce a sense of wonder in all who looked upon them, which is amply borne out in the contemporary witness of Philagathos's ekphrasis.[53] Similarly, the transubstantiation of space with the overlaying and interpenetration of exterior and interior amply fits this model of wonder-inducing forms. In the Cappella Palatina, for example, the nave space was transformed into the natural world by the garden imagery of the muqarnas. Again, the large rooms of the garden pavilions of the Zisa and Cuba became landscape by dint of the lakes and rivers they contained in their pools and channels. But wonder alone was not the point. In describing the nature of medieval "wonder behavior," Bynum adduces Aristotle's *Rhetoric* and *Metaphysics* through the medium of Thomas Aquinas' *Summa theologica* and John of Salisbury's *Policraticus*.

In these texts, wonder is portrayed as a response to majesty, *maiestas*, with which we are brought full circle.[54] *Mixta*, embodied in the transfer of arts from one context to another — so palpable a phenomenon of Norman Sicily — served the purposes of *admiratio*, wonder. Wonder led naturally and inevitably to an apprehension of the significance of that prime mover of the kingdom, that essence of the royal individual to whom all is due, which can be summarized in a single word: *maiestas*. Ultimately, it is this dynamic set of relationships — *mixta-mira-maiestas* — that forms the circuitry for both the production and reception of Norman Sicilian visual culture on a much larger scale than we have had the opportunity to examine here. In fact, it interweaves both production and reception into a whole. It binds them together. It fuses them, and shifts them to another

dimension, that of performance. The energy of Norman visual culture was not diverted and absorbed into forging and promoting a relationship with an imagined past, as in twelfth-century Rome (with its obsession with the age of the apostles) or Constantinople (intent on Old Testament kingship and Roman *imperium*). Instead, real-time performance was its *raison d'etre*. And there was no more scintillating backdrop for the performance of the court than the gardens and garden pavilions that came to encircle the royal palace, whose few precious fragments still ornament the city of Palermo.

Notes

1. Giovanni Boccaccio, *Decameron, Filocolo, Ameto, Fiammetta*, ed. Enrico Bianchi, Carlo Salinari and Natalino Sapegno (Milan: Riccardo Ricciardi, 1952), 390–95, for Giornata Quinta, Novella Sesta. See also Emilio Santini, "La Sicilia nel *Decameron*," *Archivio Storico per la Sicilia* 6 (1940): 239–52. On Boccaccio's use of the garden setting, see E.G. Kern, "The Gardens in the *Decameron* Cornice," *PMLA* 66 (1951): 503–23; Mirko Bevilaqua, "Il 'giardino' come struttura ideologico-formale del *Decameron*," *Rassegna della Letteratura Italiana* 80 (1976): 70–79; and Fabio Coccetti, "Dal labirinto al giardino: La topografia testuale del Decameron," *Rassegna della Letteratura Italiana* 94 (1990): 76–85.

2. See especially the studies on landscape, gardens and the rural economy by Henri Bresc, "Les jardins de Palerme, 1290–1460," *Mélanges de l'École Française de Rome. Moyen Age* 84 (1972): 55–127; idem, "Les jardins royaux de Palerme," *Mélanges de l'École Française de Rome. Moyen Age* 106 (1994): 239–58; and David Abulafia, *The Two Italies: Economic Relations between the Norman Kingdom of Sicily and the Northern Communes* (Cambridge: Cambridge University Press, 1977); idem, "The Crown and the Economy under Roger II and His Successors," *Dumbarton Oaks Papers* 37 (1983): 1–14; idem, *Italy, Sicily and the Mediterranean* (London: Variorum Reprints, 1987). See also *Palermo, detto Paradiso di Sicilia (Ville e Giardini, XII–XIX secolo)*, ed. Gianni Pirrone, Michele Buffa, Eliana Mauro and Ettore Sessa (Palermo: Centro Studi di Storia e Arte Giardini, 1989); Gianni Pirrone, *L'isola del Sole: Architettura dei giardini di Sicilia* (Milan: Electa, 1994); and Marco Massetti, "In the Gardens of Norman Palermo, Sicily (Twelfth Century A.D.)," *Anthropozoologica* 44 (2009): 7–34.

3. Hans-Rudolf Meier, *Die normannischen Königspaläste in Palermo: Studien zur hochmittelalterlichen Residenzbaukunst* (Worms: Wernersche Verlagsgesellschaft, 1994), 37–54.

4. Adolf Goldschmidt, "Die normannischen Königspaläste in Palermo," *Zeitschrift für Bauwesen* 48 (1898): 541–90; Maria Grazia

Paolini, "Considerazioni su edifici civili di età normanna a Palermo," *Atti della Accademia di Scienze, Lettere e Arti di Palermo* 33 (1974): 299–346; Umberto Scerrato, "Arte Islamica in Italia," *Gli arabi in Italia*, ed. Francesco Gabrieli and Umberto Scerrato (Milan: Garzanti, 1993), 307–42; Hans-Rudolf Meier, "'…das ird'sche Paradies, das sich den Blicken öffnet': Die Gartenpaläste der Normannenkönige in Palermo," *Die Gartenkunst* 6 (1994): 1–18; Giuseppe Bellafiore, *Parchi e giardini della Palermo normanna* (Palermo: Flaccovio, 1996); Meier, *Die normannischen Königspaläste*, 33–91; William Tronzo, "The Royal Gardens of Medieval Palermo: Landscape Experienced, Landscape as Metaphor," in *Le vie del medioevo: Atti del convegno internazionale di studi, Parma 28 settembre–1 ottobre 1998. I convegni di Parma* 1, ed. Arturo Carlo Quintavalle (Milan: Electa, 2000), 362–73; Jean-Marie Pesez, "Sicile arabe et Sicile normande: Chateaux arabes et arabo-normands," *Mélanges de l'École Française de Rome. Moyen Age* 10 (1998): 561–76; D. Fairchild Ruggles, *Islamic Gardens and Landscapes* (Philadelphia: University of Pennsylvania Press, 2008), 159–60; Lev Kapitaikin, "'The Daughter of al-Andalus': Interrelations between Norman Sicily and the Muslim West," *Al Masaq: Islam and the Medieval Mediterranean* 25 (2013): 113–34.

5. For the Cuba, see S. Salomone-Marino, "La Cuba di Palermo al 1571," *Archivio Storico Siciliano* n.s. 22 (1897): 547–50; Guido Di Stefano, *Monumenti della Sicilia normanna*, 2nd ed., rev. Wolfgang Krönig (Palermo: S.F. Flaccovio, 1979), 108–10; Susanna Bellafiore, *La Cuba di Palermo* (Palermo: Greco, 1984); Giuseppe Caronia and Vittorio Noto, *La Cuba di Palermo* (Palermo: Giada, 1988); Giuseppe Bellafiore, *Architettura in Sicilia nelle età islamica e normanna, 827–1194* (Palermo: Arnaldo Lombardi, 1990), 154–55; Meier, *Die normannischen Königspaläste*, 79–85. For the Zisa, see Otto Demus, *The Mosaics of Norman Sicily* (London: Routledge & Kegan Paul, 1950), 178–80; Wolfgang Krönig, "Die Rettung der 'Zisa' des normannischen Königsschlosses in Palermo," *Kunstchronik* 5 (1973): 133–51; idem, "Il palazzo reale della Zisa a Palermo: Nuovi osservazioni," *Commentari* 26 (1975): 229–47; Di Stefano, *Monumenti della Sicilia normanna*,

103–8; Giuseppe Caronia, *La Zisa di Palermo: Storia e restauro* (Rome: Laterza, 1987); Bellafiore, *Architettura in Sicilia*, 149–51; Ursula Staacke, *Un palazzo normanno a Palermo: La Zisa. La cultura musulmana negli edifice dei re* (Palermo: Arti Grafiche Siciliane, 1991); Giuseppe Bellafiore, *La Zisa di Palermo* (Palermo: Flaccovio, 2008); Meier, *Die normannischen Königspaläste*, 68–79; Ernst Kitzinger, *I mosaici del periodo normanno in Sicilia*. VI. *La Cattedrale di Cefalù, La Cattedrale di Palermo e il Museo Diocesano: Mosaici Profani* (Palermo: Istituto Siciliano di Studi Bizantini e Neoellenici, 2000), 21–22. The chapel adjacent to the Zisa is currently undergoing restoration. See Lucio Trizzino, *SS. Trinità alla Zisa: Progetto di restauro* (Palermo: D. Flaccovio, 1979).

6. Staacke, *La Zisa*, 68–70.

7. Georges Marçais, "Salsabil et Sadirwan," *Études d'orientalisme dédiées à la mémoire de Lévi-Provençal* (Paris: G.-P. Maisonneuve et Larose, 1962), 2:639–48, with illustration from the Cappella Palatina in Palermo, pl. 17; Yasser Tabbaa, "The 'Salsabil' and 'Shadirwan' in Medieval Islamic Courtyards," *Environmental Design: Journal of the Islamic Environmental Research Centre* 1 (1986): 34–37.

8. Di Stefano, *Monumenti della Sicilia normanna*, figs. 259 (Zisa) and 268 (Cuba).

9. Staacke, *La Zisa*, 30, who continues, "…sintezza la poetica della Zisa, esaltandola in un apparato iconografico ricco di spunti plastici e cromatici che conducono ad una rappresentazione metaforica del 'giardino'."

10. Meier, *Die normannischen Königspaläste*, 80.

11. Ibid., 81–85.

12. On this point, see the interesting analysis of Wolfgang Krönig, *Il Castello di Caronia in Sicilia: Un complesso normanno del XII secolo* (Rome: Edizioni dell'Elefante, 1977), 101ff.

13. See above, n. 2. In addition: Maria Stella Calò Mariani, "Utilità e diletto: L'acqua e le residenze regie dell'Italia meridionale fra XII e

XIII secolo," *Mélanges de l'École Française de Rome. Moyen Age, Temps Modernes* 104.2 (1992): 343–72; Maria di Piazza, *Palermo: Città d'acqua. Aspetti storici e naturalistici dell'aquedotto* (Palermo: Gulotta, 2008).

14. Palermo, Biblioteca Comunale.

15. G. F. Ingrassia, *Informatione del pestifero, et contagioso morbo, il quale affligge et have afflitto questa città di Palermo, & molte altre città, et terre di questo Regno di Sicilia, nel anno 1575 et 1576* (Palermo: Giouan Mattheo Mayda, 1576); image reproduced in Bellafiore, *Parchi e giardini*, 88.

16. Meier, *Die normannischen Königspaläste*, 54–63. See also Adolf Goldschmidt, "Die Favara des Königs Roger von Sizilien," *Jahrbuch des königlich preussischen Kunstsammlungen* 16 (1895): 199–215; Vincenzo Di Giovanni, "Il castello e la chiesa della Favara di S. Filippo a Mare Dolce in Palermo," *Archivio Storico Siciliano* 22 (1897): 301–74; Letizia Anastasi, *L'arte nel parco normanno di Palermo: Favara* (Palermo: Scuola tipografica ospizio di beneficenza, 1935), 28; Silvana Braida, "Il castello di Fawara: Studi di restauro," *Architetti di Sicilia* 5/6 (1965): 23–28.

17. Petrus de Ebulo, *Liber ad honorem Augusti sive de rebus Siculis. Codex 120 II der Burgerbibliothek Bern. Eine Bilderchronik der Stauferzeit*, ed. Theo Kölzer and Marlis Stähli, trans. Gereon Becht-Jördens (Sigmaringen: Jan Thorbecke Verlag, 1994), 46–47.

18. Bellafiore, *Parchi e giardini*, 27.

19. Leandro Alberti, *Descrittione di tutta Italia* (Bologna: Anslemo Giaccarelli, 1550).

20. See above, nn. 3, 4 and 5.

21. For the most extended analysis of these filiations and relationships with regard to the Zisa, see Staacke, *La Zisa*, 123–220; also Meier, *Die normannischen Königspaläste*, 68–85, for a discussion of the Zisa and the Cuba. See also David Knipp, "The Torre Pisana in Palermo: A Maghribi Concept and Its Byzantinization," in *Wissen über Grenzen: Arabisches Wissen und lateinisches Mittelalter*, ed. Andreas Speer and Lydia Wegener (Berlin: Walter de Gruyter, 2006), 745–74.

A recent discussion of the methodological issues raised by the view of Islamic art in the larger field is interesting in this context; see the contributions to vol. 6 (June 2012) of the online *Journal of Art Historiography* (http://arthistoriography.wordpress.com/number-6-june-2012-2): Gülru Necipoğlu, "The Concept of Islamic Art: Inherited Discourse and New Approaches"; Miriam Rosser-Owen, "Mediterraneanism: How to Incorporate Islamic Art into an Emerging Field"; and Avinoam Shalem, "What Do We Mean When We Say 'Islamic Art'? A Plea for a Critical Rewriting of the History of the Arts of Islam."

22. *Byzantine Garden Culture*, ed. Antony Littlewood, Henry Maguire and Joachim Wolschke-Bulmahn (Washington, DC: Dumbarton Oaks Research Library and Collection, 2002); Henry Maguire, "A Description of the Aretai Palace and Its Garden," *Journal of Garden History* 10 (1990): 209–13. For Cairo, see Jonathan Bloom, *Arts of the City Victorious: Islamic Art and Architecture in Fatimid North Africa and Egypt* (New Haven: Yale University Press in association with The Institute of Ismaili Studies, 2007), 51–87, 117–55.

23. William Tronzo, *The Cultures of His Kingdom: Roger II and the Cappella Palatina in Palermo* (Princeton: Princeton University Press, 1997), 54–62; and *La Cappella Palatina a Palermo*, ed. Beat Brenk, *Mirabilia Italiae* 15 (Modena: Franco Cosimo Panini, 2010), as well as the additional references cited below, n. 25.

24. Tronzo, *Cultures of His Kingdom*, 68–78.

25. See above, n. 23. The monograph of Ugo Monneret de Villard, *Le pitture musulmane al soffitto della Cappella Palatina in Palermo* (Rome: La Libreria dello Stato, 1950) has not been superseded. See in addition the recent study of Ernst J. Grube and Jeremy Johns, *The Painted Ceilings of the Cappella Palatina* (Genoa: Bruschettini Foundation for Islamic and Asian Art, and New York: East-West Foundation, 2005); and the essays by Johns: "The Bible, the Qur'ān and the Royal Eunuchs in the Cappella Palatina," in *Die Cappella Palatina in Palermo: Geschichte,*

Kunst, Funktionen. Forschungsergebnisse der Restaurierung Hg. im Auftrag der Stiftung Würth, ed. Thomas Dittelbach (Künzelsau: Swiridoff, 2011), 199–216, 413–24, 560–70; idem, "Iscrizioni arabe nella Cappella Palatina," and "Le pitture del soffitto della Cappella Palatina," in Brenk *La Cappella Palatina a Palermo, Saggi,* 353–407. David Knipp, "Die almoravidischen Ursprünge der Holzdecke über dem Mittelschiff der Cappella Palatina in Palermo," in *Die Cappella Palatina in Palermo,* 217–28, 425–32, 571–78; and Anneliese Nef, *Conquérir et gouverner la Sicile islamique au XIe et XIIe siècles* (Rome: École Française de Rome, 2011).

26. Monneret de Villard, *Le pitture musulmane,* 18–27; Jonathan Bloom, "The Introduction of Muqarnas into Egypt," *Muqarnas* 5 (1988): 21–28; Tronzo, *Cultures of His Kingdom,* 57–62; Maria Giulia Aurigemma, *Il cielo stellato di Ruggero II: Il soffitto dipinto della Cattedrale di Cefalù* (Milan: Silvana, 2004); and Alicia Walker, *The Emperor and the World: Exotic Elements and the Imaging of Middle Byzantine Imperial Power, Ninth to Thirteenth Centuries CE* (New York: Cambridge University Press, 2012), 144–64. I am grateful to Francesca Anzelmo for sharing with me her unpublished paper on the early development of muqarnas, in which the decorated ceramic fragments from Murcia are discussed.

27. Tronzo, *Cultures of His Kingdom,* 78–79, fig. 71.

28. William Tronzo, "Restoring Agency to the Discourse on Hybridity: The Cappella Palatina from Another Point of View," in *Die Cappella Palatina in Palermo,* 229–37, 433–39, 579–85.

29. David Gramit, "The Music Paintings of the Cappella Palatina in Palermo," *Imago Musicae: International Yearbook of Musical Iconography* 2 (1985): 9–49.

30. Monneret de Villard, *Le pitture musulmane,* 28–33; Staale Sinding-Larsen, "*Plura ordinantur ad unum*: Some Perspectives Regarding the 'Arab-Islamic' Ceiling of the Cappella Palatina at Palermo (1132–43)," *Acta ad archaeologiam et atrium historian pertinentia* 7 (1989): 55–96; and the essays by Johns cited above, n. 25.

31. Tronzo, *Cultures of his Kingdom,* 60–61, n. 119.

32. See the study by Johns cited in n. 25, "The Bible, the Qur'ān and the Royal Eunuchs in the Cappella Palatina."

33. Similar criticism could be made of the Christian reading of certain of the ceiling's images by David Knipp, "Image, Presence, and Ambivalence. The Byzantine Tradition of the Painted Ceiling in the Cappella Palatina, Palermo," *Visualisierungen von Herrschaft*, ed. Franz Bauer, *BYZAS* 5 (2006): 283–328. It more than strains credibility that a viewer of the twelfth century might have the capacity to apprehend meaning so subtly, so imperceptibly inflected from the direct and explicit, with a whole host of image comparisons in his or her mind against which he/she could play in a decidedly modern and academic manner, as Knipp posits for the Cappella Palatina.

34. The seminal text of J.L. Austin, *How To Do Things With Words* (Cambridge, MA: Harvard University Press, 1962) has been much discussed in the years following its publication. See the fundamental contributions of John R. Searle, *Speech Acts: An Essay in the Philosophy of Language* (London: Cambridge University Press, 1969); *Expression and Meaning: Studies in the Theory of Speech Acts* (Cambridge: Cambridge University Press, 1979); and, with Daniel Vanderveken, *Foundations of Illocutionary Logic* (Cambridge: Cambridge University Press, 1985). The attempt on the part of Trevor Pateman to apply speech-act theory to images is suggestive. See "How To Do Things With Images: An Essay on the Pragmatics of Advertising," *Theory and Society* 9 (1980): 603–22.

35. Tronzo, *Cultures of His Kingdom*, 60–61,

36. Monneret de Villard, *Le pitture musulmane*, fig. 230; Grube and Johns, *Painted Ceilings*, pl. XLII and 140 (28.4). For a discussion of the significance of this phrase with regard to Villard de Honnecourt, see Hans Hahnloser, *Villard de Honnecourt: Kritische Gesamtausgabe des Bauhüttenbuches ms. fr. 19093 der Pariser Nationalbibliothek*, 2nd ed. (Graz: Akademische Druck, 1972), 147–50, pl. 48; Carl F. Barnes, Jr., *The Portfolio of Villard de Honnecourt (Paris, Bibliothèque Nationale de*

France MS Fr 19093) (Burlington, VT: Ashgate, 2009), 167–70, color pl. 51, fol. 24v; James Bugslag, "'Contrefais al vif': Nature, Ideas and Representation in the Lion Drawings of Villard de Honnecourt," *Word & Image* 17 (2001): 360–78; Claudia Swan, "*Ad vivum, naer het leven,* from the life: Defining a Mode of Representation," *Word & Image* 11 (1995): 353–72; Noa Turel, "Living Pictures: Rereading 'au vif,' 1350–1550," *Gesta* 50 (2011): 163–82.

37. Monneret de Villard, *Le pitture musulmane,* figs. 228, 230; Grube and Johns, *Painted Ceilings,* pl. XVI, A9, 5.

38. Bresc, "Les jardins royaux de Palerme," 239–58; Yasser Tabbaa, "The Medieval Islamic Garden: Typology and Hydraulics," *Garden History: Issues, Approaches, Methods,* ed. John Dixon Hunt (Washington, DC: The Dumbarton Oaks Research Library and Collection, 1992), 313–16; Karla Mallette, *The Kingdom of Sicily: A Literary History, 1100–1250* (Philadelphia: University of Pennsylvania Press, 2005). See also Umberto Rizzitano, *Storia e cultura nella sicilia saracena* (Palermo: S.F. Flaccovio, 1975), 131–250; Aziz Ahmad, *A History of Islamic Sicily* (Edinburgh: Edinburgh University Press, 1975), 76–81; and for a broader context, Sammer M. Ali, *Arabic Literary Salons in the Islamic Middle Ages: Poetry, Public Performances and the Presentation of the Past* (Notre Dame, IN: University of Notre Dame, 2010); and Alex Metcalfe, *The Muslims of Medieval Italy* (Edinburgh: Edinburgh University Press, 2007), 235–53.

39. John of Salisbury, *Policraticus,* book VII, trans. Joseph B. Pike, *Frivolities of Courtiers and Footprints of Philosophers, Being a Translation of the First, Second, and Third Books and Selections from the Seventh and Eighth Books of the* Policraticus *of John of Salisbury* (Minneapolis: University of Minnesota Press, 1938), 333. See also Cary J. Nederman, *Policraticus: Of the Frivolities of Courtiers and the Footprints of Philosophers* (Cambridge: Cambridge University Press, 1990).

40. Alexander of Telese, c. VI; Giuseppe del Re, *Cronisti e scrittori sincroni napoletani editi e inediti: Cronisti e scrittori sincroni della dominazione*

normanna nel regno di Puglia e Sicilia. 1, *Normanni* (Aalen: Scientia Verlag, 1975 [rep. of Naples, 1845]), 103: "Convivia Regis caeteris Principibus admirationem incutiunt. Ad regiam discumbentibus mensam ciborum, potuumque multimodus, atque affluentissimus apparatus habebatur, ubi quidem non nisi in pateris, seu catinis aureis vel argenteis ministratum fuit. Servitor ibi nullus, nisi quem serica tegeret vestis, adeo ut ipsi etiam parobsidum reportitores sericis operirentur indumentis. Quid plura? gloria, et divitiae in domo Regis tot, et tales, tantaeque tunc visae sunt, ut omnibus, et miraculum ingens, et stupor vehementissimus fieret, in tantum, ut timor etiam non modicus universis, qui de longe venerant, incuteretur. Etenim multo plura in eo conspiciebantur, quam rumor non fuit, quem audierant."

41. Ibid., c.V (Del Re, 103): "Palatium quoque regium undique interius circa parietem palliatum glorifice totum rutilabat. Solarium vero eius multicoloriis stratum tapetis terentium pedibus largifluam praestabat suavitatem."

42. Millard Meiss, *French Painting in the Time of Jean de Berry: The Limbourgs and Their Contemporaries* (New York: G. Braziller, 1974), 1:188–91 and 2, fig. 539. For Byzantium, see, for example, *Eat, Drink, and Be Merry (Luke 12:19): Food and Wine in Byzantium. Papers of the 37th Annual Spring Symposium for Byzantine Studies, in Honour of A.A.M. Bryer*, ed. Leslie Brubaker and Kalliroe Linardou (Burlington VT: Ashgate, 2007); Eunice Dauterman Maguire and Henry Maguire, *Other Icons: Art and Power in Byzantine Secular Culture* (Princeton: Princeton University Press, 2007), 29–57. For its focus on lifestyle, see also Robert Hillenbrand, "*La Dolce Vita* in Early Islamic Syria: The Evidence of the Later Umayyad Palaces," *Art History* 5 (1982): 1–35; Cynthia Robinson, *In Praise of Song: The Making of Courtly Culture in Al-Andalus and Provence, 1005–1134* (Leiden: Brill, 2002); 'Abd Al-Rahman Al-Gailani, "Early Medieval Islamic Court Life: The Evidence of the Literary Sources," *Image and Meaning in Islamic Art*, ed. Robert Hillenbrand (London: Altajir Trust, 2005), 98–108; D. Fairchild Ruggles, *Gardens, Landscapes, and Vision in the Palaces of*

Islamic Spain (University Park: Pennsylvania State University Press, 2006).

43. Ruth Harvey, "Courtly Culture in Medieval Occitania," in *The Troubadours: An Introduction*, ed. Simon Gaunt and Sarah Kay (Cambridge: Cambridge University Press, 1999), 12.

44. See, for example, Rita Lejeune, "La Sicile et la littérature française du XIe au XIIe siècle," *Dai trovatori arabo-siculi alla poesia d'oggi: Atti del Congresso internazionale di poesia e di filologia per il VII centenario della poesia e della lingua italiana (Palermo, 6–10 giugno 1951)* (Palermo: Palumbo, 1953), 85–106; *Lyrics of the Troubadours and Trouvères: An Anthology and a History*, trans. and intro. Frederick Goldin (Gloucester MA: Peter Smith, 1983); *A Handbook of the Troubadours*, ed. F.R.P. Akehurst and Judith M. Davis (Berkeley: University of California Press, 1995); and especially the volume of collected essays, *The Troubadours: An Introduction*, ed. Simon Gaunt and Sarah Kay (Cambridge: Cambridge University Press, 1999); Marisa Galvez, *Songbook: How Lyrics Became Poetry in Medieval Europe* (Chicago: University of Chicago Press, 2012).

45. Support for this interpretation comes from Massimo Montanari, "Convivi e banchetti," in *Strumenti, tempi e luoghi di communicazione nel mezzogiorno normanno-svevo: Atti delle undecime giornate normanno-sveve, Bari, 26–29 ottobre 1993*, ed. Giosuè Musca and Vito Sivo (Bari: Centro di studi normanno-svevi, Università degli Studi di Bari, 1995), 323–44. See also Martin Aurell, *Le chevalier lettré: Savoir et conduite de l'aristocratie aux XIIe et XIIIe siècles* (Paris: Fayard, 2011).

46. *The Travels of Ibn Jubayr*, trans. R.J.C. Broadhurst (London: J. Cape, 1957), 346f.

47. Petrus de Ebulo, *Liber ad honorem*, 230–31; see G.B. Siragusa, "Di una probabile rappresentazione dell'Aula Regia del palazzo reale di Palermo," *Rendiconti Accademia dei Lincei* 15 (1906): 226–34; Bellafiore, *Parchi e giardini*, 17.

48. Karla Mallette, "Translating Sicily," *Medieval Encounters* 9 (2003): 140–63.

49. See the discussion of Ruggles, *Islamic Gardens and Landscapes*, 89–116, but also with a critical commentary on the over-extension of the interpretation, 1ff. See also Annemarie Schimmel, "The Celestial Garden in Islam," and William L. Hanaway, Jr., "Paradise on Earth: The Terrestrial Garden in Persian Literature," in *The Islamic Garden*, ed. Elisabeth B. MacDougall and Richard Ettinghausen, *Dumbarton Oaks Colloquium in the History of Landscape Architecture* IV (Washington, DC: Dumbarton Oaks, 1976), 11–39 and 41–67; *Images of Paradise in Islamic Art*, ed. Sheila Blair and Jonathan M. Bloom, Dartmouth College, Hood Museum of Art, 1991 (Austin: University of Texas Press, 1991); as well as Shirley Guthrie, *Arab Social Life in the Middle Ages: An Illustrated Study* (London: Saqi Books, 1995), 181–97.

50. Alexander of Telese, c.VI (Del Re, 103).

51. Caroline Bynum, "Wonder," *American Historical Review* 102 (1997): 1–26, with a wide-ranging discussion of relevant literature.

52. See also the observations on mixed forms in Byzantine imperial dinner parties; Dauterman Maguire and Maguire, *Other Icons,* 29–57.

53. William Tronzo, "Mixed Media/*Admirabiles mixturae*," in *Immagine e ideologia: Studi in onore di Arturo Carlo Quintavalle*, ed. Arturo Calzona, Roberto Campari and Massimo Mussini (Milan: Electa, 2007), 207–12.

54. Bynum, "Wonder," 10, 13–14 and 17–18, with the following citations: Aquinas, *Summa theologica*, Ia IIae, q. 32, art. 8, 1: 732; Ia IIae, q. 3, art. 8, 1: 601–2; IIIa, q. 30, art. 4, reply to obj. 1,2: 2182; IIIa, q. 15, art. 8, 2:2111; John of Salisbury, *Policraticus I–IV*, ed. K.S.B. Keats-Rohan, *Corpus christianorum continuatio mediaevalis* 118 (Turnhout: Brepols, 1993), c. 22, 125–36.

Fig. 25. Pliny, Historia naturalis. *Paris, Bibliothèque Nationale de France, MS lat. 6802, fol. 143v.*

PETRARCH ON THE BANK OF THE SORGUE

"And she will come again to this place,
Searching for me: will find me earth under stone."
— Petrarch, *Canzoniere* 126

GIUSEPPE BELLAFIORE ONCE SUGGESTED that the image of the *viridarium Genoard* in the late twelfth-century illustrated edition of Peter of Eboli's poem on Henry VI, *Liber ad honorem augusti* (Bern, Burgerbibliothek cod. 120 II, fol. 98r) was the representation of an actual place in Palermo and thus the first true landscape portrait in the Western tradition (Fig. 16).[1] But to my mind true portraiture possesses an emotional dimension, which can be muted, diminished, but never entirely suppressed. Even allowing for the visual conventions of the time, in their schematization and abstraction, the image of the *viridarium Genoard* is meager fare indeed.

Closer to the mark is a delicate sketch located in the margins of a beautifully produced thirteenth-century copy of Pliny's *Historia naturalis* (Paris, BNF, MS lat. 6802, fol. 143v) (Fig. 25).[2] The drawing serves to annotate a passage describing the source of the river Sorgue in the Vaucluse, the beloved home for many years of the poet Petrarch (Fig. 26): "Est in Narbonensi provincia nobilis fons Orge (*corr. in* Sorge) nomine."[3] Integral to the image is an inscription of four words, "Transalpina solitudo mea iocundissima."

Unframed, clearly adjusted to the exigencies of the pre-existing composition of the page and executed in the deft strokes of a pen that seems hardly to have touched the surface of the parchment, it is the kind of image one might easily relegate to the realm of the innocent, bland, neutral-seeming or decorative. But hovering in the background of this seemingly modest work is a set of historical issues and circumstances, more or less clearly articulated in the literature, which have the potential radically to alter this view.

Fig. 26. Pliny, Historia naturalis. *Paris, BNF, MS lat. 6802, fol. 143v.*

Foremost among them is the question of authorship, which has elicited a surprisingly lively discussion now for about a hundred years. The sketch, along with other annotations to the text, is clearly a later addition, and based largely on an analysis of the script, doubtless also a work of the fourteenth, not the thirteenth century. A perennial contender for the title of draftsman has been the poet Boccaccio, who certainly worked and lived together with Petrarch at several moments of his life, whose style of textual annotation is well known, and who also wrote on the Sorgue in his geographical treatise, *De montibus, silvis, fontibus, lacubus, fluminibus, stagnis, seu paludibus; de nominibus maris.*[4] Some scholars have even advanced the theory that Boccaccio may have executed the

design under the direction of Petrarch, the one holding the pen, the other giving instructions.⁵ But this scenario is unconvincing.

More likely — and this is an emerging consensus — the drawing was the work of Petrarch himself. We know that the book was in the possession of Petrarch, who had acquired it in Mantua in 1350. The handling of the inscription accords with what we know of his writing style from other sources. The style of the image, moreover, differs from that of Boccaccio when he turns his attention to figures and landscape. There is a window of opportunity for the execution of the drawing in and perhaps even after 1351, but probably not much later, and especially not after 1359 when "una prospettiva di vita transalpina non esisteva più."⁶ Petrarch lived near the source of the Sorgue, and he was filled with pleasure by the place. At this point, it would seem almost obdurate to think of the drawing in terms of anyone else.

Other questions have been raised about the content or iconography of the image, such as the issue of the naturalism of the bird, which possesses a sufficient number of characteristics to be identified as a heron, and the church or chapel, which has been argued to be the representation of an oratory of St. Victor or of a planned chapel to the Virgin.⁷ These observations have been made in service of the opinion that the drawing is the record of an actual experience, a view of things seen (even if the experience was by then decades old and mediated by memory), which is not out of the question. One senses in the drawing quite clearly the impact of convention, as, for instance, in the formula of the rocky slope topped by a piece of architecture which was frequently used in the landscape setting of visual narratives of the period.⁸ And yet convention and the recording of experience need not be incompatible with one another.

And finally, there is the issue of the meaning of the image, its cultural valence or symbolism. The heron, for instance, has been read as the image of Satan, who holds a Christian soul,

the fish, as victim in his grip.[9] This type of reading depends on an index of meaning external to Petrarch himself, that is to say, on a set of conventions of another sort to which the poet may or may not have had recourse. In this instance, there is no independent confirmation of the connection, or of a context for it, which makes it in the end seem rather arbitrary. In any case, as with anything else that bears the poet's touch, one wants instinctively to reach out first to the poet's work, to make connections, above all to exorcize the nagging feeling that there is more in what one encounters in the instance, in its absolute particularity, than meets the eye.

This is precisely what I propose. What I would like to undertake in the pages that follow is a close reading of the image, which will integrate it into a set of recurrent themes, narratives and juxtapositions in the poet's work, and thus show it to be more complicated and intellectually engaging than it would appear at first glance. This will bring us to a point where we can appreciate the nature and urgency of Petrarch's own particular formulation of a relationship with landscape. But I do not want to stop here. My ultimate goal is to use this train of thought as a kind of fulcrum to open up a larger issue and context, if only suggestively and with two examples, particularly regarding the intertwined phenomena of the landscape image rooted in a particular moment in time and the categories, conventions and discourses that have come to govern the understanding of it as history.

The Work

THE GRACEFUL COMPOSITION settles itself around the shadowy cave, which is the source of the river. Above it rises a rocky eminence, cleared only by a winding path that leads to a church and tower surmounted by crosses. Out of the cave and to the left flows a river that turns in the opposite

direction. Its undulating bank is lined with reeds. Near it or in it stands a heron dangling a fish in its beak, which at the same time serves to point to the inscription that stands as title to the whole.

"Transalpina solitudo mea iocundissima": the emotional exuberance of the verbal sentiment is well matched by the loose, free, energetic and exceedingly sure style of the drawing. But this sentiment is also anchored in a carefully contrived composition. Though its large size is clearly meant to suggest a placement in the close foreground, the heron is almost as tall as the mountain itself; and this — coupled with the fact that church and heron stand at the far edges of the image and opposite one another — impels us to read them as pendants: the nourishment of body and soul, perhaps, with the one, freely given by nature itself, and the other, acquired in the arduous expense of exertion in overcoming nature. Emotionally enriched, the landscape would thus appear to be filled with the implication of work that has a moral valence. But this train of thought, which moves in the direction of allegory, is clearly incomplete.

If there is work to be done in this landscape, there must also be one to do it. He is absent. Or is he? The inscription is the poet's medium, the medium in which he comes to life. These are his words, his voice. Cast in the first person, the inscription is the material trace of his presence: it renders him present as a figure recumbent on the bank of the flowing river. This is not simple scenography, therefore — a mute, impersonal vignette — but the form of landscape reverberating with scattered energy — the sound, the touch, the affect — of an individual.

At a later point, the idea would become concrete. In a monumental miniature that served as part of a sequence to introduce the poet's *Trionfi*, the painter has deployed a remarkably similar set of motifs: the winding stream, the grassy bank, the water birds and the building-topped hill in the distance; but in this

case, in place of the poet's own words, he has arranged the person of the poet himself, asleep at the river's edge, figuring the dream in which the poem is set (Fig. 27).[10] The miniature belongs to a luxurious manuscript produced in 1459, attributed in part to Jacopo da Verona, and although there is no reason to believe that the painter was aware of the earlier drawing, it is interesting to observe how deeply the image reverberates in the poet's own work. I have two examples in mind.

One is from *Familiares* XXIV.11, where, precisely through the vehicle of these physical circumstances, Petrarch was able to conjure up the presence of his great forebear, Virgil. He writes of seeking out the man in his native Mantua, not in the city itself, but in the surrounding countryside where he imagines the living, breathing Virgil at rest at the edge of the water:

> It is here I have composed what you are reading, and have enjoyed the friendly repose of your rural fields. I wonder by what path in your wanderings you sought the unfrequented glades, through what meadows you were wont to stroll, what river shore you pursued, what recess in the curving banks of the lake, what shady groves, what forest strongholds. And I wonder too what hilly turf you sought, where in your weariness you pressed your elbow upon the grass or upon the bank of a charming spring. Such sights bring you vividly to my eyes.[11]

An even more extreme scenario in a physical environment that also bears resemblance to the one depicted in the sketch is imagined by the poet at another point. In Canzone 126, the setting is the bank of a flowing stream through which Laura has just passed to bathe:

> *Chiare, fresche e dolci acque,*
> *Ove le belle membra*
> *Pose colei che sola a me par donna;*
> *Gentil ramo, ove piacque*
> *(Con sospir me rimembra)*
> *A lei di fare al bel fianco colonna.*

PETRARCH ON THE SORGUE

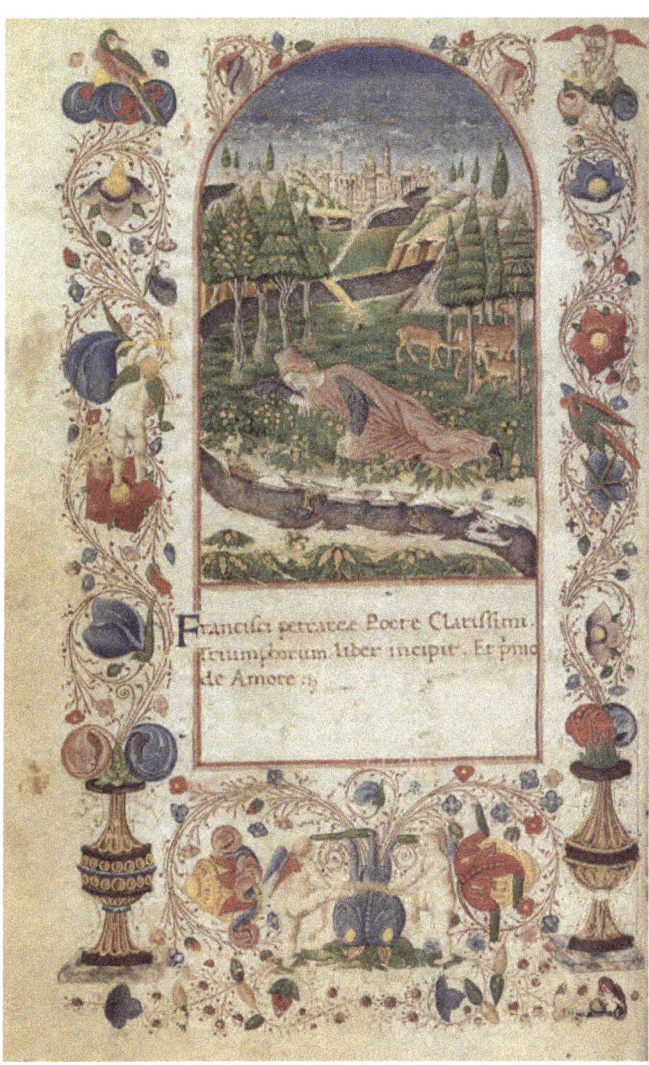

Fig. 27. Petrarch, Trionfi, *Dream of Petrarch. Vienna, Österreichische Nationalbibliothek, MS 2649, fol. 3v.*

Biting bright water
The lovely flesh of her
Rests in the chill current.
The branch sprang back with the weight of her
Side pressed in among leaves.[12]

Fast forward to the future. The poet, now dead, lies buried at the very spot he had occupied earlier to catch a glimpse of his beloved. He visualizes her returning to find him in a grave marked by a stone:

> *Tempo verrà ancor forse*
> *Ch'a a l'usato soggiorno*
> *Torni la fera bella e mansueta,*
> *E là, 'v'ella mi scòrse*
> *Nel benedetto giorno,*
> *Volga la vista disiosa e lieta,*
> *Cercandomi; et, o pieta!,*
> *Già terra in fra le pietre*
> *Vedendo, Amor l'inspiri*
> *In guisa, che sospiri*
> *Sí dolcemente che mercé m'impetre*
> *E faccia forza al cielo*
> *Asciugandosi gli occhi co'l bel velo.*

And then, after waiting,
The time might come, some time,
When gentleness tames her fierce scorn
And she will come again to this place,
Searching for me: will find me earth under stone.
Knowing love for me, finding mercy,
She would begin to teach the stars new patterns.[13]

The inner transformation Petrarch imputes to Laura, bringing her to love him, occurs at the moment in which she recognizes him through the mark or trace — "Già terra in fra le pietre" — which proves that he has now become one with the landscape itself. It is not simply that the living environment

preserves his material existence; it contradicts the very fact of his absence. Landscape is no longer external. It no longer functions as setting, erected on the scaffolding of allegory, but as a form of poetic presence.

These images in words and pictures are like the ever-widening circles caused by a momentary disturbance on the surface of a pond — echoing, amplifying and intersecting one another. The poet-ghost of the Mantuan countryside resonates with the ghostly poet of the landscape in the sketch, as both also prefigure the sleeping poet of the miniature in the *Trionfi*. At the same time, the paradox of embeddedness in the sketch, the bodiless voice, the manifestation of an individual who lacks material form, strangely prefigures the absorption of the body of the poet in his grave.

The ultimate setting of solitude. Of the four words in the inscription of the image, it is *solitudo* that figures Petrarch most clearly, and it is interesting to note the variation with which it is drawn. It is executed in letters that are larger than those of the other words and it seems darker in the tonality of its ink. The letters also have an amplitude in their spacing; certainly much more so than those of *transalpina*, which seem positively compressed by comparison. *Iocundissima* seems compressed too, but not as much. In any case, it is more in the order of things that the final word of a line be compressed than the first. Is it possible that *transalpina* was an afterthought, perhaps even along with *mea iocundissima*; in other words that *solitudo* once stood alone? The proposition is suggestive but cannot be borne out with any certainty.

The term *solitudo* evokes a complex train of thought exposed by the author at greater length in one of his treatises, *De vita solitaria*.[14] The treatise was written in 1346 (though only finished years later), when Petrarch was actually in residence in Vaucluse, within sight of the Sorgue. Early on in the work his deliberations turn to place:

Let provision first be made that, after the prosperous conclusion of his mental toil, one may be enabled to put off the burden of his weariness by having easy access to woods and fields and, what is especially grateful to the Muses, to the bank of a murmuring stream, and at the same time to sow the seeds of new projects in the field of his genius, and in the very interval of rest and recuperation prepare matter for the labor to come. It is an employment at once profitable and pleasant, an active rest and restful work, so that when he returns to that narrow and secret chamber favored by Demosthenes, he may eliminate all that is superfluous and give the desired perfection of expression to germinating thought. In this way not a moment of time will pass with any waste or loss to the student. This should apply particularly to those who compose oratorical discourses or histories, for I deem that those who ponder philosophy, and even more those who brood on poetry, whose minds are given to refined and subtle thought rather than to collecting many facts, must be left to their own devices. Let these follow the impulse of their genius, in the assurance that their minds will respond, no matter where place and time invite them, wherever they feel themselves strongly incited by the goad of their inspiration, whether it be under the open sky or the roof of a locked house, within the shelter of a solid rock or beneath the shade of a spreading pine. They have no need of turning over many books, for they can read in memory the books they have read before and often even compose in their minds what they have omitted to read, but they raise themselves aloft on the wings of their genius, for they must needs be carried away with more than human rapture if they would speak with more than human power. This, I have observed, is without doubt achieved most effectively and happily in free and open places.[15]

This sequence of observations is almost a program statement for the small sketch, not simply in its evocation of repose on the bank of a murmuring stream, but in the very terms in which the process it displays are cast, in the form of a juxtaposition. For the poet the essential activity of the landscape is defined by the chiasmus, "an active rest and a restful work,"

which is essential above all to those who follow "the wings of their genius." Like the imputed juxtaposition of the nourishment of body and spirit in the sketch, this pairing is the exposition of a synergy that can never be resolved, since to do so would result in the stilling of the impulse. Its structure is oscillation. The image-analogue that comes to mind here is a perpetual motion machine, and it is interesting to observe that Petrarch returns to this precise form of movement in describing the critical work in which he engages at the heart of his beloved home in the Vaucluse, which was already cited in the introduction, "I have acquired two small gardens, perfectly suited to my skills and taste, To attempt a description for you would be too long…".[16]

All of which brings us finally to the most famous of the poet's excursions in the landscape, set out in a narrative that forms the dramatic centerpiece of a letter to a friend: the description of his dogged, often frustrated movement to the summit of Mount Ventoux, whose secrets in the end are never entirely revealed. There was a tendency at an earlier moment in time to accept this quite unusual narrative at face value; following Jakob Burckhardt's monumental *Die Cultur der Renaissance in Italien: Ein Versuch* of 1860, it had often been mapped as the "Renaissance discovery of nature" onto the image of a culture as a whole constructed from other sources.[17]

But this approach was effectively gutted by modern scholarship. Giuseppe Billanovich has demonstrated that the letter was written not close to the time in which the events that it describes are purported to have taken place but decades later, in the 1350s and long after its addressee, Dionigi da Borgo San Sepolcro, was dead.[18] The letter, therefore, is not reportage but artifice. The choice of Dionigi as recipient of the missive itself is part of the program of the document, in which a series of

juxtapositions and contrasts between spiritual and earthly, deferment and gratification, were engineered. These included as well the old shepherd, who warns against the undertaking, not to mention the book that the protagonist carried with him. This book was the *Confessions* of St. Augustine, a passage of which, appearing at an opportune moment, not only transformed Petrarch's understanding of his own experience but, through the vehicle of his experience, reconstituted itself as a new text before his eyes. In other words, it was in the grip of landscape and his particular engagement with it, his ascent of the mountain, that tradition, the text, for Petrarch became unsettled and was itself reshaped. In the case of Petrarch's ascent, landscape becomes dynamic, interactive, interpenetrating with the protagonist as a new space for thought, or perhaps more accurately a space for new thought: it is almost synonymous with the mind itself.

But in the end what binds this narrative even more closely to the others to which we have now had recourse is the melancholy fact stressed in the more recent interpretations, namely, that the narrative is not simply one of ascent, but of descent as well. Conceiving of the narrative as the "Ascent of Mount Ventoux," as has commonly been done, has allowed it implicitly to be assimilated to the tradition of spiritual journeys from Moses' Mt. Sinai, to the Averna of St. Francis, to Dante's Purgatory, in which an arduous effort culminated in a definitive revelation.[19] Petrarch's experience on Mount Ventoux was of a different order. The moment at the top instilled an uneasiness in the poet, which he carried with him on his descent. Nor was the descent itself definitive. It offered no end to the possibility of future ambition; no end, therefore, to the possibility of continuing this set of movements as a process, like the restless movement in the landscape enacted by the poet on a daily basis in the Vaucluse.

Beginning with the sketch we have been able to follow an episodic sequence almost in the manner of a linked series of operations that interwove notions of presence and process in the landscape. What we have come to see is that the inscription, far from being an ancillary element, is, in a sense, the key to understanding the sketch as a work of the poet himself. It stands as the figure of poetic presence, of absorption in the landscape and thus aligns itself with the potent set of images Petrarch deploys elsewhere to call into being the two modalities of time that escape our grasp, the past (Virgil) and the future (his own end). At the same time, absorption is also exposure for Petrarch: landscape is the cradle of his restless movement whose very form — oscillation — exposes the mechanics of poetic creation.[20] Landscape for Petrarch operates on two levels at once, as enclosing and intimate and as outward-turning and revelatory: it thus embodies a complexity that lends it, I would like to suggest, an extraordinary new functionality.

A Milieu

LET ME ATTEMPT to frame this train of thought in conclusion — selectively, and suggestively — by moving beyond the small sketch to the monumental work of art. I make this considerable transition understanding full well that the category of form bringing the two together — landscape — was the product of a complex historical development whose lineaments have been scrutinized in the kind of detail that it will not be possible to repeat here.[21] Nonetheless, the remarks that follow are intended to reflect on this development in the sense of arguing that Petrarch himself did not stand alone, primarily through the vehicle of two early manifestations.

The first has become, in the medium of fresco painting, a *locus classicus* for the discussion of origins of landscape as an autonomous genre: Ambrogio Lorenzetti's ensemble of allegories

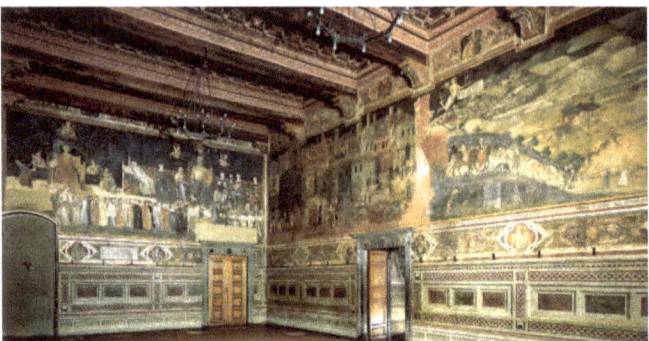

Fig. 28. Ambrogio Lorenzetti, Allegory of Good Government. Siena, Palazzo Pubblico, Sala dei Nove.

in the Sala dei Nove in the Palazzo Pubblico in Siena (Fig. 28).[22] These monumental images cover three walls of the council chamber, apportioned between good and bad government and their effects, with roughly a third of the space given over to the latter and two-thirds to the former. To a great extent, however, the city and the countryside under good government have become the star of the show. Cast in the form of a single unified view sweeping dramatically from close-up and personal to the deep distance of the edges of the ideal state, this image constitutes a commanding, indeed overwhelming presence in the relatively restricted environment of the room as a whole. In the context of the extensive discussion that the frescos have received in studies as diverse as Uta Feldges' *Landschaft als topographisches Porträt* (1980), Chiara Frugoni's *La città lontana* (1983), Randolph Starn's "The Republican Regime of the 'Room of Peace' in Siena, 1338-1340" (1987) and Quentin Skinner's "Ambrogio Lorenzetti: The Artist as Political Philosopher" (1989), I would like to focus on the countryside and particularly on the extraordinary detail, range and significance of the activities that spread out from the walls of the densely inhabited city (Fig. 29).

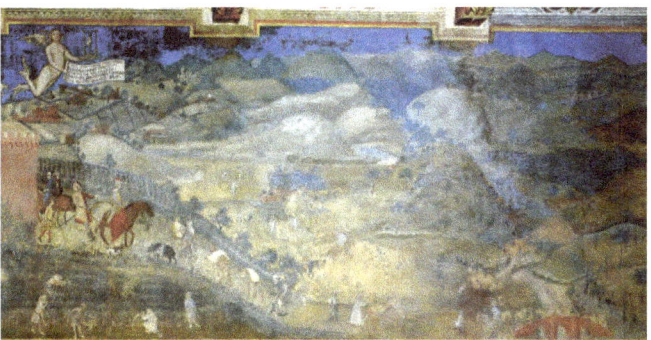

Fig. 29. Ambrogio Lorenzetti, Allegory of Good Government, Countryside. Siena, Palazzo Pubblico, Sala dei Nove.

As Frugoni argues, these activities figure the deep involvement of the city state in the surrounding territory in a decidedly reciprocal relationship.[23] The city government gives structure and brings order to the land, through the building and maintenance of roads and bridges, while the land, thoughtfully and carefully worked, returns support and sustenance to the city. The mechanism of this relationship is explored in exhaustive detail, from the ploughing, seeding and harvesting of the land to the shepherding of flocks and hunting of game. The landscape is criss-crossed with activity, moving outward through the fields and meadows, but at the same time also returning, relentlessly, by means of the carefully maintained network of roads, laden with the stuff out of which life in the city was built. But is this landscape simply an abstract platform upon which meaning is performed?

Stretched across the foreground is a wide swath of road, like a great artery, pulsing with life (Fig. 30). This pulsating movement reverberates in the undulating hills, which bear the lineaments of a heaving, breathing body filling the picture plane and spreading out into the distance. This is a body, in fact, revealed to us both inside and out, from its edges and contours,

which beckon us with the promise of touch, of enclosure, to the purposefully moving figures that stream through it like the corpuscles in a network of veins. This is a body whose essential workings of life have been exposed to us in a most forthright way in the movement coursing through it.

Although the web of evidence regarding landscape in this period is broad and dense, I would like to shift our attention at this point, to a different time as well as a different place and medium, which nonetheless has a quality that positions it

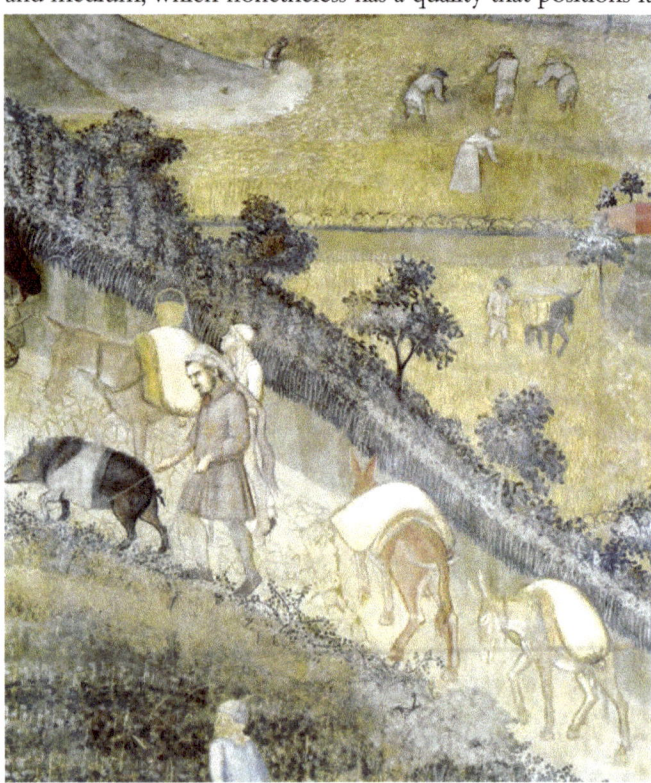

Fig. 30. Ambrogio Lorenzetti, Allegory of Good Government, Countryside, detail. Siena, Palazzo Pubblico, Sala dei Nove.

decisively in the milieu of the Lorenzetti frescoes. This is the calendar sequence from the *Très riches heures of the Duc de Berry*, executed by the Limbourg Brothers (with others) at the beginning of the fifteenth century (Figs. 31 and 32).[24] The deluxe manuscript has been rightly regarded as the culmination of a tradition. The conventions of the book of hours, centuries long in the making in one of the primary vehicles of the devotional arts of the later Middle Ages, are revisited here to stunning effect. The calendrical sequence is truly a series of monumental miniatures and a far cry from the modest images that typically embellished these precious personal books. Tradition has it that the calendar of the months was accompanied by depictions of labors appropriate to the season, and this was often accomplished with a single figure engaged in an emblematic activity in a minimally indicated setting.[25]

It is the setting that has been greatly expanded in the *Très riches heures*. Each full page miniature is crowned with an arched compartment that coordinates in diagrammatic fashion the days of the month, the cycle of the moon and the constellations. Below it opens a vista of deep space, which, however, does not typically extend to infinity but is brought up short by the vision of a great patronal residence. These residences are often tower-bedecked castles, and thus prone to dramatic silhouette against the sky. And oftentimes they constitute a decisive end-plane to the spatial conceit, almost in the manner of a scrim that defines the rearmost edge of a stage on which the human drama is played out. Only occasionally is the drama cast in the form of coursing movement through well-defined linear channels. More often than not it is grouped together at or near the center of the composition, either loosely in the case of the fieldsmen in the month of October or tightly in the case of the hunt in the month of December, but in both of these cases, as well as in others, it is interesting to observe the similarity of its structure.

PETRARCH'S TWO GARDENS

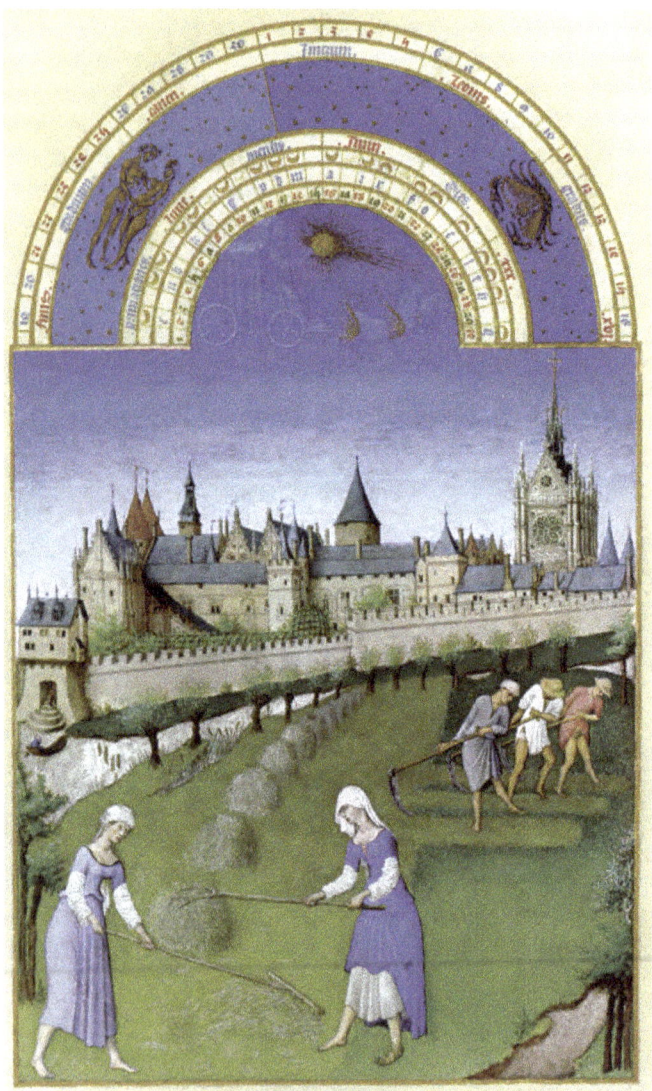

Fig. 31. Limbourg Brothers, Très riches heures of the Duc de Berry, *Calendar, June. Chantilly, Musée Condé, MS 65, fol. 6v.*

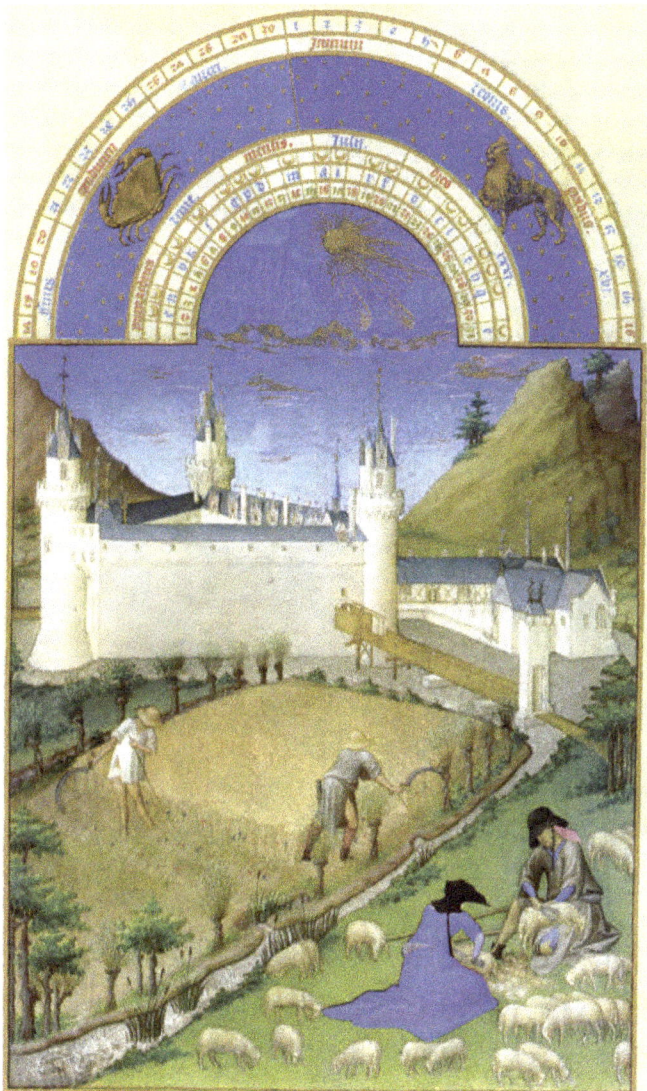

Fig. 32. Limbourg Brothers, Très riches heures of the Duc de Berry, *Calendar, July. Chantilly, Musée Condé, MS 65, fol. 7v.*

Fig. 33. Ambrogio Lorenzetti, Allegory of Good Government, Countryside, detail, workmen with scythes. Siena, Palazzo Pubblico, Sala dei Nove.

As in the fresco at Siena, the figure with a scythe that appears in several of the scenes is emblematic: this figure moves with the deliberate syncopation of advance and return in the swinging of the tool that wrests sustenance from the ground (Figs. 33 and 34). It is the figure of oscillation, whose deliberate repetitiveness — the seasonal working of the land— lies at the heart of the landscape itself as its raison d'être.[26]

Martin Warnke has argued that the landscapes of the *Très riches heures* are political, and he has taken as his example the image of

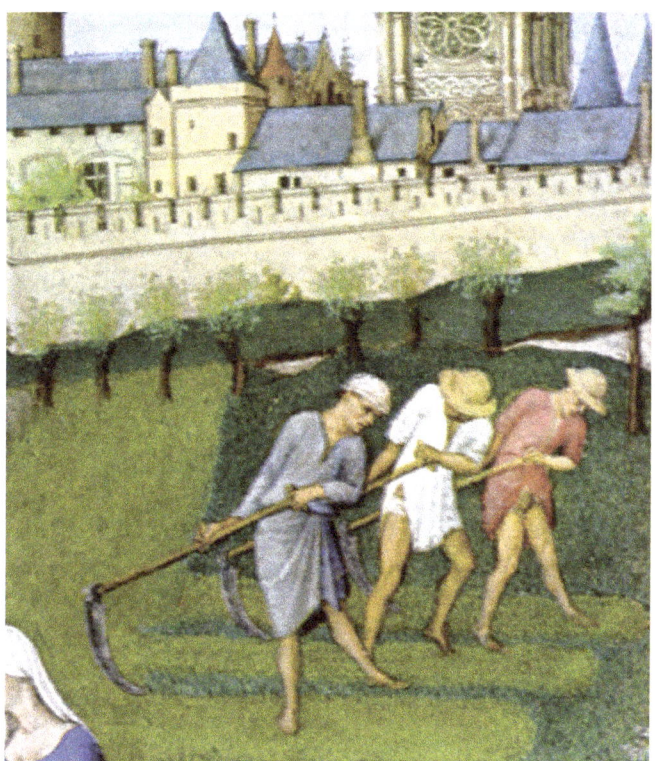

Fig. 34. Limbourg Brothers, Très riches heures of the Duc de Berry, *Calendar, June, detail, workmen with scythes. Chantilly, Musée Condé, MS 65, fol. 10v.*

March, with the duke's boundary marker standing prominently at the intersection of two roads as a sign of the order that he has given to this world.[27] The broad platform of landscape may thus be seen in the terms in which others have spoken of the countryside surrounding the city blessed with good government in the Palazzo Pubblico. Both present a catalog of the effects of power, an exposition of the mechanisms of the state under benevolent rule that, in the case of the *Très riches heures*, also include rituals of court beside the core seasonal activities.

There is an analogy here to Siena, but there are also differences. Although the palaces, manor houses, castles and towns in the miniatures of the *Très riches heures* impose themselves upon the landscape, they are accessible only through it, that is to say, through the great distance of it, which extends from the viewer's position to the magnificent materializations of the ruler's presence. Structurally speaking the image of the countryside in the Siena fresco is quite different. What opens out to embrace the viewer is the city itself, whose walls miraculously dissolve at the edge of the picture plane to enfold the viewer in the city's space. Moreover the city occupies an eminence, the crest of a hill, from which the countryside flows out downward, below and behind. Although in terms of sheer area of wall there is parity between city and countryside, the city is clearly the thing: the city as an experiential reality opened to anyone who casts an eye on its form. The countryside serves as its adjunct, its frame and its foundation and is thus absorbed by the viewer only secondarily. It stands to the right of the city and the allegorical panel, which serves as the center of the decoration, and although one might argue that this is the result above all of the exigencies of space and the nature of the program, surely it is meaningful that from the presumptive center the landscape is apprehended in a sidelong glance.

Landscapes in the *Très riches heures* have come to occupy front and center, and with their slightly elevated angle of view and deep recession, they have become the unavoidable means by which the viewer apprehends the picture. These landscapes have become fully present to the viewer. Although the rulers' castles and palaces are intended to be seen as towering over it and thereby dominating it, the landscape trumps them in its position, its extent, but above all in its intensely dramatic visual interest. The figures who occupy it have been aggrandized accordingly. In the Sienese fresco these figures are more like figure-signs, ciphers that stand for the actions that they perform, although here too they,

like the harvester in the month of October, embody a principle of movement as the exposition of meaning that fully accords with what we have observed in the images and writing of Petrarch.

One might infer here a heightened importance imputed to landscape; and although it would be difficult on the basis of these two examples to argue a chronological development in a narrow sense, given the complexity of the phenomenon and the obvious differences in function, purpose and medium, the lineaments of change on a broader scale seem tantalizingly on the horizon. The primary possibility worth pondering is that this change had at its heart a new concept of the functionality of landscape. And in what might this new functionality consist? What binds these two cases together and links them decisively to Petrarch is precisely the image of work. Work is the essential point of both landscapes, work defined to embrace a whole host of activities, and not simply that of poetic creation per se, which was the case with Petrarch and which was in turn deeply embedded in the landscape. As was the case with Petrarch's drawings and descriptions, the landscape itself takes shape from this work (as in the planting of seeds, Figs. 35 and 36), forms itself to contain and enclose the work but also to reveal it at the same time. Such work is housed within these respective landscapes but it also cannot be extricated from them. The two in fact are inseparable. And like Petrarch's two gardens, these are also landscapes of subdivisions, of fields, of fields of vision. One might even say that the emergence of the field is one of the contributions of these landscapes, for the existence of the field — that entity definable as a clearly delineated part of a whole — is essential to work. Work makes necessary a field in which the worker may operate, and the field is that arena in which the worker may come to exert some control, to dominate.

Work links these cases, expressed as the creative, poetic act of an individual in the case of Petrarch, or as the communal

Figs 35 (L). Limbourg Brothers, Très riches heures of the Duc de Berry, *Calendar, October, detail, workman sowing seeds. Chantilly, Musée Condé, MS 65, fol. 6v.*
Fig. 36 (R). Ambrogio Lorenzetti, Allegory of Good Government, Countryside, detail, workman sowing seeds. Siena, Palazzo Pubblico, Sala dei Nove.

or social manifestation of the well-governed state in the case of the Palazzo Pubblico and the *Très riches heures,* whose form has taken shape within the landscape. What is work in the end but a state of becoming, and becoming a form of motion? Questions that bring us back to our theme. As the image of perfection, the Garden of Eden could never have housed such activity. But once the possibility that landscape might function in this way was broached, it moved from an abstraction to an arena in which an infinitely expanding set of content could be performed.

Notes

1. Bellafiore, *Parchi e giardini*, 27.
2. Pierre de Nolhac, *Pétrarque et l'humanisme* (Paris: Librairie Honoré Champion, 1965, repr. of 1907 ed.), 1:113; 2:69–83, 269–71 and pl. 277; Lucia Chiovenda, "Die Zeichnungen Petrarcas," *Archivum Romanicum* 17 (1933): 42–50, fig. 22; E. Pellegrin, "Manuscrits de Pétrarque dans les bibliothèques de France (Censimento dei codici Petrarcheschi, II)," *Italia medioevale e umanistica* 6 (1963–64), 283; Armando Petrucci, *La scrittura di Francesco Petrarca* (Vatican City: Biblioteca Apostolica Vaticana, 1967), 127 n. 45; Bernhard Degenhart and Annegrit Schmitt, *Corpus der italienischen Zeichnungen 1300–1450* 1. *Süd- und Mittelitalien* (Berlin: Mann, 1968), 130–31; Millard Meiss, *French Painting in the Time of Jean de Berry: The Late Fourteenth Century and the Patronage of the Duke* (London: Phaidon, 1969), 25 (with an attribution to the Master of the St. George Codex); Giuseppe Frasso, *Itinerari con Petrarca* (Padua: Antenore, 1974), pl. 85; Florence Callu and François Avril, *Boccace en France: De l'humanisme à l'érotisme* (Paris: Bibliothèque Nationale, 1975), 14 n. 20; S. Clap, *Fontaine-de-Vaucluse: Le temps retrouvé* (Marguerittes: Equinoxe, 1992), 4; Billanovich, *Petrarca e il primo umanesimo*, 150–57; Eve Duperray, *L'or des mots: Une lecture de Pétrarque et du mythe littéraire de Vaucluse des origines à l'orée du XXe siècle. Histoire de Pétrarchisme en France* (Paris: Publications de la Sorbonne, 1997), fig. 1; Corrado Bologna, "Petrarca petroso," *L'Io lirico: Francesco Petrarca. Radiografia dei* Rerum vulgarium fragmenta, ed. Giovannella Desideri, Annalisa Landolfi and Sabina Marinetti, *Critica del testo* 6 (2003): 367–420; *Petrarca nel tempo: Tradizione lettori e immagini delle opere. Catalogo della mostra, Arezzo, Sottochiesa di San Francesco, 22 novembre 2003 – 27 gennaio 2004*, ed. Michele Feo (Edizioni Bandecchi e Vivaldi, 2003), 486, fig. M113 A76 on 487, 499–512; Giannetto, "Writing the Garden in the Age of Humanism," 232, fig. 1; Maurizio Fiorilla, *Marginalia figurati nei codici di Petrarca* (Florence: Leo S. Olschki, 2005), 52–58, fig. 53; and Trapp, "Petrarchan Places."

3. "Est in Narbonensi provincia nobilis fons Orge (*corr. in* Sorge) nomine. In eo herbe nascuntur in tantum expetite bubus, ut totis eas querant viribus (ut mersis capitibus totis eas querant *ed.*). Sed illas in aqua nascentes certum est non nisi ymbribus ali" (18, 190).

4. Callu and Avril, *Boccace en France*, 14 n. 20; Maria Grazia Ciardi Dupré Dal Poggetto, "Boccaccio 'visualizzato' dal Boccaccio, I: Il corpus dei disegni e cod. Parigino It. 482," *Studi sul Boccaccio* 22 (1994): 199–200.

5. Michele Feo, *Le cipolle di Certaldo e il disegno di Valchiusa* (Pontedera: Bandecchi & Vivaldi, 2004), 12–30 (rev. ed. of *Petrarca nel tempo*, 499–512); Fiorilla, *Marginalia figurati*, 54.

6. Feo, *Le cipolle di Certaldo e il disegno di Valchiusa*, 40.

7. Fiorilla, *Marginalia figurati*, 53 n. 132; Nolhac, *Pétrarque*, 2:270 n. 3. See also Chiovenda, "Die Zeichnungen Petrarcas," 47–48; Fiorilla, *Marginalia figurati*, 53 n. 130; Trapp, "Petrarchan Places," 4.

8. On Petrarch's interest in the visual arts, see Maurizio Bettini, "Tra Plinio e sant'Agostino: Francesco Petrarca sulle arti figurative," *Memoria dell'antico nell'arte italiana*, ed. Salvatore Settis, I, *L'uso dei classici* (Turin: Giulio Einaudi, 1984), 221–67; Anne Dunlop, "Allegory, Painting and Petrarch," *Word & Image* 24 (2008): 77–91.

9. Fiorilla, *Marginalia figurati*, 53 n. 132.

10. *Petrarca nel tempo*, M37. See also the discussion with regard to the Virgil Frontispiece: Joel Brink, "Simone Martini, Franceso Petrarca and the Humanistic Program of the Virgil Frontispiece," *Mediaevalia: A Journal of Mediaeval Studies* 3 (1977): 83–117; L.B.T. Houghton, "Simone Martini's frontispiece to Petrarch's Vergil," *Paragone* 53 (2002): 54–76.

11. Trans. Bernardo, *Letters on Familiar Matters*, 3:341. See also Greene, *The Light in Troy*, 89–90.

12. *Francesco Petrarca Canzoniere*, ed. Ugo Dotti, 8th ed. (Milan: Feltrinelli, 2008), 368; Greene, *The Light in Troy*, 91–92. See also Jennifer Petrie, *Petrarch: The Augustan Poets, the Italian Tradition and the Canzoniere* (Dublin: Irish Academic Press, 1983), esp. 51–102; John

Freccero, "The Fig Tree and the Laurel: Petrarch's Poetics," *Diacritics* 5 (1975): 34–40; Marguerite R. Waller, *Petrarch's Poetics and Literary History* (Amherst: University of Massachusetts Press, 1980), 27–104; Giuseppe Mazzotta, *The Worlds of Petrarch* (Durham, NC: Duke University Press, 1993), 58–79; Marco Santagata, *I frammenti dell'anima: Storia e racconto nel Canzoniere di Petrarca* (Bologna: Il Mulino, 1993); and Gur Zak, *Petrarch's Humanism and the Care of the Self* (Cambridge: Cambridge University Press, 2010).

13. *Canzoniere*, ed. Dotti, 370–71.

14. Among recent scholarly editions: Francesco Petrarca, *De vita solitaria*, ed. Guido Martellotti with Italian trans. by Antonietta Bufano (Turin: Einaudi, 1977); Francesco Petrarca, *De Vita Solitaria, Buch I: Kritische Textausgabe und Ideengeschichte Kommentar von K.A.E. Enenkel* (Leiden: E.J. Brill, 1990); *Pétrarque, De vita solitaria/La vie solitaire, 1346–1366*, ed. Christophe Carraud with an intro. by Nicholas Mann (Grenoble: Éditions Million, 1999). For the most recent scholarly consensus, see the three essays in part 3: "Contemplative Serenity," in Kirkham and Maggi, *Petrarch*, 165–208.

15. *De vita solitaria*, I.7, section 8; trans. Jacob Zeitlin, *The Life of Solitude by Francis Petrarch* (Westport, CT: Hyperion, 1978, repr. of Urbana: University of Illinois Press, 1924), 157.

16. Petrarch, *Epistolae Familiares* XIII.8, addressed to Francesco Nelli in 1352, in Bernardo, *Letters on Familiar Matters* 2:206; and *Petrarch at Vaucluse: Letters in Verse and Prose*, trans. Ernst Hatch Wilkins (Chicago: University of Chicago Press, 1958), 122–23.

17. Burckhardt, *Civilization of the Renaissance in Italy*, 293–97. See, for example, Joachim Ritter, "Landschaft: Zur Funktion des Ästhetischen in der modernen Gesellschaft," *Subjektivität: Sechs Aufsätze* (Frankfurt am Main: Suhrkamp Verlag, 1974), 141–63.

18. Billanovich, *Petrarca e il primo umanesimo*, 168–84. See also Martinelli, "Del Petrarca e il Ventoso"; Durling, "The Ascent of Mt. Ventoux"; Greene, *The Light in Troy*, 104–11; O'Connell, "Authority

and the Truth of Experience"; Robbins, "Petrarch Reading Augustine"; and Ascoli, "Petrarch's Middle Age."

19. See Nicolson, *Mountain Gloom and Mountain Glory*; Thomasset and James-Raoul, *La montagne*; and Camos, *Les Montagnes de l'esprit*.

20. See the remarks of Leonard Barkan, *The Gods Made Flesh: Metamorphosis and the Pursuit of Paganism* (New Haven: Yale University Press, 1986), 206–21; and Zak, *Petrarch's Humanism*.

21. See, for example, Otto Pächt, "Early Italian Nature Studies and the Early Calendar Landscape," *Journal of the Warburg and Courtauld Institutes* 13 (1950): 13–47; Comito, *The Idea of the Garden in the Renaissance*; Bertone, *Lo sguardo escluso*; and Wamberg, *Landscape as World Picture*.

22. Ursula Feldges-Henning, "The Pictorial Programme of the Sala della Pace: A New Interpretation," *Journal of the Warburg and Courtauld Institutes* 35 (1972): 145–62; Michael Baxandall, "Art, Society, and the Bouguer Principle," *Representations* 12 (1985): 32–43; Hans Belting, "Remarks on Communal Paintings in the Fourteenth Century in Siena and Pisa," *Studium Artium Orientalis et Occidentalis* 2.1 (1985): 11–16; idem, "The New Role of Narrative in Public Painting of the Trecento: *Historia* and Allegory," *Pictorial Narrative in Antiquity and the Middle Ages,* ed. M.S. Simpson and Herbert L. Kessler, *Studies in the History of Art of the National Gallery of Art* 16 (1985): 151–68; Randolph Starn, "The Republican Regime of the 'Room of Peace' in Siena, 1338–40," *Representations* (1987): 1–32; Jack M. Greenstein, "The Vision of Peace: Meaning and Representation in Ambrogio Lorenzetti's *Sala della Pace* Cityscapes," *Art History* 11 (1988): 492–510; Quentin Skinner, "Ambrogio Lorenzetti: The Artist as Political Philosopher," *Malerei und Stadtkultur in der Dantezeit: Die Argumentation der Bilder*, ed. Hans Belting and Dieter Blume (Munich: Hirmer, 1989), 85–103; Chiara Frugoni, *A Distant City: Images of Urban Experience in the Medieval World*, trans. William McCuaig (Princeton: Princeton University Press, 1991); Randolph Starn and Loren Partridge, *Arts of Power: Three Halls of State in Italy, 1300–1600* (Berkeley: University of

California Press, 1992), 11–59; Randolph Starn, *Ambrogio Lorenzetti: Palazzo Pubblico a Siena* (Turin: Società Editrice Internazionale, 1996); Maria Monica Donato, Chiara Frugoni and Alessio Monciatti, *Pietro e Ambrogio Lorenzetti*, ed. Chiara Frugoni (Florence: Le Lettere, 2002).

23. Frugoni, *A Distant City*, 158–74.

24. Millard Meiss, *French Painting in the Time of Jean de Berry: The Limbourgs and Their Contemporaries* (New York: Braziller, 1974).

25. James Carson Webster, *The Labors of the Months in Antique and Mediaeval Art to the End of the Twelfth Century* (Evanston, IL: Northwestern University, 1938); Charles E. Nicklies, "Cosmology and the Labors of the Months at Piacenza: The Crypt Mosaic at San Savino," *Gesta* 34 (1995): 108–25; David Hill, "Eleventh-Century Labors of the Months in Prose and Pictures," *Landscape History* 20 (1998): 29–39; Bridget Ann Henisch, *The Medieval Calendar Year* (University Park: Pennsylvania State University Press, 1999); Colum Hourihane, *Time in the Medieval World: Occupations of the Months and Signs of the Zodiac in the Index of Christian Art* (Princeton: Index of Christian Art, Department of Art and Archaeology, Princeton University, in association with Pennsylvania State University Press, 2007).

26. By contrast, see the discussion of Michael Camille, "'Labouring for the Lord': The Ploughman and the Social Order in the Luttrell Psalter," *Art History* 10 (1987): 423–54.

27. Warnke, *Political Landscape*, 9–20.

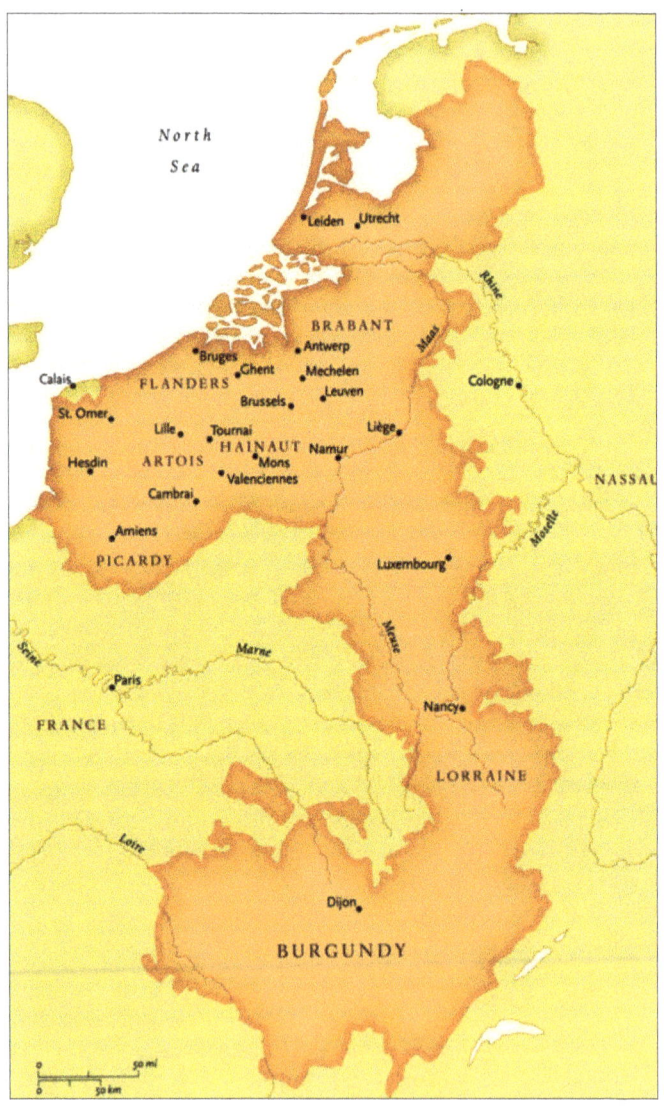

Fig. 37. Map of the Burgundian Lowlands with Hesdin (after Illuminating the Renaissance, fig. on p. 5).

GOLD AND FLEECE: THE PARK AT HESDIN

"Though Jason's Fleece was fam'd of old
The British wool is growing gold."
— John Dryden, *King Arthur*, I, 544

IN A CERTAIN SENSE, the history of intervention in the landscape for any purpose other than the purely utilitarian may be considered a history of intended effects, many of which, from antiquity on were contrived to soothe the *sensorium*. In the classic formulation of Joseph Addison, "A Garden...is naturally apt to fill the mind with Calmness and Tranquility, and to lay all of its turbulent Passions to rest."[1] But there is another category of intervention where the intention was anything but soothing. The manipulation of scale immediately comes to mind: witness the plan of the architect Deinokrates in the fourth century BCE to carve, out of Mount Athos, a colossal figure of Alexander the Great, with a city in one hand and a cup in the other from which would have flowed, in a kind of perpetual libation, the water from all of the rivers of the mountain.[2] This never-completed project is the distant forebear of Giambologna's personification of the Apennine Mountains at Pratolino or Gutzon Borglum's Mt. Rushmore, whose unnerving dimensionality was so shrewdly exploited by Alfred Hitchcock in *North by Northwest*.[3]

More unsettling still was the implementation of mechanical devices, whose surprise actions were calculated to put viewers on the defensive, if not to frighten or humiliate them. Heron of Alexandria was a master of such devices, and the sources are filled with the tales of the magical machines or *automata*: the weeping, bleeding and roaring creatures that he and his successors made beginning in the first century CE.[4] These are the threads of another story of landscape, not as mitigating and conciliatory but provocative and unsettling, and it is one of

them that I would like to follow here. I would like to focus on the phenomenon of artificial or mechanical movement, and specifically as manifest at one site, the park at Hesdin in Artois, one of the favorite residences of the dukes of Burgundy in the later fourteenth and fifteenth centuries (Fig. 37).

Hesdin was famous for its machines ever since it was founded in the late Middle Ages, and in histories of *automata* following the long trajectory from antiquity to modern times, Hesdin has occupied a prominent place.[5] A prominent place in a trajectory in which inventions of the classical age are typically presented as transformed by Byzantium and Islam, before they are transmitted to the late medieval and early modern West. Although some of what constitutes this sequence with regard to Hesdin has been disputed by Anne Hagopian van Buren and others, I would like to go even further in pulling things apart. I would like to look at Hesdin again closely and to make some distinctions that will suggest not a unified set of motives and impulses but a constellation of them.

But I would also like to shift the discussion a degree from its customary track in another sense. Narratives of Burgundian culture often perform a kind of elision almost as a sleight of hand, folding the magical machines of Hesdin into the mix of the other extravagant displays and courtly excesses instigated by the dukes, such as the infamous Feast of the Pheasant at Lille in 1454, where Philip the Good swore a crusade to the Holy Land on a live bird bedecked with jewels; and Philip's entry into Ghent in 1458, when an animated version of the Ghent Altarpiece was performed (*Chorus beatorum in sacrificium Agni paschalis*).[6]

The degrees of connectedness to the culture as a whole that I detect in Hesdin, however, cannot readily be fitted into this framework; they seem less explicit, less mimetic in nature, more in the manner of resonances or reverberations, such as one might pick up surreptitiously in overhearing a conversation

conducted at a slight distance and *sotto voce*. In this essay I would like to try to follow some of these leads — admittedly in a preliminary way — which means that I will often be coming at Hesdin from quite an oblique angle.[7]

Hesdin

THE STORY OF HESDIN is quite complicated, spanning as it does a period of about 250 years, with different areas developed

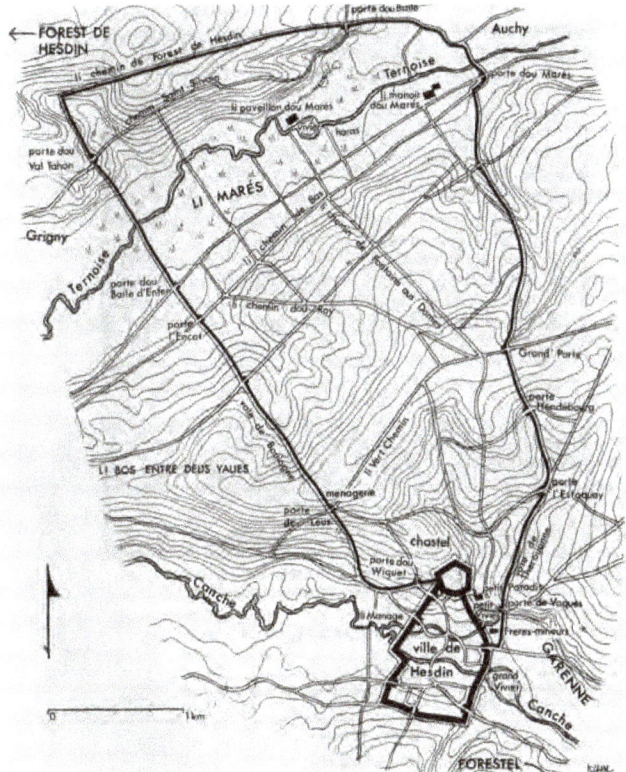

Fig. 38. Hesdin plan, after Van Buren, "The Park of Hesdin," Medieval Gardens, *fig. 2.*

at different times (Fig. 38). It is complicated above all by the fact that it was destroyed by Charles V in 1553.[8] By that time, Hesdin had long been identified with the Valois dukes of Burgundy, who had put their stamp on it in the fourteenth and fifteenth centuries and whose patrimony, including the park, had been absorbed by their successors, the Hapsburgs. But the origins of Hesdin go back to a pre-Burgundian moment, to Robert II, count of Artois and nephew of Louis IX of France.[9] In the late thirteenth century, Robert took a twelfth-century castle and embellished it with a landscape setting unlike any that had ever been constructed in northern Europe. Robert had traveled widely in the Mediterranean, as crusader and then as member of the party that brought the body of King Louis back from Tunis in 1270. One strand of thinking places the inspiration for Hesdin in the Islamic-derived garden traditions of Byzantium, Norman Palermo and the Naples of Frederick II.[10] But the fact is that none of these can be proven as source, in composition, in concept or in any specific detail.[11]

We are on firmer ground with form. Documents now preserved in the Département du Nord at Lille in the form of rolls and registers recording payments for the improvements to the castle and its surrounding land give many particulars.[12] The park at Hesdin was about four km wide, along its greater axis, north–south.[13] It extended northward from the castle, which stood at the northern edge of the medieval town of Hesdin on the river Canche, midway between Boulogne and Arras. It was surrounded by a fence with eleven gates. It had three main sections: to the south, the area adjacent to the castle, which included utilitarian gardens, stables, a menagerie and a walled garden called *li petit Paradis*; woods and hills in the central section; and a marsh to the north, *li Marés*, fed by the river Ternoise. The marsh had a fish pond and a pavilion, *li paveillon dou Marés*, built partly over water. This building had rooms for

entertainment and included water-spouting devices, probably wooden statues according to van Buren, the *engiens dou paveillon*, which were played for guests. There were also six groups of mechanical monkeys, carved wooden figures clothed in badger skins, which waved and nodded from the bridge by which the pavilion was reached. The castle included an aviary with a fountain in the shape of a tree and galleries with water-spouting statues. The names of some of the overseers and master craftsmen who executed these works are recorded in the documents. These included Renaud Coignet, who supervised the work at Hesdin, and Master Guissin, who executed some mechanical boars' heads for the great hall of the castle, where there were also mechanized fountains, clocks and other devices.[14]

There is not space enough here to savor this environment in the amplitude of its strangeness[15]; suffice to say that it was maintained and cared for over the following decades, that it was added to, and finally, that it was augmented under the dukes of Burgundy, and especially under Philip the Good (1396–1467), to whom I would now like to turn. The possibility of visualizing the park is offered by a work presumably of the fifteenth century that exists now in two copies (the most often cited being the one in the Musée du Chateau at Versailles; the other is in the Musée des Beaux Arts in Dijon). The work upon which the copies are based has been attributed to Jan van Eyck by several scholars and argued to be the depiction of Hesdin under Philip the Good, although the argument is lacking proof and must remain an intriguing hypothesis (Fig. 39).[16]

Among the innovations that occurred under Philip were a large fountain near the castle and a dining house on wheels, which "could be rolled out to the park and turned to face the sun."[17] Philip also renewed the decoration of a large room of the castle, with a cycle of scenes from the story of Jason and the Argonauts. According to van Buren, the decoration was first

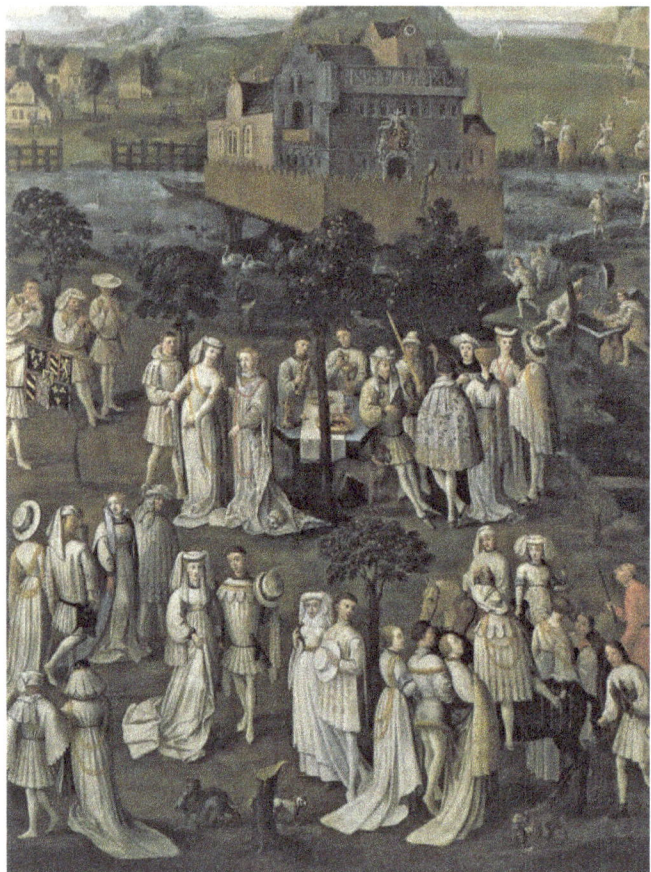

Fig. 39. Copy of painting attributed to Jan van Eyck purportedly showing the Park at Hesdin. Versailles, Musée du Chateau.

executed under Philip's predecessor, Philip the Bold (1342–1404), by Melchior Broederlam, in the 1380s.[18] At that time, it was associated with another room, the chamber of the hermit, to which it was adjacent, or it may in fact have been the chamber of the hermit itself.[19] The sources are inconsistent in their designation, but the connection continues to be spoken

of in the first half of the fifteenth century. However, there also appears to be something new. In 1433, a clerk recorded a payment to Colard le Voleur, "varlet de chambre et painter de MS le duc, le somme de mil livres du pris de XL groz, monnoie de Flandres la livre," for a number of items including,

> Item en la sale devant l'ermite qui fait plouvoir tout par tout comme l'eaue qui vent du ciel, et aussi tonner et néger et aussi esclitrer comme se on le veoit ou ciel.
>
> Item au plus prez de ladicte sale a ung hermite de bois pour parler aux gens qui vendront en icelle sale.
>
> Item avoir fait faire pavement pour paver icelle sale semblable comme devant estoit la moitié ou environ; et là a une place que quant les gens vont pardessus pour eulx garantir de la pluie, ilz cheent du hault en bas en un sac là où ilz sont tous emplumez et très bien brouilliez. A faire lesqulz ouvraiges MdS lui a fait livrer bois, charpenterie et maçonnerie pour faire les edifices propices à faire les choses dessus dictes.
>
> Item lui a convenu mettre jus et sus, oultre la devise avant dicte, la plus grant partie du ciellement d'icelle sale et lambrouchier là où il doit plouvoir, pour ce que trop estoit foible et meschans pour faire les engiens ad ce appartenans.
>
> Item a fait d'abondance que en icelle galerie a ung point, que quant l'en veult, l'en fait cheoir en l'eaue ceulx qui vont pardessus.
>
> Item sont en plusieurs lieux engiens, que quant l'en veult toucher à aucunes touches y estans, ou fait cheoir grands habondance d'eaue sur les gens.
>
> Item sont en la galerie six personages, plus que paravant n'y avoit, qui moillent les gens et par plusieurs manières.
>
> Item à l'entrée d'icelle, VIII conduiz pour moullier les dames par dessoubz et trois conduis que quand les gens arrestent pardevant ilz sont tous blanchiz et broullez de farine.[20]

Although there is some evidence that the rain-effect in the room was in place in the period before Colard, there is the

impression that the complexity of the ensemble was increased exponentially under Philip the Good, whose name attached to it in the decades that followed.[21] In his prologue to the *Historie of Jason*, the English diplomat and printer William Caxton (c.1422–92) mentions these effects, which he had the opportunity to see firsthand:

> But well wote I that the noble Duc Philippe firste foundeur of this sayd ordre/ dyd doo maken a chamber in the Castell of Hesdyn/ where in was craftily and curiously depeynted the conqueste of the golden flese by the sayd Iason/ in whiche chamber I haue and seen the sayde historie do depeynted. In remembraunce of Medea & of her connyng & science, he had do make in the sayde chamber by subtil engyn that whan he wolde it shuld seme that it lightend & then thondre/ snowed & rayne. All within the sayde chamber as ofte tymes & whan it shuld please him which was al made for his singuler pleasir.[22]

It is interesting to observe that Caxton links the effects to the subject of the paintings, a point to which we shall return.

If this brief and selective chronology conveys the impression of a unified enterprise guided by an evolutionary spirit, in which layer upon layer of invention was superimposed, elaborating, ramifying, complicating the original scheme — which is the predominant impression purveyed in the literature on Hesdin — from another vantage point, an important difference emerges. It has to do with method or approach.

On the one hand, there are the *automata* properly speaking, that is to say, those *integral* elements, which are statuesque or sculptural — the moving figures, such as the monkeys on the bridge, or the shaped fountains. These have the most clearly delineated context, beginning (as mentioned) with Heron of Alexandria, whose collected wisdom was played forward to the ages to practitioners like Bernardo Buontalenti and Salomon de Caus, in the texts that Heron wrote, which were influential particularly in the Arabic

speaking world.²³ Liutprand of Cremona's account of the bronze tree with singing birds and the rising throne with roaring lions in the emperor's palace in Constantinople in the tenth century is one among many descriptions of *automata* in Byzantium and Islam.²⁴ Villard de Honnecourt gives over some pages of his treatise to portraying and describing them.²⁵ The phenomenon was broadly diffused (Fig. 40), even in the Burgundian court, where

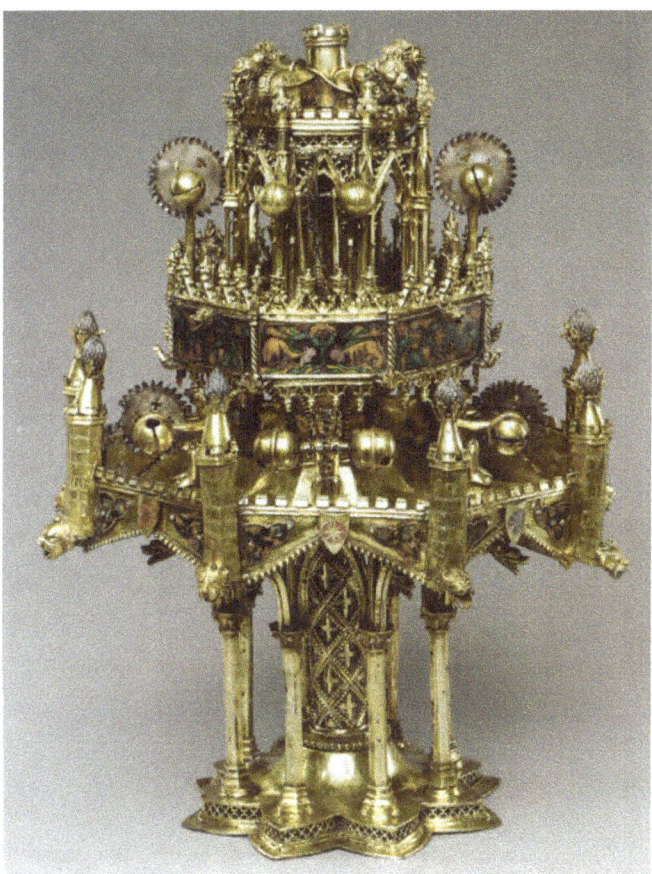

Fig. 40. Table fountain. Cleveland, Cleveland Museum of Art.

extravagant feasts were numerous and often accompanied by *automata* as entertainment.²⁶

But at Hesdin there were also elements that were less sculpture than effect, such as the exterior weather of rain and snow in the room of Jason and Medea in the castle. These, therefore, are more properly termed *simulacra*, simulations, than *automata*, automations, and as a historical category, they are considerably more rare.²⁷ Nor can they be associated with any individual inventor or prescriptive text. One ancient precedent comes to mind, the dining room of Nero's *Domus aurea*, "with fretted ceilings of ivory, whose panels could turn and shower down flowers and were fitted with pipes for sprinkling the guests with perfumes. The main banquet hall was circular and constantly revolved day and night, like the heavens."²⁸ Though the moment is distant in time, the ambient, embracing a patron with unlimited means committed to rendering a spectacle of courtly pleasure, is resonant with late medieval Hesdin. This characterization, of course, would hold for the *automata* as well, with the following proviso: the participatory dimension seems deeper, more ample in the case of the *simulacra*. These effects are not something simply to be taken in visually by an audience standing apart from them as if in a theater, but to be experienced with the complete immersion of the body in the work.

It is the latter on which this analysis will now focus, and particularly on the phenomenon of the outside brought in, in the weather effects of the chamber that included the scenes of Jason and the Argonauts. There is something raucous about the experience of being buffeted by the wind, wetted down by rain and then, possibly, catapulted into feathers — clearly so — which suggest the possibility of pursuing the phenomenon as a form of humor. This world has been amply explored by Bakhtin, for example, whose chapter in *Rabelais* on *the material bodily lower stratum* provides a rich context to approach the

topic, not to mention, among others, Huizinga and Gurevich on play and Lehmann and Bayless on parody.[29] There is an immense repertory of potentially relevant images in the marginalia of illuminated manuscripts where the erotic, scatological or just plain comic flourished in precisely this period of the late Middle Ages in Burgundy, France and England. These motifs have been cataloged by Lilian Randall and closely studied by Michael Camille, Jean Wirth and others, and although in the end I could never see beyond them to anything more than a certain kind of randomness, I was struck by the degree to which they resonated with another body of material that constitutes a prime locus for the discussion of late medieval humor, the Old French fabliaux.[30]

These tales, roughly twelfth to fourteenth century in date, were probably originally intended to be recited aloud and seem to have been widespread in the culture in which Hesdin was created.[31] They are filled with an infinitude of social inversions and sexual escapades. There is a certain randomness to the depiction of reality here too but the connections with the image world of the manuscripts is striking, as the same cast of characters — venal clergy, deceitful wives, pernicious animals — and many of the same motifs surface in both places. But the territory is murky, and it challenges our descriptive and analytical categories — the humorous, the erotic, the scatological — which seem too sharp and clearly differentiated for this culture. The forms and sentiments that these terms separate out, in fact, often bleed through to the other realm we insist existed, the exalted realm, as marginal images bleed through to sacred iconography on the manuscript page. In other words, it would seem that humor was not exclusive, but pervasive, and it pervaded Hesdin as well.

Another frame of reference is in the realm of literature, where effects like the ones attested at Hesdin are clearly signs

of power. Merriam Sherwood has collected a number of the relevant texts in her study, "Magic and Mechanics in Medieval Fiction."[32] It will suffice simply to allude to them here: the description of a visit to the emperor's palace in Constantinople in the twelfth-century *Chanson de Girart de Roussillon*, wherein occurred "a storm of rain and wind produced by magicians"; the magic of Virgil's bones in Naples, as narrated by Conrad, bishop of Hildesheim in the late twelfth century, said bones being ". . . in the neighboring fortress at the edge of the city and entirely surrounded by the sea, . . . and, if they are freely exposed to the air, the whole atmosphere becomes darkened, the sea rises from its depths, violent winds rage and suddenly the roar of the tempest breaks forth"; and the passage in the the *Pèlerinage Charlemagne*, a poem which has been called an "extraordinary mélange" of fabliau, parody, *conte à rire* and epic, where Charlemagne journeys, at the instigation of his wife, to Constantinople to visit the palace of Hugo le Fort and to witness a marvel of a miraculous wind that makes the palace itself revolve (while "admiring the workmanship of the hall, behold there came from the sea sculptured at the lower end of the hall a sudden wind").[33] That these climatological effects were associated, in the literary imagination, with castles and palaces, often also the residence of the ruler, is precisely the point.

The Golden Fleece

WILLIAM CAXTON explains the wind, rain and snow at Hesdin in terms of the decoration of the room, that is, in terms of Medea and her "connyng & science," which was depicted in the cycle of scenes from the story of Jason and the Argonauts.[34] This is one of the great narratives of classical antiquity whose dramatis personae include Medea, of course (Fig. 41).[35] Medea was the lover betrayed by Jason, but not before she had helped him win the golden fleece of Colchis.

GOLD AND FLEECE: THE PARK AT HESDIN

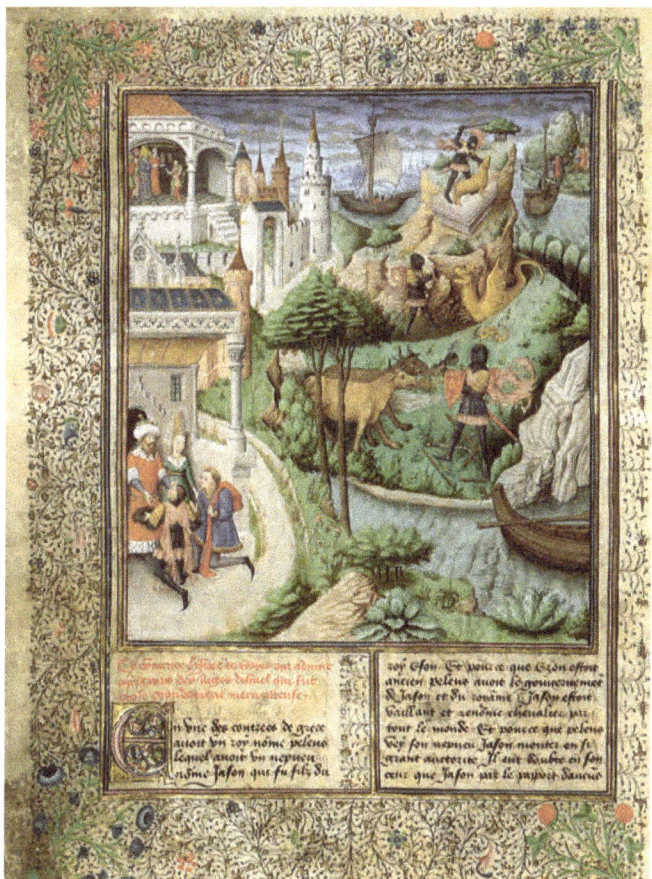

Fig. 41. Jean Mansel, La fleur des histoires, *Jason and the Argonauts, 1446–51. Brussels, Royal Library, MS 9231, fol. 109v.*

The fleece came from a ram sent to transport the children of the king of Boeotia to Colchis, where it was then sacrificed and hung on a tree protected by fire-breathing bulls (or a dragon). And last but not least, there is the hero Jason, who had been sent on a mission to retrieve the fleece by his evil uncle Pelias, who had wanted him done away with

and believed that this one impossible task would achieve that goal. Jason's helpmates in the long series of adventures that led up to the fleece were his comrades in arms, the Argonauts, but above all Medea, whose magic enabled him to unravel the three important final challenges that he faced. But Jason's relationship with Medea also unraveled, especially after he married Creusa: this however is the stuff of great literature (i.e., Euripides) and not Hesdin.

The scenes of Jason and the Argonauts in the great room at Hesdin were executed by Melchior Broederlam at the end of the fourteenth century, under Philip the Bold, according to the argument of Anne Hagopian van Buren, who has also discerned in a set of drawings in the Staatliche Museum, Berlin what is perhaps a visual record of this decoration.[36]

The story was fairly widely circulated in a variety of versions, both verbal and visual, in the later Middle Ages; but what is interesting here is that its renewal under Philip the Bold coincided with a singular event: the transformation of the Jason story into a political emblem. This occurred with the founding of the Order of the Golden Fleece during the wedding celebration of Philip the Good to Isabella of Portugal, of which it was clearly a highlight.[37] As one of the most prestigious institutions of aristocratic prerogative ever created, the order has survived to the present day. Some sense of the pomp and circumstance of its gatherings may be gleaned from an image painted by the Master of Fitzwilliam 268 in *Ordinance of Charles the Bold* (Bruges, 1475), where Charles is shown receiving his military captains in a ceremony modeled on chapters of *The Golden Fleece*.

The extensive scholarly commentary on the order conveys something of the drama of the enterprise as a performative act, implicitly claiming to serve several purposes at once: to codify an age-old ideal of chivalry and to instill it with new

life; to formalize a bond between the duke and his most important subjects by giving structure to the personal obligations that constituted a state otherwise lacking an obvious unity; and, finally, to throw down a challenge to the king of England whose Order of the Garter it co-opted as model.[38] There were twenty-four knights inducted to begin with, but the number was soon raised to thirty-one (including Philip).[39] As a narrative device the figure of Jason and the Argonauts, the noble hero and his heroic followers, was incisive: it captured the fervor of deeply embedded structures, such as Christ and the Apostles or the Arthurian legend, but in the more neutral-seeming language of classical culture.

I find it difficult not to see the institution of the order as a defining moment in the political/cultural evolution of Burgundy, although it itself was not without its discontinuities and dissonances. Within a year after the order was founded, there was a move to displace Jason as its guiding light, because of his sin of infidelity. At the meeting of the chapter in Lille in 1431, the first chancellor of the order, Jehan Germain, put forth as replacement the biblical hero Gideon, whose life was also entangled with a fleece (as narrated in Judges 6:37–40).[40]

The move was only partly successful. In the iconography of the order thereafter, the biblical Gideon clearly came to the fore. But the classical Jason never entirely disappeared, and one of the circumstances that redeemed him was Christian allegory.[41] His life and deeds, particularly as they came to be expounded in poetry, became a pretext for Christianity, as Christianity became entangled with hopes for a crusade, which was increasingly on the horizon in the last decades of the life of Philip the Good.[42] But there was nothing even vaguely approaching this interpretive turn in the first phase of the Jason story at Hesdin, or least there is nothing in the material that would suggest so.

The Ghent Altarpiece

IN ORDER TO BRING these threads together, there is one final element at Hesdin that I would like to adduce. Although it has been little commented on, it is omnipresent in the sources: namely, the hermit. The figure of the hermit, described as a speaking wooden statue in some sources — "ung hermite de bois" — serves to denote a room of the castle, which may be the room adjacent to the room of Jason, or which may be the Jason room itself.[43] This uncertainty notwithstanding, the existence of the figure is beyond doubt, and the questions it raises, therefore, worth pondering. Why a hermit? The term "hermite," deriving not from Hermes (which has bequeathed to us "hermeneutics"), but from the Greek, *hermites*, via medieval Latin, means "solitary ascetic." It leaves no doubt as to his identity. But did he have an identity beyond his role? Considering the possibilities that tradition offers, the various meanings imputed to them, and especially the limited nature of the evidence at Hesdin, I have to admit that these questions ultimately cannot be answered with any certainty. On the other hand, I cannot help but feel that the connection with the Jason cycle is key, and from it come some potentially interesting hypotheses.

There is one piece of visual evidence, certainly circumstantial, that I found quite striking at first, namely, a ducal jeton (in copper), in which the image of St. Andrew on one side is joined to the Golden Fleece on the other.[44] This is a powerful pairing of subjects in the realm of political iconography, reflecting not only the importance of the order in the ducal concept of the state, but also the esteem with which the saint was held in the context of the order.[45] Andrew was the patron saint of Burgundy and then subsequently of the order, whose annual chapter was held on his feast day (Nov. 30, until 1445).[46] But even though Andrew was often rendered with shaggy hair — which sometimes approached the hermit-shagginess of the

Fig. 42. Hubert and Jan van Eyck, Altarpiece, detail, St. Anthony. Ghent, St. Bavo.

desert-dwelling ascetic John the Baptist — he was never considered to be a hermit.[47] So, barring the possibility that the authors of the various texts were consistently misled in identifying the figure, my incipient train of thought becomes too tenuous to hold.

There was a second piece of visual evidence, however, that also captured my attention, and although it requires some framing, I believe that it holds the possibility of a more suggestive delineation of the relevant historical circumstances. Foremost among hermits in the medieval imagination was St. Anthony, the ur-hermit of Christian legend, who was also widely revered as the founder of monasticism and whose cult was promoted by the dukes of Burgundy.[48] St. Anthony also figures prominently in a context in which there is, I would like to argue, the distinct reverberation of the pairing of elements found in the castle of Hesdin; it is also the context of a major monument and a monumental work of art. In the Ghent Altarpiece Anthony stands prominently to the left of the main panel of the bottom register at the forefront of a group of holy hermits (*heremite sancti*) (Fig. 42).[49] To the right is a panel of holy pilgrims (*peregrini sancti*), and as pendants on the opposite side, holy knights (*Christi milites*) and just judges (*iusti iudices*).

This magnificent double-sided altarpiece was the commission of a wealthy citizen of Ghent, Joos Vijd, along with his wife Elisabeth Borluut, who was also a member of the suite of Philip the Good (Figs. 43 and 44).[50] It was intended to adorn a chapel in the church of John the Baptist (later the cathedral of St. Bavo), and it was painted, at least in part, by Jan van Eyck, while he was *valet de chambre* of Philip the Good. He held this office from 1424 through the completion of the altarpiece in 1432, a date quite close to the founding of the Order of the Golden Fleece. In fact, it was dedicated on May 6, 1432, the day on which Philip the Good's son was baptized in Ghent by

GOLD AND FLEECE: THE PARK AT HESDIN

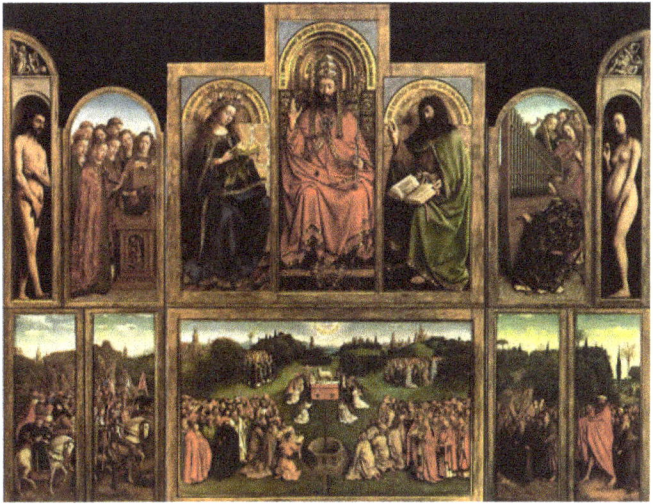

Fig. 43. Hubert and Jan van Eyck, Altarpiece. Ghent, St. Bavo.

Cardinal Beaufort of England. In the words of Jeffrey Chipps Smith, "most likely Jodocus Vijd wished to honor Philip" with the painting.[51]

The altarpiece is an immensely complicated work, both historically and historiographically, although many of the issues, such as the much-discussed division between Hubert and Jan, remain outside of the scope of this essay. But I have developed an opinion about two that impinge directly on the argument here. First, although some have questioned whether the panels were intended to go together as we see them now, I do not see a problem with the present arrangement.[52] Secondly, although disparate opinions have also been voiced about the subject in the central panel of the lower register, it seems clear that the setting is an earthly one; it is in fact quite like the landscape in parts of the Burgundian state, but made perfect, with various recognizable architectural features in the distance, although some of these too were the result of repainting at a later time (Fig. 45).[53]

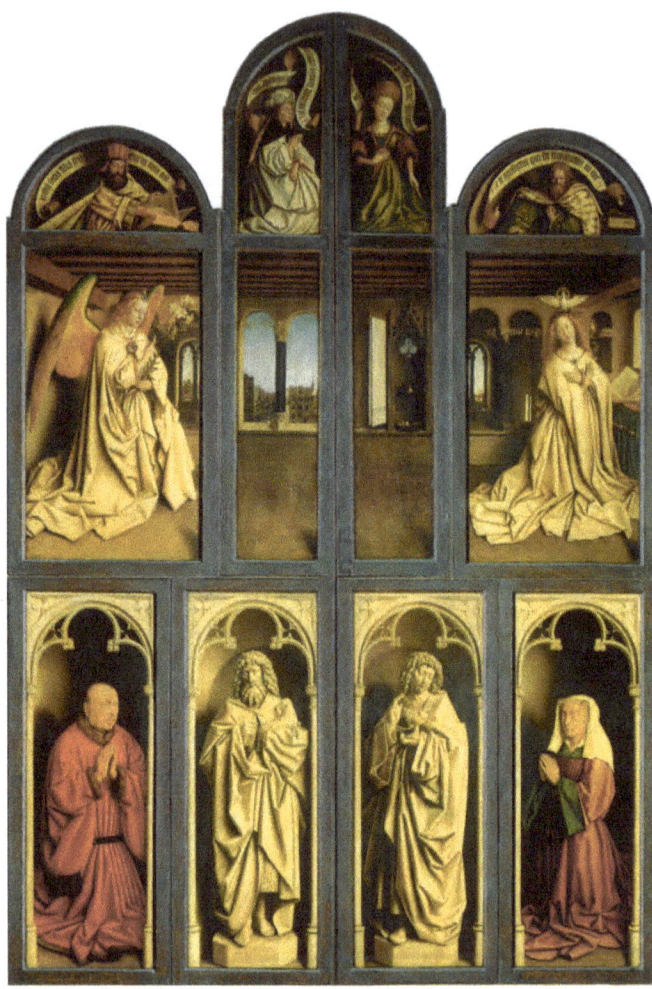

Fig. 44. Hubert and Jan van Eyck, Altarpiece, view closed. Ghent, St. Bavo.

The figures in this panel, beside the angels, are divided between the secular and ecclesiastical realms, and they surround an altar on which a lamb, radiant with golden light, stands. The surrounding figures' adoring attitude toward this lamb — the

GOLD AND FLEECE: THE PARK AT HESDIN

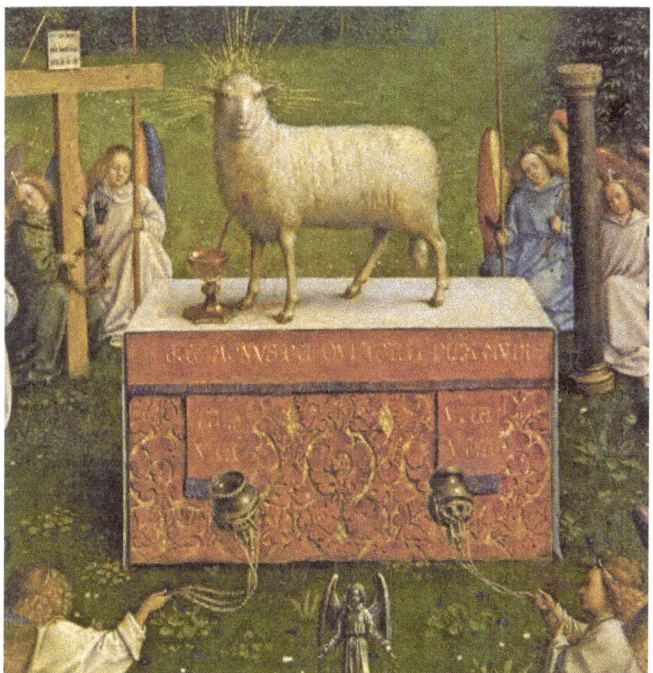

Fig. 45. Hubert and Jan van Eyck, Altarpiece, detail, Adoration of the Lamb. Ghent, St. Bavo.

Lamb of God, Christ — strongly suggests why the orderly and prosperous landscape looks the way that it does. The lower zone therefore inflects in the direction of the earthly, as the upper zone — with its singing angels, God the Father, John the Baptist and the Virgin — inflects in the direction of the heavenly, but for two jarring accents. To each side stand the figures of Adam and Eve, whose bulky physicality and strident nudity are all the more riveting in the harsh light that has been cast on them, with its spotty brightness and dark shadows (Fig. 46). These figures seem almost inescapably the heroes of the painting. Indeed in the early sources the altarpiece is often called the picture of Adam and Eve.[54]

119

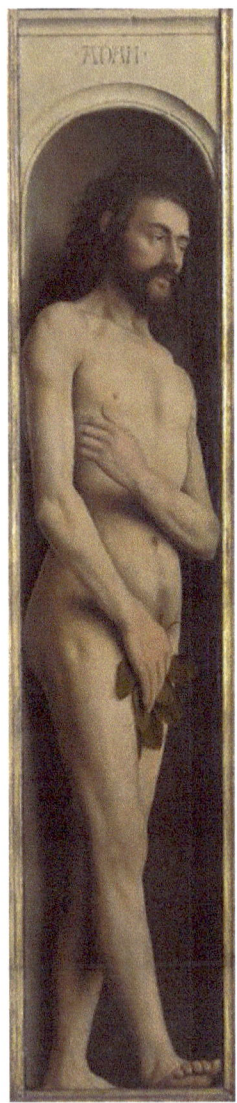 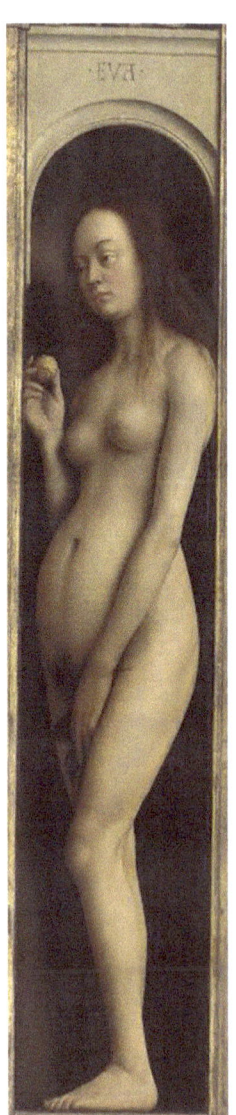

Fig. 46. Hubert and Jan van Eyck, Altarpiece, detail, Adam and Eve. Ghent, St. Bavo.

One final point about the lower zone: it too divides into two parts, with a long central panel and two pairs of framing panels on each side. And whereas the central panel shows its figures in loose affiliation in various stationary groups, as if they were the building blocks, solid and firm, that constituted the state of civilized humanity, the framing panels show large figures in motion, moving from the outside in. Hermits and pilgrims, knights and judges: these are the trustees, guardians, defenders and keepers of the state ensconced in between them, presented as pendants, spiritual and material.

I would like to suggest that the Ghent Altarpiece offers us, in a near-contemporary visual structure — albeit cast in the form of holy image — the code that informed the precise choice of elements in the room or rooms of the castle at Hesdin that we have been speaking about. It is this pairing of framing panels, and particularly the juxtaposition of hermits and knights, that is reflected at Hesdin, and the parallelism, I would argue, was meaningful. The hermit figure, the image of otherworldly beneficence, together with the Jason cycle, as the expression of the new knightly ideal of the Burgundian court, constituted a visualization of the spiritual and material stewardship of the Burgundian state. Thus it is possible, or even likely, that this much commented-on ensemble in Hesdin was once more of the conceptual heart of the castle than we had thought. This would also go some way toward explaining the presence of the climatological effects, often taken in the realm of literature as a sign of the power of the ruler.

The Wool Trade

AS CULTURAL FORMS with links to Philip the Good, the Ghent Altarpiece, the Order of the Golden Fleece and Hesdin may seem only proximate in chronology and context, but there

is one further level of connectedness that I would suggest now in bringing this chapter to a close. It stems partly from a conundrum — seemingly minor in this context — and partly from a few stray thoughts that have already been voiced in the literature, which I would like draw out and to amplify. The conundrum has to do with the figures of Adam and Eve on the altarpiece, our naked earthly parents placed on the same level as the richly bejeweled and robed heavenly figures. Otto Pächt has discussed *in extenso* the difficulties inherent in the present placement of the figures, which, to some scholars, has called into question the coherence of the whole.[55]

The angle at which I would like to come at this problem, however, is provided by the remarks of Elisabeth Dhanens and Thomas Tolley, both of whom saw in the Ghent Altarpiece

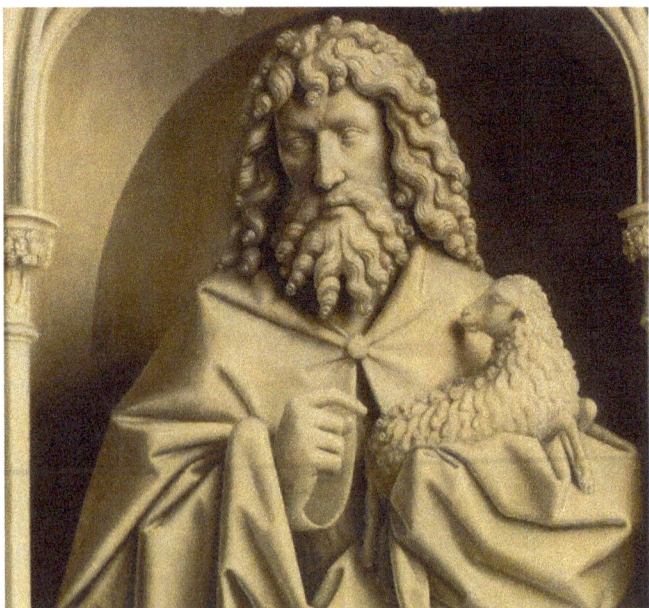

Fig. 47. Hubert and Jan van Eyck, Altarpiece, detail, John the Baptist. Ghent, St. Bavo.

the stamp of a fundamental reality of Valois Burgundy. In her monograph on the altarpiece, Dhanens astutely drew attention to this reality with regard to the choice of John the Baptist as patron saint of the city itself and of the cathedral for which the altarpiece was made and as object of special devotion to the patron who commissioned it: "Ghent's patron saint was John the Baptist. The connection between his attribute, the Lamb of God (Fig. 47), and the wool industry, which was one of the main sources of the city's prosperity, is clear."[56] In his essay on Jan van Eyck, Thomas Tolley extends this insight to the central panel of lower register: "Whatever the devotional, Christological and liturgical aspects of the Adoration of the Lamb, for the population of Ghent the image of the lamb as the centre of attention — the lamb itself maturer than in conventional Christian iconography and clearly painted to draw attention to its thick, wooly fleece — would have presented a clear political message (Fig. 45). The very prosperity of the city depended on a continuous supply of high-quality wool, to be woven into luxury cloth."[57]

Economic historians have written about these circumstances at length, and we can trace the lineaments of their consensus with two propositions that follow the essential fault lines along which this fraught economy was always on the verge of fracturing.

One: the fault line between the lowland cities and their overlord, the duke of Burgundy. Ever since the late Middle Ages and in a rising curve, the cloth industry was the basis of the prosperity of the Burgundian lowlands, including Ghent, Lille and Ypres (even Hesdin), whose local governing bodies and citizens often found themselves at odds with the ducal court, and with whom they were not averse to expressing their disagreement in sometimes violent ways.[58] The particular moment of crisis in the late 1420s and early 1430s "united Philip

the Bold and his traditionally independent drapery town subjects as no previous issue had," to invoke the economic historian John H. A. Munro.[59] But the situation was full of tension and had the potential to fall apart at any time.

Two: the fault line between Burgundy and England. The Burgundian cloth industry was predicated on a raw material not produced locally — sheep's wool — which was grown in England and imported into Burgundy.[60] As a matter of fact, over the course of the years it had become clear that only England had the capacity to produce wool of the highest quality, which was the most desirable since it resulted in the highest grade of end product. The tensions inherent in the relationship between England and Burgundy were ongoing, and they came increasingly to express themselves in two ways: in terms of access on the part of Burgundy to the English market, which became formalized in an institution called the Company of the Staple, housed at Calais, a permanent trading company under royal charter where the actual exchanges were made; and in monetary terms, that is, in terms of the sheer act of payment, with the dukes of Burgundy and their citizens favoring a system of credit that allowed for flexibility and the expansion of markets, and the English kings and their minions, preferring cold hard cash in the form of gold bullion.[61] One of the crisis points in this constant struggle occurred in 1429–30, a year or so before the marriage of Philip and the institution of the Golden Fleece, and three years or so before the installation of the altarpiece in Ghent. In these years, the English parliament issued legislation known as the Bullion and Partition Ordinances, which required the entire price of wool to be paid in bullion, thus effectively ending the use of credit for the purchase of wool at Calais.[62]

These issues of wool and cloth were pervasive and inescapable in the very milieu and among the people on which we

have focused, the source of significant satisfaction and yet also considerable anxiety. It thus seems highly probable that the wool trade — whose rising crisis threatened the foundations of the Burgundian state — and the image of the fleecy sheep (or ram or lamb, to take in its variants), which gained a sudden new-found currency at precisely this time, were connected in some way more profound than mere chronological proximity.[63] Yet I think we would be hard pressed to define the connection unequivocally. Without putting too fine a point on it, let me offer the following concluding proposition to argue for a specific set of relationships almost in the manner of a conversation. In order to conduct it let us simply substitute, in our mind's eye, the concept and image of wool, and its necessary corollary, woven cloth, for the sheep (or lamb or ram), in a few final observations on the works on which we have focused in this essay. The result will be a dialogue of assertion and response in three parts.

The first part goes to Philip the Good in the founding of the Order of the Golden Fleece in 1430. Speaking from the elemental, constitutive script of Jason and the Argonauts, one might summarize its essential point as this: "Wool is gold. It is money. It is our money, even if it now resides in a distant land, like England.[64] And like the Argonauts in search of the Golden Fleece, we will go and get it, using every means in our quite considerable arsenal to do so, and we will succeed, since we are great, and cunning, and powerful."[65] This is wool seen as the currency of politics and the economy, by a ruler who sought to put on public display the goals and ambitions of the small circle of men with whom he wanted to be most closely associated. The first assertion: "Wool is the form and substance of a single preponderant authority."

The response comes from a city, or perhaps more accurately, one exponent of the ruling class who sought to preserve an

efficacious relationship with power but also to broaden and redefine it. The Ghent Altarpiece has been seen through the ages as supremely a work of theology in the service of religion and the liturgy, but a rough sketch of another narrative might go something like this: "Time immemorial (i.e., God) ordained wool (not Christ, but wool) to come to us, but wool is also inscribed in the very fabric of history. Nakedness was the natural state of our race up to the time of our first parents' first sin, but this sin made nakedness impossible (Gen 3:6-7: 'and she took of the fruit thereof, and did eat, and gave to her husband who did eat. And the eyes of both were opened… and they perceived themselves to be naked'). It was Adam and Eve's singular contribution to history to make clothing, and hence cloth, weaving and wool, the first and absolute necessity of humanity. Time immemorial and history played their role, but now wool resides with us, in our midst, as lynchpin and foundation of our greatness. Through it we are saved. We adore it. Wool, therefore, is not your responsibility alone to sustain, Philip. It belongs to all of us, but we should hasten to add that among us you will always have a privileged place." The response: "Indeed wool is a cosmic context of human endeavors."[66]

Where does this leave the garden at Hesdin? William Caxton's account in 1477 of the weather effects in the room as a manifestation of the magical powers of Medea strikes me as too narrowly iconographic and more likely the product of an explanation in the service of tourism than an active ingredient in the program of Philip the Good or of any earlier time. I am inclined to see these effects as an expression of the power of ruler whose immediate impact on the viewer would have been experienced directly, as the literary tradition teaches us. I am also inclined to see in this experience an element of humor, although its valence at this juncture is still difficult to pinpoint:

was this the kind of buffoonery that led to belly laughs or was it tinged with cruelty as some have suggested?

But against this backdrop, there is an aspect of this room — what happened here, what was affected, what changed — that comes, perhaps, more sharply into focus. Doubtless the individual changed, but more so and more permanently the very garments that he or she wore. The room or rooms of Jason and the hermit were awash in the disarrangement of cloth. Clothing was transformed here by the effects that were experienced, which included wind and snow, but above all rain, in the form of water cascading from above and being shot out from below. The wetting of clothing drew attention to its very substance — cloth, its deformation evoked its formation — weaving, not to mention the necessity of the changing of it, the exchanging of it, and one can only surmise at considerable expense given the nature of the costume of the court of the time — the economy. The entire cycle implicit in our analysis up to this point, therefore, was activated at Hesdin. It was set into motion as performance, in the midst of the politically animated ingredients of Jason and the hermit, that is to say at the behest of the ruler, which leads us to one final point.

As the ruler's residence, I have no doubt that Hesdin aligned with the sentiments expressed in the statement of the Golden Fleece, but it was not perfectly conforming to them. It occupied a slightly different ground, tending to belief but also tinged with skepticism. By rendering as entertainment the very means by which institutions presented themselves, in images, the ensemble laid claim to seeing them for what they really were: representation. The environment thus defined became the world of cognoscenti, at whose disposal it had been put for the purposes of delight. Last therefore but not least: "This is wool as pleasure."

It is right to end on a performative note, since the point is that the aforementioned are not simply works of theology, politics or

garden design but modalities of performance in which or though which issues of urgency were channeled.[67] And in the end I cannot help but connect them to the culture as whole on a broader scale, in the single most potent outward sign of the existence of the Burgundian state, which was also a phenomenon of electrifying visual pleasure. Cloth is everywhere in art, but perhaps nowhere more so than in fifteenth-century Burgundy, where it appears abundantly, beautifully, exuberantly, for the first time (Fig. 48).[68] Cloth cascades to the very forefront of our consciousness everywhere in this culture as living presence, from the extraordinary

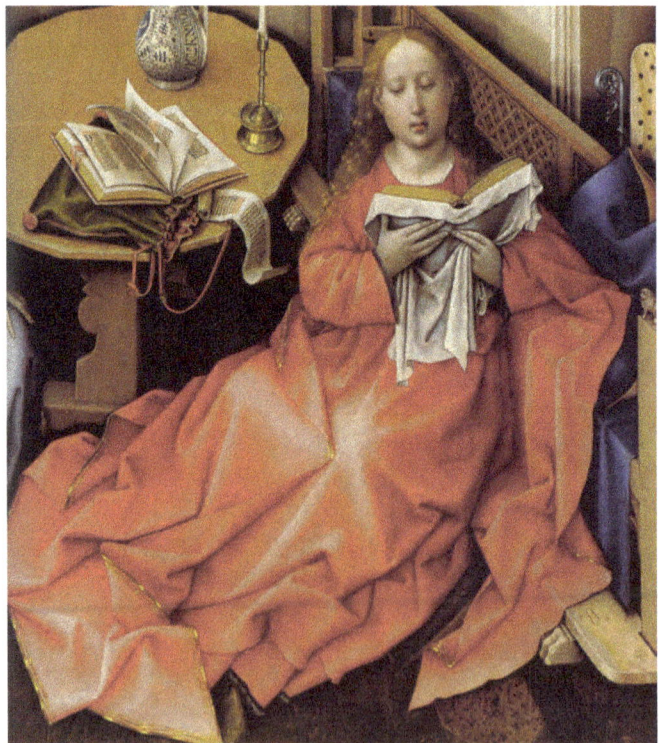

Fig. 48. Robert Campin, Merode Altarpiece, detail, Virgin of Annunciation. New York, Metropolitan Museum of Art, The Cloisters.

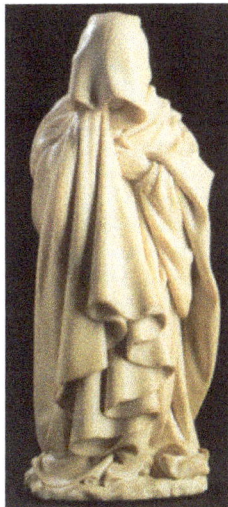

and haunting swathing of the alabaster mourners carved by Claus Sluter for the Tomb of Philip the Bold (1384–1410) in the Chartreuse de Champmol, Dijon, to the exuberant and effusive unfurling that occurs in the Decent from the Cross by Roger van der Weyden now in the Prado (Figs. 49 and 50). It is a veritable *lingua franca* of visual experience whose force was widely felt.

Fig. 49 (above). Claus Sluter, Pleurant, Tomb of Philip the Bold. Dijon, Chartreuse de Champmol. Fig. 50 (below). Roger van der Weyden, Descent from the Cross, detail. Madrid, Prado.

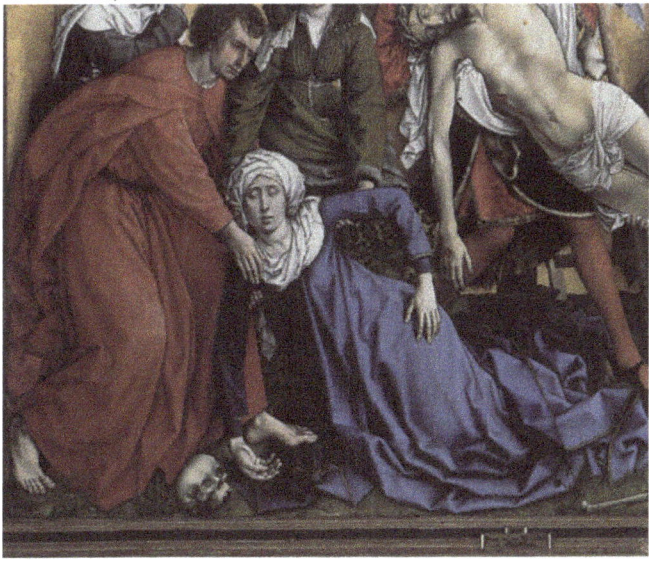

Notes

1. As cited by James Elkins, "On the Conceptual Analysis of Gardens," *Journal of Garden History* 13 (1993): 189. This essay reappears in edited form in Elkins, *Our Beautiful, Dry and Distant Texts: Art History Writing* (University Park: Pennsylvania State University Press, 1997), 254–71, and in *Landscape Theory,* ed. DeLue and Elkins, 69–86.

2. Vitruvius, *De architectura*, 2.1–2.

3. *Scale and Geographic Inquiry: Nature, Society, and Method*, ed. Eric Sheppard and Robert B. McMaster (Oxford: Blackwell Publishing Ltd., 2004).

4. See below, n. 23.

5. See the essential articles on Hesdin by Anne Hagopian van Buren: "The Model Role of the Golden Fleece," *The Art Bulletin* 61 (1979): 359–76; idem, "Reality and Literary Romance in the Park of Hesdin," in *Medieval Gardens*, ed. Elisabeth MacDougall (Washington, DC: Dumbarton Oaks, 1986), 115–34; idem, "Un Jardin d'amour de Van Eyck dans une commande ducale," *La Revue du Louvre et des musées de France* 35 (1985): 185–92; and idem, "Images monumentales de la Toison d'Or: Aux murs du chateau de Hesdin et en tapisserie," in *L'ordre de la Toison d'Or de Philippe le Bon à Philippe le Beau (1430–1505): Idéal ou reflet d'une société?*, ed. Pierre Cockshaw and Christiane Van den Bergen-Pantens (Turnhout: Brepols, 1996), 226–33. In addition, Michel Brunet, "Le parc d'attractions des ducs de Bougogne à Hesdin," *Gazette des Beaux Arts* 78 (1971): 331–42; Danielle Queruel, "Le jardin d'Hesdin et les jardins de la cour de Bourgogne," *Le jardin médiéval: Les Cahiers de l'abbaye de Saint-Arnoult* 3 (1990); Birgit Franke, "Gesellschaftsspiele mit Automaten — 'Merveilles' in Hesdin," *Marburger Jahrbuch für Kunstwissenschaft* 24 (1997): 135–58; Jeremy A. Ashbee, "'The Chamber called Gloriette': Living at Leisure in Thirteenth- and Fourteenth-Century Castles," *Journal of the British Archaeological Association* 157 (2004): 17–40, esp. 32; François Ducepp-Lamarre, "The Ducal Residence at Hesdin and Its Place in Courtly

Arts under Philip the Bold and His Son (1384–1419), in *Art from the Court of Burgundy 1364–1419*, Musée des Beaux-Arts de Dijon, May 28–September 15, 2004/The Cleveland Museum of Art, October 24, 2004–January 9, 2005 (Paris: Réunion des musées nationaux, 2004; Cleveland: The Cleveland Museum of Art, 2004), 160–61; and Sharon Farmer, "Aristocratic Power and the 'Natural' Landscape: The Garden Park at Hesdin, c.1291–1302," *Speculum* 88 (2013): 644–80. Also see below, nn. 8, 9 and 10. Anne Élisabeth Cléty, *Les machines extraordinaires d'Hesdin*. Sucellus: *Dossiers Archéologiques, Historiques et Culturels du Nord-Pas-de-Calais* 44 (1997) was unavailable to me.

6. Georges Doutrepont, "Les historiens du banquet des voeux du Faisan," *Mélanges d'histoire offerts à Charles Moeller* (Louvain: Bureau du Recueil, 1914), 1:654–70; Otto Cartellieri, *The Court of Burgundy: Studies in the History of Civilization* (New York: Haskell House, 1970), 135–63; Richard Vaughan, *Valois Burgundy* (London: Allen Lane, 1975), 162–93; idem, *Philip the Good: The Apogee of Burgundy* (Woodbridge, Suffolk: Boydell Press, 2002), 136–63; A.J. Armstrong, "The Golden Age of Burgundy: Dukes That Outdid Kings," in *The Courts of Europe: Politics, Patronage and Royalty 1400–1800*, ed. A.G. Dickens (London: Thames and Hudson, 1977), 55–75; Jeffrey Chipps Smith, "The Artistic Patronage of Philip the Good, Duke of Burgundy," PhD dissertation, Columbia University, 1979, 142ff. (Feast of the Pheasant), 168ff. (Entry into Ghent); Agathe Lafontaine-Martel, *Fête noble en Bourgogne au XVe siècle: Le Banquet du Faisan (1454). Aspects politiques, sociaux et culturels* (Montreal: Vrin, 1984); D.H. Eichberger, "The *Tableau Vivant*: An Ephemeral Art Form in Burgundian Civic Festivities," *Parergon. Bulletin of the Australian and New Zealand Association for Medieval and Renaissance Studies* n.s. 6a (1988): 37–60; Jeffrey Chipps Smith, "'Venit Nobis Pacificus Dominus': Philip the Good's Triumphal Entry into Ghent in 1458," in *"All the World's a Stage…": Art and Pageantry in the Renaissance and Baroque*, ed. Barbara Wisch and Susan Scott Munshower (University Park: Pennsylvania State University Press, 1990), 1:258–90; Pierre Cockshaw, "Les voeux du Faisan: Examen des différentes versions du texte," in *L'ordre de la Toison d'or*, 115–17; Marina Belozerskaya, *Rethinking the*

Renaissance: Burgundian Arts across Europe (New York: Cambridge University Press, 2002), 67–75; Arjo Vanderjagt, "The Princely Culture of the Valois Dukes of Burgundy," in *Princes and Princely Culture 1450–1650*, ed. Martin Gosman, Alasdair MacDonald and Arjo Vanderjagt (Leiden: Brill, 2003), 51–79, with 55 for the Entry into Ghent and 60–62 for the Feast of the Pheasant; *Staging the Court of Burgundy: Proceedings of the Conference, "The Splendour of Burgundy,"* ed. Wim Blockmans, Till-Holger Bochert, Nele Gabriëls, Johan Oosterman and Anne van Oosterwijk (London: Harvey Miller, 2013). On ceremonies, see also the related study of David Nicholas, "In the Pit of the Burgundian Theater State: Urban Traditions and Princely Ambitions in Ghent, 1360–1420," *City and Spectacle in Medieval Europe*, ed. Barbara A. Hanawalt and Kathryn L. Reyerson (Minneapolis: University of Minnesota Press, 1994), 271–95; Birgit Franke, "Alttestamentliche Tapisserie und Zeremoniell am burgundischen Hof," in *Zeremoniell als höfische Ästhetik in Spätmittelalter und Früher Neuzeit* (Tübingen: Max Niemeyer, 1995), 332–52; Christina Hofmann-Randall, "Die Herkunft und Tradierung des Burgundischen Hofzeremoniells," *Zeremoniell also höfische Ästhetik*, 150–56; Peter Arnade, *Realms of Ritual: Burgundian Ceremony and Civic Life in Late Medieval Ghent* (Ithaca, NY: Cornell University Press, 1996); and Jesse D. Hurlbut, "Immobiliers et cérémonies urbain: Les Joyeuses Entrées Françaises à la fin du moyen age," *Civic Ritual and Drama*, ed. Alexandra F. Johnston and Wim N.M. Hüsken (Amsterdam: Rodopi, 1997), 125–42.

7. A debt to the work of Anne Hagopian van Buren, who devoted a large part of her scholarly life to Hesdin, must be acknowledged; see above, n. 5.

8. Pieter Martens, "La destruction de Thérouanne et d'Hesdin par Charles Quint en 1553," *La fortresse à l'épreuve du temps: Destruction, dissolution, dénaturation, XIe–XXe siècle*, ed. Gabriel Blieck, Philippe Contamine, Christian Corvisier, Nicolas Faucherre and Jean Mesqui (Paris: Editions du CTHS, 2007), 63–117.

9. J. Lestocquoy, "Les origins d'Hesdin-le-vieux," *Revue du Nord* 32 (1950): 94–104; Charles Petit, "Vieil-Hesdin: L'exploration

archéologique d'une Ville disparue," *Revue du Nord* 59 (1977): 545–72.

10. Marguerite Chargeat, "Le Parc d'Hesdin: Création monumentale du XIIIe siècle. Ses origines arabes. Son influence sur les miniatures de l'épître d'Othéa," *Bulletin de la Société de l'Histoire de l'Art Français* 1950 (1951): 94–106.

11. Van Buren, "Reality and Literary Romance," 117.

12. Ibid., 118–19, for a discussion of the archival sources. The case for Mediterraenean prototypes has been made again by Sharon Farmer, "Aristocratic Power," but unconvincingly.

13. The description is derived from Van Buren, "Reality and Literary Romance," 118–25.

14. Ibid., 126–29.

15. The features mentioned here are but a few of those recorded in the sources and discussed in the literature on Hesdin; for a more detailed treatment of the ensemble, see the works cited in n. 5, especially the studies by Van Buren and Franke.

16. Louise Roblot-Delondre, "Un Jardin d'Amour de Philippe le Bon," *Revue archéologique* 1 (1911): 420–29; Paul Post, "Ein verschollenes Jagdbild des Jan van Eyck," *Jahrbuch des preussischen Kunstsammlungen* 52 (1931): 120–32; Chipps Smith, "The Artistic Patronage," 271–75; Van Buren, "Un Jardin d'amour," 185–92. On the copy in Dijon, see the entry of François Duceppe Lamarre in *Art from the Court of Burgundy 1364–1419*, 162–63.

17. Van Buren, "Reality and Literary Romance," 124.

18. Van Buren, "The Model Role," 359–76.

19. The point is made by Franke, "Gesellschaftsspiele," 141.

20. Léon Emmanuel Laborde, *Les Ducs de Bourgogne: Études sur les letters, les arts et l'industrie pendant le XVè siècle*, Pt. 2.1 (Paris: Plon Frères, 1849), 268–69.

21. But see the remarks of Van Buren, "Images monumentales de la Toison d'Or," 227.

22. Prologue to *The Historie of Jason* published by William Caxton in 1477, as reproduced in W.J.B. Crotch, *The Prologues and Epilogues of William Caxton* (London: Early English Text Society, 1928), 33–34.

23. James Douglas Bruce, "Human Automata in Classical Tradition and Medieval Romance," *Modern Philology* 10 (1912–13): 511–26; M.R. Cohen and I.E. Drabbin, *A Source Book in Greek Science* (Cambridge, MA: Harvard University Press, 1958), 326–51; A.G. Drachman, *The Mechanical Technology of Greek and Roman Antiquity: A Study of Literary Sources* (Madison: University of Wisconsin Press, 1963); Silvio Bedini, "The Role of Automata in the History of Technology," *Technology and Culture* 5 (1964): 24–42; Derek J. DeSolla Price, "Automata and the Origins of Mechanism and Mechanistic Philosophy," *Technology and Culture* 5 (1964): 9–23; William Eamon, "Technology as Magic in the Late Middle Ages and the Renaissance," *Janus: Revue internationale de l'histoire des sciences, de la médecine, de la pharmaire, et de la technique* 70 (1983): 171–212; Henner v. Hesberg, "Mechanische Kunstwerke und ihre Bedeutung für die höfische Kunst des frühen Hellenismus," *Marburger Winckelmann-Program* (1987): 47–72; and Summers, *Real Spaces*, 326–28. See also the discussion of Franke, "Gesellschaftsspiele," 137–38, 144–50; and Stephen Perkinson, "Engin and Artifice: Describing Creative Agency at the Court of France, ca. 1420," *Gesta* 41 (2002): 51–67.

24. Gerard Brett, "The Automata in the Byzantine Throne of Solomon," *Speculum* 29 (1954): 477–87; James Trilling, "Daedalus and the Nightingale: Art and Technology in the Myth of the Byzantine Court," in *Byzantine Court Culture from 829–1204*, ed. Henry Maguire (Cambridge, MA: Harvard University Press, 1997), 217–30; Eunice Dauterman Maguire and Henry Maguire, *Other Icons*, 42–46.

25. Hahnloser, *Villard de Honnecourt*, 259–63; Roland Bechmann, *Villard de Honnecourt: La Pensée technique au XIIIe siècle et sa communication* (Paris: Picard, 1991), 295–303.

26. A rare surviving example of a late medieval device, as may have served to entertain the assembled at the court of Burgundy, is a table fountain in Cleveland; see Stephen N. Fliegel, "The Cleveland Table Fountain and Gothic Automata," *Cleveland Studies in the History of Art* 7 (2002): 6–49; Van Buren, "Reality and Literary Romance," 128; and Klaus Oschema, "Liquid Splendour – Table Fountains and Wine-Fountains at the Burgundian Courts," in *Staging the Court of Burgundy*, 133–40.

27. Price, "Automata," 9–23.

28. Suetonius, Nero 31. See William MacDonald, *The Architecture of the Roman Empire* 1. *An Introductory Study*, rev. ed. (New Haven: Yale University Press, 1982), 31–32, 42; Axel Boethius, *The Golden House of Nero: Some Aspects of Roman Architecture* (Ann Arbor: University of Michigan Press, 1960), 121–28.

29. Mikhail Bakhtin, *Rabelais and His World*, trans. Helene Iswolsky (Cambridge, MA: MIT Press, 1965), 368–436; Johan Huizinga, *Homo Ludens: A Study of the Play-Element in Culture* (Boston: Beacon Press, 1955); idem, *The Autumn of the Middle Ages*, trans. Rodney J. Payton and Ulrich Mammetzsch (Chicago: University of Chicago Press, 1996); Aaron Gurevich, *Medieval Popular Culture: Problems of Belief and Perception*, trans. János M. Bak and Paul A. Hollingsworth (Cambridge: Cambridge University Press, 1988); Paul Lehmann, *Die Parodie im Mittelalter* (Stuttgart: Anton Hiersemann, 1963); Martha Bayless, *Parody in the Middle Ages: The Latin Tradition* (Ann Arbor: University of Michigan Press, 1996). Mention may be made in addition of *A Cultural History of Humour from Antiquity to the Present Day*, ed. Jan Bremmer and Herman Roodenburg (Cambridge: Polity Press, 1997); *Laughter in the Middle Ages: Epistemology of a Fundamental Human Behavior, Its Meaning and Consequences*, ed. Albrecht Classen (Berlin: Walter de Gruyter, 2010); *The Playful Middle Ages: Meanings of Play and Plays of Meanings. Essays in Memory of Elaine C. Block*, ed. Paul Hardwick (Turnhout: Brepols, 2011). See also the contribution of John R. Clarke, albeit for the earlier period: *Looking at Laughter:*

Humor, Power, and Transgression in Roman Visual Culture, 100 B.C.–A.D. 250 (Berkeley: University of California Press, 2007); as well as the classic text of Henri Bergson, *Laughter: An Essay on the Meaning of the Comic*, trans. C. Brereton and F. Rothwell (New York: Macmillan, 1911).

30. Lilian M.C. Randall, *Images in the Margins of Gothic Manuscripts* (Berkeley: University of California Press, 1966); Michael Camille, *Image on the Edge: The Margins of Medieval Art* (Cambridge, MA: Harvard University Press, 1992); Jean Wirth, *Les marges à drôleries des manuscrits gothiques, 1250–1350* (Geneva: Librairie Droz, 2008).

31. See, for example, *The Humor of the Fabliaux: A Collection of Critical Essays*, ed. Thomas D. Cooke and Benjamin L. Honeycutt (Columbia: University of Missouri Press, 1974); B. Roy, "L'humor érotique au XVe siècle," in *L'érotisme au moyen age: Études présentées au Troisième Colloque de l'Institut d'études médiévales* (Montreal: Aurore, 1977), 155–64; Thomas D. Cooke, *The Old French and Chaucerian Fabliaux: A Study of Their Comic Climax* (Columbia: University of Missouri Press, 1978); Charles Muscatine, *The Old French Fabliaux* (New Haven: Yale University Press, 1986); Howard Bloch, *The Scandal of the Fabliaux* (Chicago: University of Chicago Press, 1986); Roy J. Pearcy, *Logic and Humor in the Old French Fabliaux: An Essay in Applied Narratology* (Cambridge: D.S. Brewer, 2007); and for additional bibliography, see Anne Elizabeth Cobby, *The Old French Fabliaux: An Annotated Bibliography* (Woodbridge: Tamesis, 2009).

32. Merriam Sherwood, "Magic and Mechanics in Medieval Fiction," *Studies in Philology* 44 (1947): 567–92.

33. Ibid., 568–74. For the text of Conrad of Hildesheim, see *MGH SS* 21(1925), 194. The letter has been translated in Ronald G. Musto, *Medieval Naples: A Documentary History, 400–1400* (New York: Italica Press, 2013), 119–23. See also Tom Peete Cross, "Observations on the Pèlerinage Charlemagne," *Modern Philology* 25 (1927–28), 331–54; and Sharon Kinoshita, "*Le Voyage de Charlemagne*: Mediterranean Palaces in the Medieval French Imaginary," *Olifant* 25 (2006): 255–70.

34. Above, n. 22.

35. Alain Moreau, *Le mythe de Jason et Médée: Le va-nu-pied et la sorcière* (Paris: Belles Lettres, 1994).

36. Van Buren, "The Model Role," 359–76; idem, "Images monumentales de la Toison d'Or," 226–33.

37. Georges Doutrepont, "Jason et Gédéon, patrons de la Toison d'Or," *Mélanges Godefroid Kurth 2: Mémoires littéraires, philologiques et archéologiques* (Paris: Honoré Champion, 1908), 191–208; Luc Hommel, *L'Histoire du Noble Ordre de la Toison d'Or* (Brussels: Éditions Universitaires, 1947); Victor Tourneur, "Les origines de l'ordre de la Toison d'Or et la symbolique des insignes de celui-ci," *Bulletin de la Classe des letters et des sciences morales et politiques, Bruxelles, Académie royale de Belgique* 42 (1956): 300–323; *La Toison d'Or: Cinq Siècles d'Art et d'Histoire, Musée Communal des Beaux Arts, 14 Juillet–30 Septembre 1962* (Bruges: Lanno-Tielt, 1962); Jean-Philippe Lecat, *Le Siècle de la Toison d'Or* (Paris: Flammarion, 1986); *L'ordre de la Toison d'Or, de Philippe le Bon à Philippe le Beau (1430–1505): Idéal ou reflet d'une société?* (Turnhout: Brepols, 1996); D'Arcy J.D. Boulton, "The Order of the Golden Fleece and the Creation of Burgundian National Identity," and Jan R. Veemstra, "'Le prince qui se veult faire de nouvel roy': The Literature and Ideology of Burgundian Self Determination," in *Ideology of Burgundy: The Promotion of National Consciousness 1364–1565*, ed. D'Arcy J.D. Boulton and Jan R. Veemstra (Leiden: Brill, 2006), 21–97 and 195–221; and *Charles the Bold 1433–1477: Splendour of Burgundy*, exh. cat., ed. Gabrielle Keck, Susan Marti and Till Holger-Borchert (Brussels: Mercatorfonds, 2009).

38. Above, n. 37; and Barbara Haggh, "Between Council and Crusade: The Ceremonial of the Golden Fleece in the Fifteenth Century," in *Staging the Court of Burgundy*, 51–58.

39. Doutrepont, "Jason et Gédéon," 196–97.

40. Hommel, *L'Histoire du Noble Ordre*, 14–15; Boulton, "The Order of the Golden Fleece," 74.

41. Doutrepont, "Jason et Gédéon," 196–208.

42. See Guillaume Fillastre, second chancellor of the order, *Le premier (–second) volume de la Toison d'Or* (Paris: Francoys Regnault, 1516[?]); Doutrepont, "Jason et Gédéon," 204–8; Jean de la Croix Bouton, "Un poème à Philippe le Bon sur la Toison d'Or," *Annales de Bourgogne* 42 (1970): 5–29.

43. See above, n. 20.

44. Boulton, "The Order of the Golden Fleece," 66–68; Luc Smolderen, "Médailles et jetons," in *L'ordre de la Toison d'Or, de Philippe le Bon à Philippe le Beau*, 165–83, fig. 1 on 180.

45. It is worthy of note that the Breviary of Philip the Good (Brussels, Royal Library, MS 9511, 1445–66) contains an image of the duke kneeling, with the emblem of the Order of the Golden Fleece hanging from his neck, beside a figure of St. Andrew, as an illustration to the Office of St. Andrew.

46. Doutrepont, "Jason et Gédéon," 198; Boulton, "The Order of the Golden Fleece," 66–68.

47. On the iconography of St. Andrew, see Louis Réau, *Iconographie de l'Art Chrétien* 3.1 (Paris: Presses Universitaires de France, 1958), 76–84.

48. Réau, *Iconographie*, 101–15.

49. On this topic, see the discussions of Erwin Panofsky, *Early Netherlandish Painting: Its Origins and Character* (New York: Icon Editions, 1971), 1:225–27; 2, pl. 147; Lotte Brand Philip, *The Ghent Altarpiece and the Art of Jan van Eyck* (Princeton: Princeton University Press, 1971), 187–90; Elisabeth Dhanens, *Van Eyck: The Ghent Altarpiece* (London: Allen Lane, 1973), 69–75.

50. See, for example, Panofsky, *Early Netherlandish Painting*, 1:205–46; 2, pls. 142–51; Philip, *The Ghent Altarpiece*; Dhanens, *Van Eyck: The Ghent Altarpiece*; Dana Goodgal, "The Iconography of the Ghent Altarpiece," PhD diss., University of Pennsylvania, 1981; Carol Purtle, *The Marian Paintings of Jan van Eyck* (Princeton: Princeton University

Press, 1982), 16–40; Otto Pächt, *Van Eyck and the Founders of Early Netherlandish Painting*, ed. Maria Schmidt Dengler, trans. David Britt (London: Harvey Miller, 1994), 119–70; *Early Netherlandish Paintings: Rediscovery, Reception and Research*, ed. Bernhard Ridderbos, Anne van Buren and Henk van Veen (Los Angeles: The J. Paul Getty Museum, 2005), 42–59; Linda Seidel, "Visual Representation as Instructional Text: Jan van Eyck and *The Ghent Altarpiece*," in *Making Knowledge in Early Modern Europe: Practices, Objects, and Texts, 1400–1800*, ed. Pamela H. Smith and Benjamin Schmidt (Chicago: University of Chicago Press, 2007), 45–67; Hugo van der Velden, "The Quatrain of the Ghent Altarpiece," *Simiolus* 35 (2011): 5–39 (with a response by Volker Herzner and additional comment by Van der Velden in *Simiolus* 35 (2011); Albert Chatelet, *Hubert et Jan van Eyck: Créateurs de l'Agneau Mystique* (Dijon: Éditions Faton, 2011). See also the magnificent website, closertovaneyck.kikirpa.be, for images, details and conservation and condition reports on the painting.

51. Chipps Smith, "The Artistic Patronage of Philip the Good"; and Barbara Haggh, "The Mystic Lamb and the Golden Fleece: Impressions of the Ghent Altarpiece in Burgundian Music and Culture," *Revue belge de musicologie* 61 (2007), 5–59.

52. Panofsky, *Early Netherlandish Painting*, 1:205–46; Dhanens, *Van Eyck: The Ghent Altarpiece*, 88–125; Pächt, *Van Eyck*, 119ff.

53. J.R.J. van Asperen de Boer, "A Scientifc Reexamination of the Ghent Altarpiece," *Oud Holland* 93 (1979): 141–215; Pächt, *Van Eyck*, 119–70.

54. Pächt, *Van Eyck*, 162–70. According to Goodgal, these figures are "earthbound and quite chilly"; *The Iconography of the Ghent Altarpiece*, 329. Huizinga, *The Autumn of the Middle Ages*, 337: "The eye continues to be drawn to the margin: to Adam and Eve and to the portraits of the donors." See also the study of Linda Seidel, "Adam and Eve: Shameless First Couple of the Ghent Altarpiece," *Different Visions: A Journal of New Perspectives on Medieval Art* 1 (2008): 1–18.

55. Pächt, *Van Eyck*, 123–70; Philip, *The Ghent Altarpiece*, 36–52; Goodgal, *The Iconography of the Ghent Altarpiece*, 51–84.

56. Dhanens, *Van Eyck: The Ghent Altarpiece*, 19.

57. Thomas Tolley, "Jan van Eyck and the English," *England and the Continent in the Middle Ages: Studies in Memory of Andrew Martindale. Proceedings of the Harlaxton Symposium*, ed. John Mitchell, assisted by Matthew Moran (Stamford: Shaun Tyas, 2000), 267–97, and 286 for quotation. See also the discussion in Marie Tanner, *The Last Descendant of Aeneas: The Hapsburgs and the Mythic Image of the Emperor* (New Haven: Yale University Press, 1993), 146–53.

58. *Studies in English Trade in the Fifteenth Century*, ed. Eileen Power and M.M. Postan (London: Routledge, 1933), 39–90; John H.A. Munro, *Wool, Cloth, and Gold: The Struggle for Bullion in Anglo-Burgundian Trade 1340–1428* (Brussels: Éditions de l'Université de Bruxelles, 1972); idem, *Textiles, Towns and Trade: Essays in the Economic History of Late-Medieval England and the Low Countries* (Aldershott, Hampshire: Variorum, 1994); T.H. Lloyd, *The English Wool Trade in the Middle Ages* (Cambridge: Cambridge University Press, 1977); and Walter Prevenier and Wim Blockmans, *The Burgundian Netherlands* (Cambridge: Cambridge University Press: 1986), 70–96.

59. Munro, *Wool, Cloth, and Gold*, 93.

60. Ibid., passim; Lloyd, *The English Wool Trade*, 1–24.

61. Munro, *Wool, Cloth, and Gold*, 38–41; Lloyd, *The English Wool Trade*, 257–87.

62. Munro, *Wool, Cloth, and Gold*, 65–92; Lloyd, *The English Wool Trade*, 257–62; Jenny Kermode, *Medieval Merchants: York, Beverly and Hull in the Later Middle Ages* (New York: Cambridge University Press, 1998), 165–66.

63. W. Smith, *The Golden Fleece, wherein is related the Riches of English Wools in its manufacturers* (London: I. Grismond, 1656).

64. Compare the oft-cited passage of Dryden's, quoted at the beginning of this chapter, "Though Jason's Fleece was fam'd of old/The

British wool is growing gold" (King Arthur, I, 544).

65. It is interesting in this context to recall one of the Latin devices attached to the Order of the Golden Fleece: *Pretium laborum non vile* (Not a bad reward for labor).

66. See the suggestive remarks of Penny Howell Jolly, "More on the van Eyck Question: Philip the Good, Isabelle of Portugal and the Ghent Altarpiece," *Oud Holland* 101 (1987): 237–53.

67. See also James J. Bloom, "Performance as Paradigm in the Visual Culture of the Burgundian Court," in *Staging the Court of Burgundy*, 143–47.

68. Note the remarks of Lisa Monnas, "Silk Textiles in the Paintings of Jan van Eyck," in *Investigating Jan van Eyck*, ed. Susan Foister, Sue Jones and Delphine Cool (Turnhout: Brepols, 2000), 147–62: "Scarlet features prominently in the work of Jan van Eyck, who not only portrayed his patrons weaving it, but positively celebrated this locally produced fabric by clothing the Virgin in several of his Marian paintings as well as the figure of God in the interior of the Ghent Altarpiece in scarlet. By doing this he simultaneously complimented his fellow countrymen and was able to explore the obvious possibilities of this brilliant red cloth for allusions to the Passion of Christ and to the Eucharist" (147). Additionally: W. Wescher, "Fashions and Textiles at the Court of Burgundy," *CIBA Review* 51 (1946): 1830–68; Robert L. Wyss, "The Dukes of Burgundy and the Encouragement of Textiles in the Netherlands," *Connoisseur* 194 (1977): 164–71; Lisa Monnas, "Contemplate What Has Been Done: Silk Fabrics in Paintings by Jan van Eyck," *Hali* 60 (1991): 103–28; *Encountering Medieval Textiles and Dress: Objects, Texts, Images*, ed. Desirée Koslin and Janet E. Snyder (New York: Palgrave, 2002), 173–94; Belozerskaya, *Rethinking*, 104–25; Margaret L. Goehring, "The Significance of Cloth-of-Gold Borders in Burgundian and Post-Burgundian Manuscript Illumination in the Low Countries," *Oud Holland* 119 (2006): 22–41; idem, "The Representation and Meaning of Luxurious Textiles in Franco-Flemish Manuscript Illumination," in *Weaving, Veiling, and Dressing: Textiles and Their Metaphors*

in the Late Middle Ages, Medieval Church Studies 12, ed. Kathryn M. Rudy and Barbara Baert (Turnhout: Brepols, 2007), 121–55; Lisa Monnas, *Merchants, Princes and Painters: Silk Fabrics in Italian and Northern Paintings 1300–1550* (New Haven: Yale University Press, 2008); *Kleidung im Bild: Zur Ikonologie dargestellter Gewandung*, ed. Philipp Zitzlsperger (Emsdetten: Edition Immorder, 2010). See also Rembrandt Duits, *Gold Brocade and Renaissance Painting: A Study in Material Culture* (London: Pindar Press, 2008).

Fig. 51. Hendrick III van Cleve, Cortile delle statue from view of Vatican, 1589. Brussels, Musées royaux des Beaux Arts de Belgique.

THE *CORTILE DELLE STATUE* IN ROME
COLLECTING FRAGMENTS, INDUCING IMAGES

"The statue now from darkness returns
To see the stronghold of Rome's second life."
— Jacopo Sadoleto, *De Laocoontis statua*

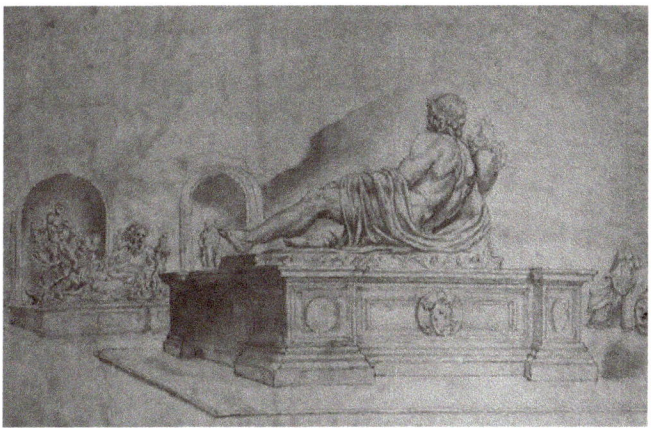

Fig. 52. Marten van Heemskerck, Cortile delle statue, *c.1532. London, British Museum.*

THE EXPERIENCE OF THE PLACE today could hardly be different: propelled through the Vatican Museum by a relentless, surging mass of humanity, the visitor to the *Cortile delle statue* (now called *Il Cortile Ottagono*) instinctively seeks out the corners of the bleached and desiccated courtyard (whose form was fundamentally recast in the eighteenth century), where, in the cooler air and dimmer light, the ancient marble statues have managed to hold on. At an earlier point, in the sixteenth century when it was created, the *Cortile delle statue* was ample and calm, fragrant with citrus, framed by the geometry of classically articulated walls and niches and appointed with beauty in the form of ancient marble fragments, some of which had found their place and others lay waiting, heaped to the side (Figs. 51 and 52).[1] The arrangement of

these ancient stones was never definitively finished (and ultimately profoundly changed). But this could only have added another layer of pleasure to the appreciation, the pleasure of anticipation.

The garden came first, or rather the space that contained it, as an act of pure form. It was set by the architect to serve as the transition from a monumental new courtyard that fundamentally reshaped the idea of the papal palace, the *Cortile del Belvedere,* and a small villa of the recent past, which now seemed old-fashioned.[2] Quickly, however, the collection became the thing. It grew gradually but decisively in the sixteenth century under a sequence of popes from Julius II (1503–13) to Paul III (1534–49). It soon became famous. It has also been the subject of intensive scholarly scrutiny, including an excellent symposium devoted to it in 1992.[3] That there is more to the lay of the land, however, is the point of this chapter, in the spirit of which I will begin with a few words of preface. Although these comments are drawn from a different time and place, they get to the heart of the hypothesis about the *Cortile delle statue* that I will offer here, namely, the capacity of a group of objects to possess something that transcends their particular material existence, something like a soul (to use an archaic metaphor), an intangible presence that gives meaning without ever being manifest to the senses.[4]

It was with considerable pain over three hundred years later that the British Museum in London wrestled with the acquisition of another group of ancient fragments that has gained its own fair share of world renown. The story here is too familiar to repeat, beyond evoking certain salient details: the partial destruction of the great Temple of Athena, the Parthenon, in 1687, when a stray Venetian shell touched off a Turkish powder magazine stored inside; the desire of Lord Elgin, English diplomat and antiquarian, to take drawings and casts of the remaining sculptures in 1801; the remarkable

firman he obtained from Turkish authorities that allowed him to "remove pieces of stone with old inscriptions or figures thereon," without "hindrance or opposition"; the unequivocal recommendation against the restoration of the old stones by Antonio Canova, who declared it a "sacrilege in him or any man to presume to touch them with a chisel"; the transportation of the pieces to England; and finally, their installation in a succession of rooms in the British Museum culminating in an immense wing subsidized by Joseph Duveen, begun in the 1930's but only fully realized in 1962.[5]

Not the least impressive in this fantastic story is its final phase, the Duveen installation, where the fragments of the ancient temple — and there are many of them — have acquired an amplitude of setting that has rarely been accorded to a group of objects in the history of art. And within this amplitude an extraordinary thing has occurred. With the two pediments on the short sides of the room, to the left and right, and the frieze on the long walls, the fragments have assumed something close to their place in the original architectural setting of the temple — but inside out, like an giant negative of an original positive — in a huge gallery, which seems more like atmosphere than space (Figs. 53 and 54).[6]

This contrasts sharply with earlier installations of the same sculptures. To judge from photographs, these installations tried to maintain a semblance of the original order of the pieces. But it was profoundly undercut in the end by the unreal juxtapositions forced on the objects by the exigencies of space. In an installation view of 1920, for example, the discomfort engendered by the setting of the groups of sculptures cheek by jowl trumps the wan effort made to mimic the shape of the pediment by manipulating the heights of the figure fragments.[7] It also contrasts sharply with another contemporary approach embodied in the display of Pergamon in Berlin,

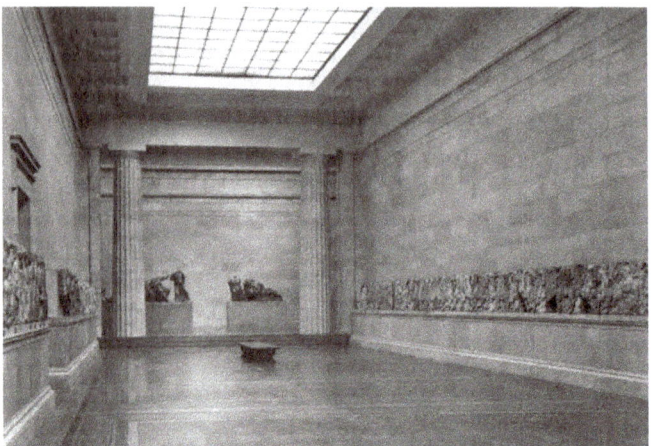

Fig. 53. Duveen Gallery with Parthenon marbles. London, British Museum.

where the larger setting of the figure fragments was elaborately reconstructed.[8] This engenders its own discomfort in a viewer standing in the space: not the discomfort of chaos, but the shock of a most unlikely building being literally, even oppressively there.

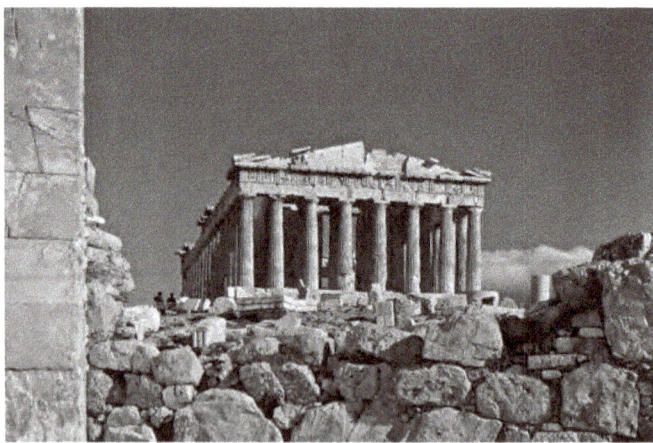

Fig. 54. Parthenon, Athens. Photo: Alison Frantz.

The Duveen installation is neither circumstantial nor literal in its approach. It is metaphorical, and the figure is that of the missing building under a prodigious sky. Unlike the Berlin display, the Duveen installation does not render the source, the site and the architecture irrelevant by an act of blatant replacement. It does not supersede Athens, as Berlin supersedes Pergamon. It evokes the distant place, whose existence is still deemed necessary to an understanding of the figure fragments. The ghost of the Parthenon hovers over the Duveen room. In fact, it is the Duveen room, and by binding the two places, London and Athens, in a bond that is as real as it is intangible, it has also, and insidiously, added another link to a chain that has proven so difficult to break. It is a bond of this sort that my exposition of the *Cortile delle statue* will now seek to uncover.

With the *Cortile delle statue*, we enter the moment of monumental cultural unrest that is the era of Pope Julius II. Julius reigned only briefly, from 1503 to 1513, but managed nonetheless to confound history with an image of the supreme spiritual leader of the West in military garb on horseback. A significant insight into his ambition is given by the twin projects that he assigned his architect of choice, Bramante: namely, the rebuilding of Old St. Peter's and the expansion of the papal palace at the Vatican, both of which were initiated soon after he took office (Figs. 55 and 56).[9] The rebuilding of St. Peter's followed upon earlier efforts of Nicholas V but in an entirely new key. The expansion of the palace took the form of a garden courtyard, the *Cortile del Belvedere*, which flowed northward from the medieval residence in a stepped sequence of three broad platforms to reach a villa built by Innocent VIII (1484–87) at the far edge of the papal property of the Vatican to the north.[10]

In order to make tangible the link between the villa and the garden court, Bramante added a small square courtyard between the two, known today as the Statue Court, the *Cortile*

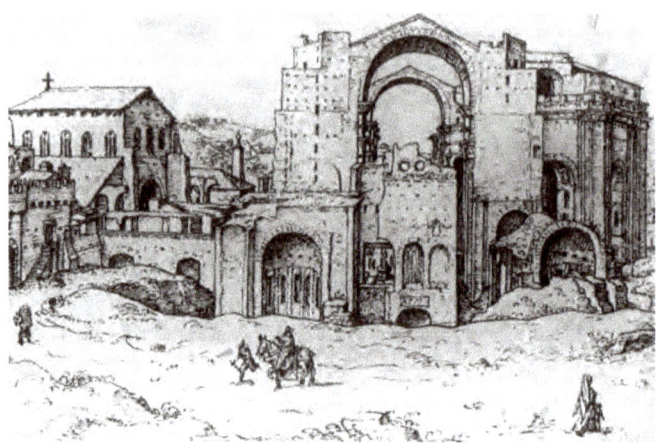

Fig. 55. After Marten van Heemskerck, Old and New St. Peter's, 1538–42. Berlin, Kupferstichkabinett, 79.D.2, vol. 1, fol. 15r.

delle statue. As it stands now, the *Cortile delle statue* is a complex affair of colonnades and vaulted rooms devoted to the display of sculpture (Fig. 57).[11] In its original incarnation it was considerably simpler, a square open space with a rounded niche in each of the four corners of the surrounding wall (Fig. 58). Hans

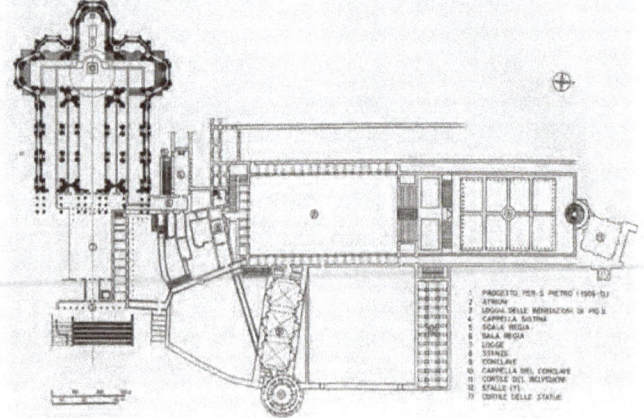

Fig. 56. Reconstruction of Bramante's plan for the Vatican (after Frommel, "I tre progetti," Il Cortile delle statue, fig. 7).

THE CORTILE DELLE STATUE IN ROME

Fig. 57 (above): Cortile delle statue, *Vatican, modern view.*
Fig. 58 (below): Reconstruction of site in the 16th c. (Brummer, The Statue Court in the Vatican Belvedere, *pl. II).*

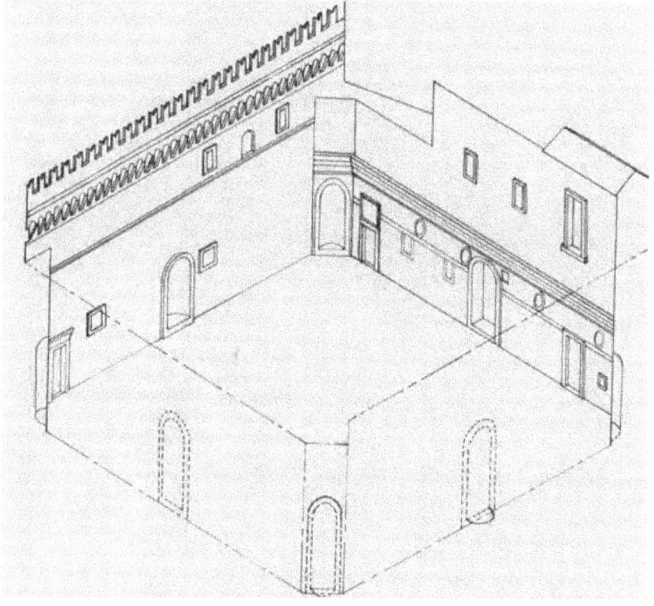

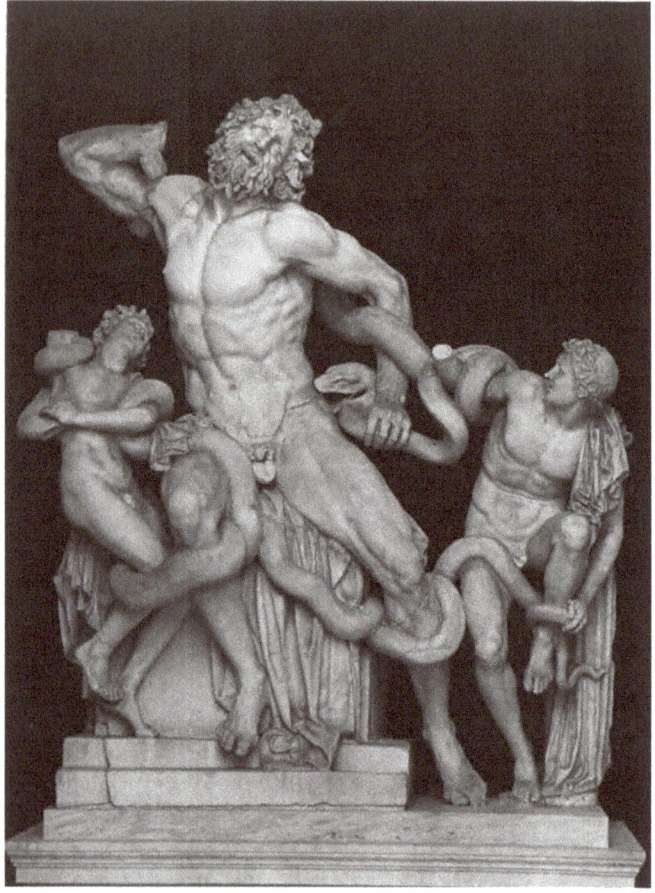

Fig. 59. Laocoon, from the Cortile delle statue. *Vatican Museums.*

Henrik Brummer has raised the possibility that the *Cortile* was not intended originally for sculpture, but given the nature of the evidence, it is difficult to tell.[12]

The situation changed dramatically with the discovery of the Laocoon in Rome on January 14, 1506 (Fig. 59).[13] The discovery occurred in the vineyard of Felice de Fredis, and the speed

with which knowledge of the find was disseminated is legendary. The story is that Giuliano da Sangallo got involved, and Michelangelo, and the piece was soon thereafter acquired by the pope. It was taken to the Vatican, where it was installed in a large niche built expressly for it, whose original design may be recorded in a drawing attributed to Antonio da Sangallo the Elder (Fig. 60).[14] The installation was described in June 1506 by Cesare Trivulzio as "come una capella."[15]

This installation defined the purpose of the *Cortile* from that moment on, a purpose that was then fulfilled with the addition

Fig. 60. Antonio da Sangallo the Elder (attr.). Niche for Laocoon in Cortile delle statue. *Vienna, Albertina, Inv. 48v.*

of other sculptures. Julius took the next significant step sometime before 1509 by adding the torso of Hercules and Antaeus (now ensconced in the Palazzo Pitti in Florence), perhaps together with the Apollo from his own collection.[16] Acquisition of major pieces (often attendant upon excavation) followed rapidly thereafter: the Venus Felix in 1509; the Hercules and Telephos or Hercules and Hylas, which was also interpreted as Commodus, also 1509; the Ariadne, which was interpreted as Cleopatra or Dido, 1512; the Tiber, 1512; the Nile, added by Leo X; the Tigris, added under Clement VII (1523–34); the newly rediscovered seated female figure, the so-called Zitella, identified in the sixteenth century as Vesta, also under Clement VII; the torso, interpreted as Hercules, under Clement VII or Paul III (1534–49); the *Venus ex balneo*, under Paul III; and the Antinous, known as Hermes or Meleager, also under Paul III.[17] This mere listing gives no account of the fundamental forces of desire and ambition that played a role in the formation of the ensemble. However it does highlight the intertwined phenomena of opportunity and discrimination.

Opportunity lay in the relentless digging that occurred in Rome and elsewhere in the sixteenth century, to which excavations many of the above pieces may be attributed. Discrimination lay in the enactment of choice in the arena of a larger field of possible acquisitions. The cases of the Laocoon and the Hercules and Antaeus proved relatively easy. Apparently Sangallo identified the Laocoon at its find spot as a sculpture from the palace of Titus described by Pliny, where it was singled out as the world's greatest work of art.[18] Based on a reading of Pliny, the Hercules and Antaeus was also identified as a masterwork by Polykleitos.[19]

Each work had its own exigencies, and yet, however circumstantial, they soon merged into an ensemble in the aesthetic imagination to the extent to which they formed a unity, emblematic of the modern age. In the words of Giorgio Vasari:

After them, indeed, their successors were enabled to attain to it through seeing excavated out of the earth certain antiquities cited by Pliny as amongst the most famous, such as the Laocoon, the Hercules, the Great Torso of the Belvedere, and likewise the Venus, the Cleopatra, the Apollo, and an endless number of others, which, both with their sweetness and their severity, with their fleshy roundness copied from the greatest beauties of nature, and with certain attitudes which involve no distortion of the whole figure but only a movement of certain parts, and are revealed with a most perfect grace, brought about the disappearance of a certain dryness, hardness, and sharpness of manner....[20]

Intensive historical study of the *Cortile delle statue*, beginning with Michaelis' analysis in the late nineteenth century, has yielded a surprisingly narrow range of interpretations.[21] I cannot help but agree with Arnold Nesselrath that the initial impulse behind the collection was aesthetic, based on the Plinian notion of the work of art.[22] But Nesselrath then argues that this motive was superseded soon thereafter by an idea imposed on it, a political program, which has come to loom so large in modern historiography that it has practically effaced any other way of seeing the material.

This political program has been conceptualized in several forms, sometimes argued to be sequential instead of overlapping, but all ultimately located first in the reign of Julius II. In Matthias Winner's estimation, a decisive step even preceded the Laocoon: the acquisition, by Julius II in 1503/4, of a granite basin from the Baths of Titus to serve as the centerpiece of the Belvedere, as the Laocoon served to form the first centerpiece of the *Cortile delle statue*.[23] The operative connection here is Titus — the basin from his baths, the Laocoon from his personal collection, according to Pliny — thus establishing the milieu of *imperium* to which Julius made claim. This is the imperial theme.

A second theme has been detected in the choice of subjects, beginning again with the Laocoon.[24] High priest of Troy, Laocoon ushers in Aeneas, and with him the history of the founding of Rome, and by indirection Virgil and the age of Augustus, in which Apollo, Venus, Hercules and even Cleopatra are implicated in one way or another. This is the Virgilian theme.

A third interpretation (which may in fact be only a subset of one or both of the above) is that of the golden age. For Nesselrath this resides in the inscription put up by Julius by 1509 over the entrance to the Statue Court, "Procul este profani," "Begone, ye uninitiated," which, in the words of Nesslerath, "is an obvious indication of Julius II's desire to expand his own 'pageant of heroes' as Pope via the statue display, propagating his own pontificate as the beginning of a new golden age."[25] The words are those of the Cumaean Sibyl spoken to protect hallowed ground as Aeneas prepares to enter the underworld and thereby ultimately to come to the Elysian Fields (*Aen.* VI, 258). "Procul este profani": the phrase is interesting in the degree to which it interweaves literary allusion and real-time performance in the *Cortile delle statue*.

These interpretations are underpinned by various kinds of evidence and scholarly reasoning, but there are some troubling deficiencies, discrepancies and gaps. Even from the point of view of an age that has prided itself on deconstruction, there is something unsettling, for example, in the shifting nature of the identities of many of the statues. There seems to have been a high tolerance for variants in the early sixteenth century, even within learned circles — Dido or Cleopatra, Hercules or Commodus — and although this is not unusual for the period, it is difficult to imagine how political conceits as specific as the ones outlined above could be conceptualized and then understood by an audience with such protean building blocks.

Conversely, while Julius II was an extraordinary man, what we know about him has largely come from outside of the *Cortile*, in the events of the world with which he was engaged. We have such a powerful image of him as leader, in fact, that I wonder whether it has not influenced our view of everything to which he put his hand, to the extent that these things have all become a litany of a particular kind of worldly ambition.

It is interesting, therefore, to read again a famous early witness to the *Cortile delle statue* in the form of an extended reverie on the Laocoon by Jacopo Sadoleto (1477–1547), cardinal and humanist scholar who later came to tangle with Calvin over the faith of the citizens of Geneva.[26] As a developed argument, this text differs in kind from the brief mentions of the *Cortile delle statue* in reports and letters and thus is worth a moment of our time. The poem is fifty-nine lines long and divided into two parts. The first concentrates on the suffering of the heroes and the second on the marvel of the statue as a work of art.

The first part is a graphic reenactment of the moment of death presented as a third-person narrative of emotion, color and touch:

> *Horret ad haec animus, mutaque ab imagine pulsat*
> *pectora non parvo pietas commixta tremori.*

> The mind recoils and pity's self appalled
> Gazing on voiceless statues beats her breast.

> *Absistunt surae, spirisque prementibus arctum*
> *crus tumet, obsaepto turgent vitalia pulsu,*
> *liventesque atro distendunt sanguine venas.*

> The knees press outward, and the leg compressed
> By tightening windings swells; the blood confined
> Chokes up the vitals and swells black the veins.

The address shifts in the second part, directly to the makers of the work: *"vos rigidum lapidem vivis animare figuris/eximii*

et vivos spiranti in marmore sensus/inserere: aspicimus motumque iramque doloremque, et paene audimus gemitus" ("It is yours with living shapes to quicken stone, / To give hard marble feeling till it breathes. / We gaze upon the passion, anger, pain, / We all but hear the groans, so great your skill"). Yet there is only the merest hint in one phrase in the preamble of the grand stage of history: *"nunc celsa revisit/exemptum tenebris redivivae moenia Romae"* ("The statue now from darkness returns / To see the stronghold of Rome's second life"). It would take some scholarly gymnastics to turn this poem on its head and make this brief mention the definitive insight into the meaning of the *Cortile delle statue*. But this is just about what has happened, and it has happened with the warrant of the ruler mystique with which history has surrounded Julius.

Taking the poem at its word presents a challenge that has yet to be met, in the spirit of which I would like to offer two preliminary observations: first, that the emphasis on aesthetic appreciation in the second part of the poem lends support to Nesselrath's perception that the initial impulse behind the collection was an aesthetic one, and second, that this perception in the end does not go far enough. The poem is an elaborately contrived balance between art and passion; indeed, it gives pride of place to passion — not passion simply and solely in itself, but in the context of its effect, what one is tempted to call its ethical dimension, in the narrative of the marble figures and of the viewer who contemplates them. In the extremity of the imagining of "the dreadful death," "the cruel tragedy," there is something of a religious experience in a devotional sense, as if the object of contemplation were a Christian image, of Christ on the Cross say, whose purpose was not representation but presence. Images like this could instigate a spiritual updraft simply by being looked at; as material forms they were consumed in an instant in the fire of the imagination, as the mind

leapt forward to the human presence invoked. This is also how Sadoleto treats the Laocoon.

That images have been insufficiently inscribed in the discourse on the reception of the Laocoon by Sadoleto, and indeed others, suggests itself as soon as we widen our frame of reference to embrace them: consider the possibilities raised by an altarpiece for the Santissima Annunziata in Florence begun by Perugino in 1503 and eventually finished by Filippino Lippi (now in the Galleria dell'Accademia) (Fig. 61). The essential features of the painting — the rhythmic asymmetry of the body of Christ, the taut balancing act of the two assistants to Joseph who rush in to tend Christ and the winding strips of cloth that flutter and intertwine beside them foreshadow those of the Laocoon.[27] The fact that the painting predates the discovery of the sculpture means that the path of influence could not have flowed, as one might assume, from the ancient work to the modern. But could it have gone the other way around? Could the modern image have shaped the perception of the older one? To put the matter in broader terms: is it possible that other traditions of image making, and perhaps more importantly, other traditions of image use, conditioned the viewing and the understanding of the ancient sculptures collected for the *Cortile delle statue?*

In the latest and perhaps most eloquent manifestation of the sculpture's critical reception, Michael Baxandall deftly exposes the classical framework of the poem, its Virgilian cadences and resonances and its place in the ekphrastic tradition.[28] But in attempting to answer the crucial question that he poses midway through his analysis — "What is this text really about?" — Baxandall neglects to draw attention to one striking fact. As a piece of sustained looking and emotional engagement with a work of art, Sadoleto's *Laocoon* is without precedent or peer in its own time. The classical tradition offers nothing comparable

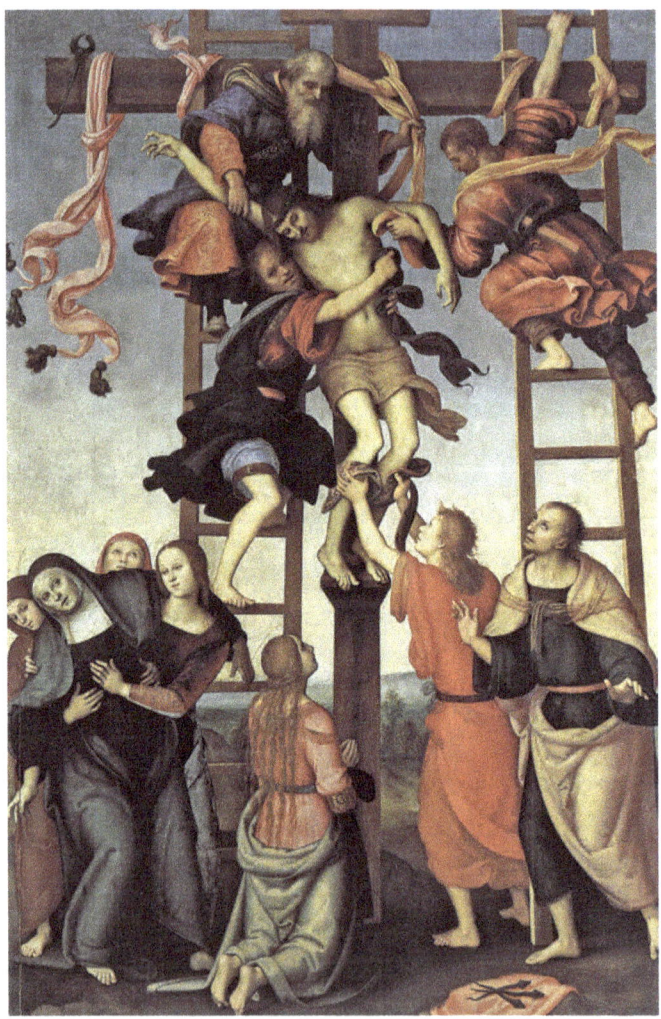

Fig. 61. Perugino and Filippino Lippi, Deposition. Florence, Galleria dell'Accademia.

until one reaches Winckelmann. But in other genres, such as devotional literature, the lessons are rich: the few phrases cited make the connection almost palpable; so much so in fact that

one wonders whether Sadoleto's text is properly categorized by us today as art criticism. The Laocoon is one of the most heavily texualized objects in the Western tradition — and textualized as an object of art criticism— but it may well be that the text that stands at the head of this tradition is not a work of art writing per se, but an act of devotion. Cesare Trivulzio likened the setting of the Laocoon to a "capella." Is such a metaphor a key?

If it is, it can only be grasped by us today in the long view, and in part against the backdrop of the development of gardens and collecting in fifteenth- and early sixteenth-century Rome. To a certain extent this is possible with the magisterial contribution of David Coffin to garden history as well as with the more recent studies of Henning Wrede and Kathleen Christian.[29] One of the points that emerges from this work is the Cortile's distinctiveness. The collecting of ancient sculpture and its installation in a garden rapidly became a convention in the fifteenth century, so that Julius would come to the papacy with a substantial family collection already in hand. Leo X, who succeeded him, would have in his background the Medici garden at San Marco in Florence, among others.[30] Our knowledge of collections from the period preceding the *Cortile delle statue* is considerably less detailed than from the period following. But the *Cortile* appears to stand apart in two respects.

For one, the clutter that seems to characterize other installations of ancient sculpture is considerably diminished (Fig. 62). The *Cortile delle statue* is dominated by the discipline as well as the expansiveness of classical architecture: the rhythm and symmetry of the niches and the geometry of the plan, whose right angles are the principle of alignment for the pieces in the courtyard center. In the *Cortile,* the individual pieces came to the fore, so that their gestures, movements and expressions seemed all the more strikingly purposeful. This is the second point. Ancient sculpture was collected by Renaissance patrons

Fig. 62. After Marten van Heemskerck, Garden of the Galli, 1532–37. Berlin, Kupferstichkabinett, 79.D.2, vol. 1, fol. 72.

for a variety of reasons, and there is a sense, in some ensembles, of an iconographic ordering of parts, of a family connection or of an interest in a particular form or style.[31] But there is also a sense of the limitations of the market in the relentless repetition of similar types such as togate figures or nude torsos, which must have given a muted or even monotonous impression to some collections. The statues in the *Cortile*, by and large, were not only extraordinarily vivid; they were also vividly differentiated from one another, in their suffering, triumph, struggle and repose. These variations are striking, and I cannot help but think that they too played a role in the mechanisms of choice that determined the collection. These mechanisms are the crucial point, and in bringing this essay to its conclusion, the train of thought I would like to follow regarding them begins with a drawing.

The drawing is by Federico Zuccari (Fig. 63).[32] It was executed in the late sixteenth century as part of a visual biography of his older brother, Taddeo, most likely for the decoration of the family palace in Rome.[33] The choice of subject may

Fig. 63. After Federico Zuccari, Taddeo Zuccari drawing in the Cortile delle statue. Florence, Uffizi, Gab. Disegni.

be regarded as exemplary, if not also allegorical. The drawing shows Taddeo c.1540 sketching in the Cortile, and it contains a certain amount of fantasy. But clearly the openness of the courtyard, which was in fact walled, and the presence of a spiral column in the middle distance, which was not near the Vatican, hung together with a view of the papal palace and the rising walls of the New St. Peter's as an argument about the visual and cultural richness of the Roman environment.

In this vein, the juxtaposition of the two primordial pieces of the papal collection, the Laocoon and the Apollo, is crucial. Having been wrested from their true placement by the artist, they form a massive frame for the creative activity taking place in between them. They are at once pendants, polarities and a dialogue of statement and response: suffering, collapse and imminent death versus rising and empowered triumph. That this juxtaposition reverberated, and deeply, with the archetypal story of post-classical civilization, the story of Christ in his suffering, death and resurrection, can hardly be denied. Nor can the subsequent relationships that the visual tradition established linking the one to the other. Almost everything about the Laocoon, from the presence of three figures to the gestalt of suffering, could usefully be deployed in the Passion of Christ: witness, for example, the Deposition by Tommaso della Porta of late

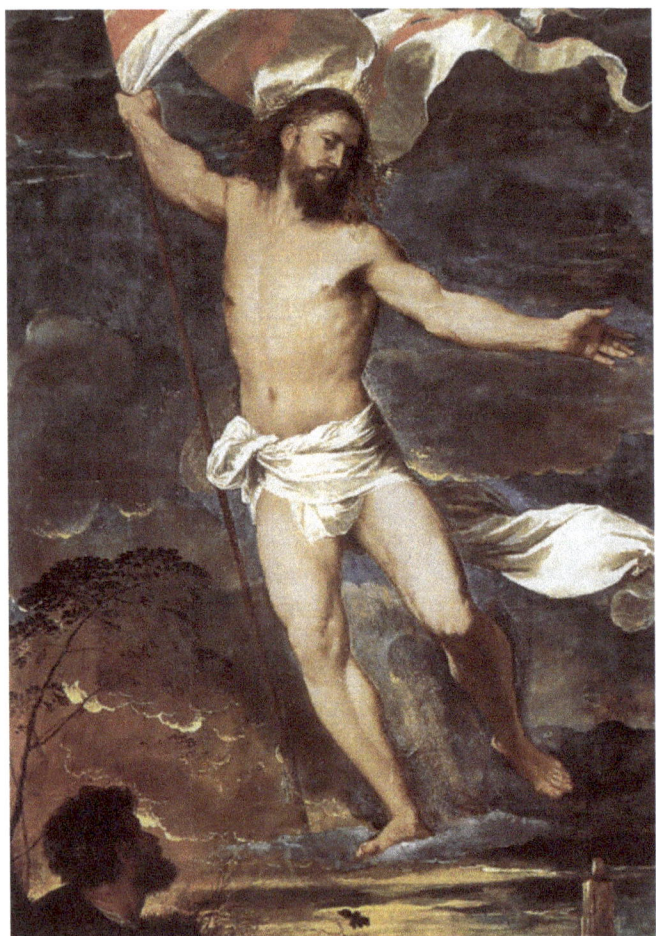

Fig. 64. Titian, Resurrection Altarpiece, detail, Christ triumphant. Brescia, Ss. Nazaro e Celso.

sixteenth century in S. Ambrogio al Corso in Rome.[34] Such examples could be multiplied many times over. Titian's Christ of the *Resurrection* in Brescia (Ss. Nazaro e Celso, 1522, Fig. 64) has been spoken of too in terms of Laocoon, whose raised right

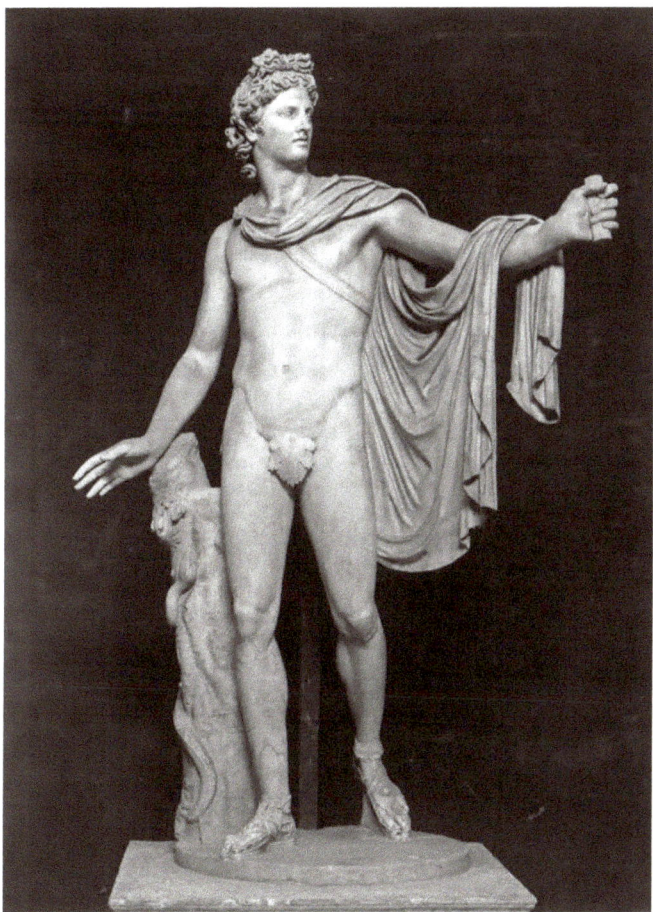

Fig. 65. Apollo Belvedere, from the Cortile delle statue. *Vatican Museums.*

arm mimics that of the ancient figure.[35] But I feel the more compelling adumbration is that of the Apollo (Fig. 65), with his reach and forward, outward movement, or perhaps more accurately, the Laocoon becoming the Apollo, resurrection triumphing over death.

There are so many comparanda on this order that one might be tempted to fold them into the more general phenomenon of the Renaissance use of ancient sculpture as model.[36] But I think, instead of model, the operative performance was metaphor. In a ground-breaking study of the Laocoon, L.D. Ettlinger has probed the significance of the figure as an *exemplum doloris*, a model of suffering, first in Stoic thought and then in the theology of the Counter Reformation.[37] For Ettlinger, moral reverberation is the explanation: "That is why theologians during the Counter Reformation could recommend the *Laocoön* to those who had to make images of the Passion of Christ, of suffering saints and martyrs."[38] Other pieces of the collection, such as the Apollo, the Cleopatra and the Torso, may suggest similar conceptual fault lines.[39]

Modern art historians have become so inured to the use of ancient models by Renaissance artists that they have almost lost sight of an alternate mode of seeing and thinking, what I would describe as a kind of visual double think, which took

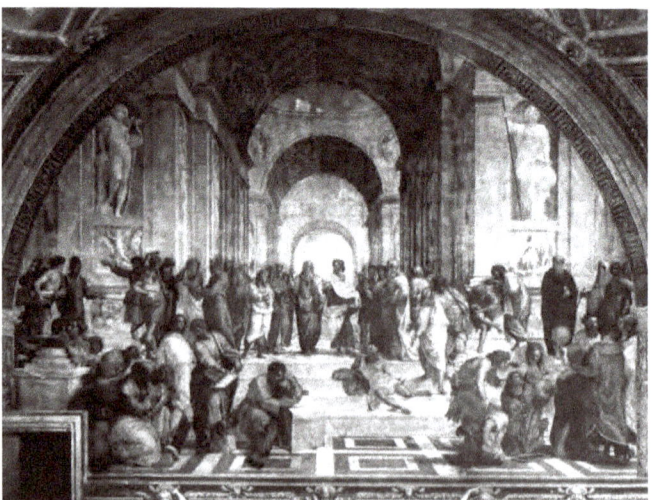

Fig. 66. Raphael, School of Athens. Vatican Palace.

root in sixteenth-century Rome.⁴⁰ A case in point is the monumental architecture of Raphael's *School of Athens* (Fig. 66).⁴¹ As the setting for a colloquy of ancient thinkers, it was meant to be antiquity incarnate. Yet it is inconceivable without Bramante's New St. Peter's (Fig. 67). Likewise, as James Ackerman has observed, the delicately rendered landscape of a fresco fragment now in the Castel Sant'Angelo is intended to depict the Vatican in antiquity, including an artificial pond where mock naval battles were staged.⁴² But it is unimaginable without Bramante's great three-tiered garden court, the *Cortile del Belvedere*. These pictures are a created past of the graphic artist's imagination, created in the image of the present in order to argue that the present, in fact, is the past's most perfect realization. In other words, the paths of connectivity worked in multiple ways. In the Renaissance, antiquity, and especially ancient sculpture, came to hold the present in its grip, but the present was also the means by which antiquity itself was imagined. Present-day reality recreated antiquity in its own image. I

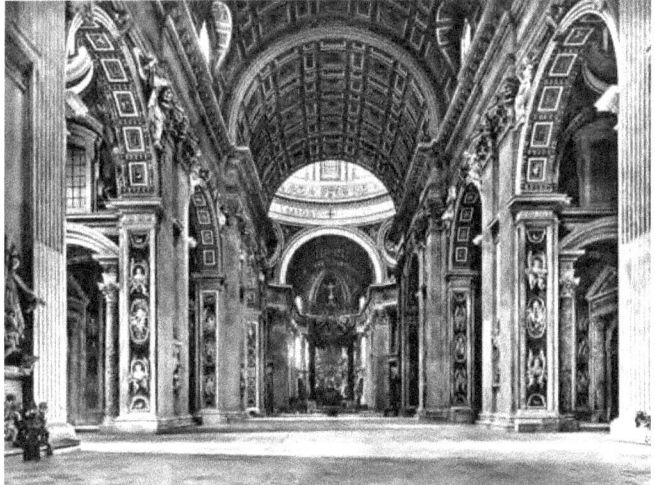

Fig. 67. St. Peter's in the Vatican, view of interior to west.

would like to propose that a similar pattern of visual connectedness underlay the choice of ancient sculpture in the *Cortile delle statue*.

Although much remains to be said about the influence of the present on the past in terms of restoration, I would like to focus on the problem of choice, to return to a point that I raised earlier.[43] Movement and passion were the critical visual elements that conjured up the story of Christ in the juxtaposition of the Laocoon and the Apollo. But this story was only a part, albeit a crucial part, of a larger narrative that bound Julius and the Vatican to St. Peter and Rome and made the relationship between modernity and antiquity a coherent whole. In its drama and simplicity *the* narrative was known to all. The physical lineaments of this story, at once continuously changing but also profoundly stable, had become a set of conventions by the early sixteenth century, deeply embedded in the visual culture: the weight of the visual evidence is crucial. Its significance to the *Cortile* is revealed through the long lens of historical perspective by means of a dense matrix of comparisons. What they sketch, I would like to suggest, is a trajectory of expectations extending from the distant past into the present, from the world of tradition into the arena of practice, which shaped the perception of the statues themselves. It was the story of the creation of humanity, of the fall from grace, of the redemption of love and of salvation. It involved the first man and the first woman (Figs. 68, 69), the birth of the first offspring and the struggle of sin (Figs. 70, 71). Its heroes were a powerful, distant and awe-inspiring father (Figs. 72, 73); a tender, palpable, even vulnerable mother (Figs. 74–77); and a son heroic in his suffering and in his triumph (Figs. 59, 61 and 64, 65).

The inscription that Julius II placed over the entrance to the Sculpture Court, "Procul este profani," it should be recalled, was drawn from the words of the Cumaean Sibyl uttered to

Aeneas as he was about to enter the nether world and the land of earthly heroes. It prompts us to ask what manner of hero we are about to encounter as we enter this space. These are the heroes of antiquity. They are the heroes of art. Recently retrieved from the grave of the earth, their broken bodies now reside, not in heaven or hell, but in the Elysian Fields where they wait to be reborn. In the words of Aeneas' father Anchises, "These are the souls who are destined to live in the body a second time."[44] And it is only natural, indeed inevitable that they reveal in themselves — in their bodies, in their gestures and in their affect — the truth that is to come. They foreshadow, that it to say, they form the shadow image of another narrative, a biblical and Christian story, in which they will play no role. But it is the narrative in which they will find their fulfillment. This is the ghost of the collection — the ghost of a Christian future that was now the Christian past — and its sense as an empowering spirit is suggested by the very words used to describe the sculpture by Evangelista Maddaleni de'Capodifero: "marmoreos lares."[45] As an ensemble and from the platform from which they have now been allowed to address the world, these statues, therefore, can be seen not simply as antiquities but as representatives of a cultural synthesis in which ancient and modern, pagan and Christian, have become inextricably linked. One might go even further and suggest that the astounding critical fortune of these statues in Western aesthetics and thought derived in no small part from their very collectedness, which was the primary mechanism by which an extraordinary sublimation was accomplished, of Christian narrative in pure, unretouched classical form.[46] The fragment was thus made whole.

Space does not permit us to pursue important questions, such as the theoretical implications of this reconstruction, particularly as manifest in literature and art criticism of the period,

as well as the persistence of the concept over the course of several papacies in the first half of the sixteenth century (to which, arguably, the drawing of Zuccaro's adduced above bears witness). Nor can we deal with the critique that the collection elicited in its own day, including the bizarre poem by Giovanni Francesco Pico della Mirandola, *"De Venere et Cupidine expellendis,"* which Ernst Gombrich has brilliantly connected to the Moresca of 1521, or the gloomy comments of Adrian VI (1522–23), whose remark apropos of the statuary, "sunt idola antiquorum," has lived in infamy.[47] Suffice to say that, in a strange way, these critical attitudes and behaviors confirm the strong impression of the statues as life forms, embodying presence, in the midst of which contemporary viewers stood painfully open to their affective power. There is an analogy to this combined force of object, performance and space, in the enormously famous Sacro Monte di Varallo begun in the late fifteenth century, whose passion tableaux enacted with life-size figures also once possessed an aura that is lost to us today.[48] This analogy is worth exploring, though not here, because it should help maintain perspective on the ruler mystique that has so deeply embedded itself in our image of the collection to the extent to which it has displaced another, more fragile image, an image conjured up like a light show by the pale marble surfaces of these few, judiciously chosen fragments of the past.

Fig. 68. Belvedere Torso, from the Cortile delle statue. Vatican Museums.

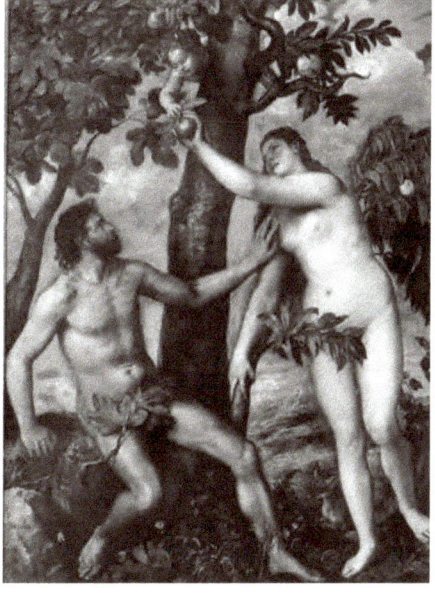

Fig. 69. Titian, Adam and Eve. Madrid, Prado.

Fig. 70. Marten van Heemskerck, Hercules and Antaeus from the Cortile delle statue. *Berlin, Kupferstichkabinett, 79.D.2, vol. 1, fol. 59r.*

Fig. 71. Michelangelo, Flood, detail. Sistine Chapel, Vatican Palace.

Fig. 72. Baccio Bandinelli or Battista Naldini, The Nile, from the Cortile delle statue. *Lisbon, Museu Nacional de Arte Antigua, inv. no. 1072.*

Fig. 73. Michelangelo, Creation of Adam, detail, God the Father. Sistine Chapel, Vatican Palace.

Fig. 74. Cleopatra (now identified as Ariadne), from the Cortile delle statue. Vatican Museums.

Fig. 75. Lorenzo Ghiberti, bronze doors, Nativity, detail, Virgin. Florence, Baptistery of S. Giovanni.

THE CORTILE DELLE STATUE IN ROME

Fig. 76. Venus Felix, from the Cortile delle statue. Vatican Museums

Fig. 77. Raphael, Madonna of the Meadow. Vienna, Kunsthistorisches Museum.

Notes

1. See, above all, the important compendium of papers, *Il Cortile delle Statue: Der Statuenhof des Belvedere im Vatikan. Akten des Internationalen Kongresses zu Ehren von Richard Krautheimer, Rom, 21.–23. Okt. 1992*, ed. Matthias Winner, Bernard Andreae and Carlo Pietrangeli (Mainz am Rhein: Philipp von Zabern, 1998), which contains an overview of the history of the *Cortile* as well as studies of its individual components (cited hereafter as *Der Statuenhof*). The volume is also useful in the extent to which it presents a chronicle of changes to the architecture of the courtyard and placement of the collection after the early sixteenth century. See more recently the catalog of the 2006 exhibition at the Vatican commemorating the discovery of the Laocoon: *Laocoonte: Alle origini dei Musei Vaticani* (Rome: "L'Erma" di Bretschneider, 2006), with a bibliography of previous literature. Also worthy of note: Hans Henrik Brummer, *The Statue Court in the Vatican Belvedere* (Stockholm: Almquist & Wiksell, 1970); G. Daltrop, "Zur Aufstellung antiker Statuen in der Villetta di Belvedere des Vatikans," *Boreas: Münstersche Beiträge zur Archäologie* 6 (1983): 217–32; Uwe Geese, "Antike als Programm: Der Statuenhof des Belvedere im Vatican," *Natur und Antike in der Renaissance*, exh. cat., Liebighaus, Museum alter Plastik, Frankfurt am Main, 5. Dezember 1985 bis 2. März 1986 (Frankfurt am Main: Liebighaus, 1986), 24–50; *Vachikan no runesansu bijutsu ten: Tensai geijutsukatachi no jidai = High Renaissance in the Vatican: The Age of Julius II and Leo X*, exh. cat., The National Museum of Western Art, Tokyo, 21 September–28 November, 1993, 2 vols. (Tokyo: Kokuritsu Seiyo Bijutsukan, 1993); Paolo Liverani, "Il Cortile delle statue in Belvedere," *Il torso del Belvedere: Da Aiace a Rodin*, ed. Raimund Wünsche (Vatican City: Direzione Generale Monumenti, Musei e Gallerie Pontificie, 1998), 13–19.

2. Christof Luitpold Frommel, "I tre progetti bramanteschi per il Cortile del Belvedere," in *Der Statuenhof*, 17–65.

3. *Der Statuenhof*, passim.

4. For a different view of the collecting of ancient sculpture, see Claudia Franzoni, "'Rimembranze d'infinite cose.' Le collezioni rinascimentali di antichità," *Memoria dell'antico nell'arte italiana* 1. *L'uso dei classici*, ed. Salvatore Settis (Turin: Einaudi, 1984), 304–60; Salvatore Settis, "Des ruines au musée: La destinée de la sculpture classique," *Annales: Économies, sociétés, civilizations* 48 (1993): 1347–80.

5. Jacob Rothenberg, *"Descensus Ad Terram": The Acquistion and Reception of the Elgin Marbles* (New York: Garland Publishing, 1977); Ian Jenkins, *Archaeologists and Aesthetes: In the Sculpture Galleries of the British Museum 1800–1939* (London: British Museum Press, 1992); William St. Clair, *Lord Elgin and the Marbles* (Oxford: Oxford University Press, 1998); Mary Beard, *The Parthenon* (Cambridge, MA: Harvard University Press, 2003); Marc Fehlmann, "Casts and Connoisseurs: The Early Reception of the Elgin Marbles," *Apollo* 165 (June 2007): 44–51.

6. Beard, *Parthenon*, 167–68, whose conclusion is exactly the opposite of the one propounded here: "Overall the effect (and the intention) of the gallery design is to efface what remains in Athens."

7. Jenkins, *Archaeologists and Aesthetes*, fig. 84.

8. Max Kunze, *The Pergamon Altar: Its Rediscovery, History and Reconstruction* (Mainz: Philipp von Zabern, 1995).

9. The fundamental work on the *Cortile del Belvedere* is James Ackerman, *The Cortile del Belvedere* (Vatican City: Biblioteca Apostolica Vaticana, 1954). For the Renaissance phase of New St. Peter's, see Christof Thoenes, "Renaissance St. Peter's," *St. Peter's in the Vatican*, ed. William Tronzo (New York: Cambridge University Press, 2005), 64–92.

10. Frommel, "I tre progetti," in *Der Statuenhof*, 17–66.

11. Brummer, *Statue Court*, figs. 4–5.

12. Ibid., 20–42.

13. Margarete Bieber, *Laocoon: The Influence of the Group since Its Rediscovery* (Detroit: Wayne State University Press, 1967); Michael and

Renate Hertl, *Laokoon: Ausdruck des Schmerzes durch zwei Jahrtausende* (Munich: K. Thiemig, 1968); Brummer, *Statue Court*, 73–119; G. Daltrop, *Die Laokoongruppe im Vatikan: Ein Kapitel aus der römischen Museumsgeschichte und der Antiken-Erkundung* (Constance: Universitätsverlag Konstanz, 1982); Hanno-Walter Kruft, "Metamorphosen des Laokoon: Ein Beitrag zur Geschichte des Geschmacks," *Pantheon* 42 (1984): 3–11; Bernard Andreae, *Plinius und der Laokoon*, ed. Günter Grimm, Trierer Winckelmannsprogramme 8 (1986) (Mainz am Rhein: Philipp von Zabern, 1987); *Der Statuenhof*, passim; Salvatore Settis, *Laocoonte: Fama e stile* (Rome: Donzelli Editore, 1999); Richard Brilliant, *My Laocoön: Alternative Claims in the Interpretation of Artworks* (Berkeley: University of California Press, 2000); Michael Koortbojian, "Pliny's Laocoön?," *Antiquity and Its Interpreters*, ed. Alina Payne, Ann Kuttner and Rebekah Smick (Cambridge: Cambridge University Press, 2000), 199–216; *Le Laocoon: Histoire et reception*, ed. Élisabeth Décultot, Jacques LeRider and François Queyrel (Paris: Presses Universitaires de France, 2003); Lynn Catterson, "Michelangelo's Laocoön," *Artibus et Historiae* 26 (2005): 29–56; Christoph Schälzle, "*Immo vivo*: Laokoon in Literatur und Kunst. Interdisziplinäre Tagung an der Universität Bonn, 30. November bis 2. Dezember 2006," *Kunstchronik* 12 (2007): 551–58; Brian Curran, "Teaching (and Thinking About) the High Renaissance: With Some Observations on Its Relationship to Classical Antiquity," *Rethinking the High Renaissance: The Culture of Visual Arts in Early Sixteenth-Century Rome*, ed. Jill Burke (Burlington, VT: Ashgate, 2012), 27–55.

14. Arnold Nesselrath, "Il Cortile delle Statue: Luogo e storia," in *Der Statuenhof*, fig. 4.

15. Settis, *Laocoonte*, appendix ed. Sonia Maffei, 108, letter of Cesare Trivulzio to Pomponio Trivulzio dated June 1, 1506.

16. Brummer, *Statue Court*, 43–71, 139–41; *Der Statuenhof*, passim.

17. Brummer, *Statue Court*, 121–29; *Der Statuenhof*, passim.

18. Settis, *Laocoonte*, appendix ed. Sonia Maffei, 110–11, letter of Francesco da Sangallo to Vincenzo Borghini dated February 28, 1567.

19. Brummer, *Statue Court*, 140–41.

20. Giorgio Vasari, *Le vite dè più eccelenti pittori, scultori e architettori*, ed. G. Milanesi (Florence: G.C. Sansoni, 1906), 4:10; trans. Gaston de Vere (New York: Alfred A. Knopf, 1996), 1:619. See Leonard Barkan, *Unearthing the Past: Archaeology and Aeshtetics in the Making of Renaissance Culture* (New Haven: Yale University Press, 1999), 110 and chap. 5.

21. A. Michaelis, "Geschichte des Statuenhofes im Vatikanischen Belvedere," *Jahrbuch des Deutschen Archäologischen Institutes* 5 (1890): 5–72.

22. Nesselrath, "Il Cortile delle Statue," in *Der Statuenhof*, 1–16.

23. Matthias Winner, "Einleitung: 'Il Cortile delle Statue nel Belvedere'," in *Der Statuenhof*, ix–xi.

24. Hans Henrik Brummer, "On the Julian Program of the Cortile delle Statue in the Vatican Belvedere," in *Der Statuenhof*, 67–76.

25. Nesselrath, "Il Cortile delle Statue," in *Der Statuenhof*, 1–16.

26. For the text, see Settis, *Laocoonte*, appendix ed. Sonia Maffei, 118–21. The translation cited here is H.S. Wilkinson's reproduced in Bieber, *Laocoon*, 2–5. See Richard M. Douglas, *Jacopo Sadoleto 1477–1547: Humanist and Reformer* (Cambridge, MA: Harvard University Press, 1959), 9–10; John Calvin and Jacopo Sadoleto, *A Reformation Debate: Sadoleto's Letter to the Genevans and Calvin's Reply*, ed. and trans. John C. Olin (New York: Harper & Row, 1966); Gian Pietro Maragoni, *Sadoleto e il Laocoonte: Di un modo di descrivere l'arte* (Parma: Zara, 1986); G. Maurach, "Sadoletos 'Laokoon': Text, Übersetzung, Kommentar," *Würzburger Jahrbücher für die Altertumswissenschaft* n.s. 18 (1992): 245–65; Mathilde Pigeaud, "La découverte du Laocoon et le poème de Jacques Sadolet," *Thesauramata philologica Iosepho Orozio Oblata*, ed. M.R. Herrera, S. García-Jalón and M.A.M. Casquero, *Helmantica* 46 (1995): 463–86; Michael Baxandall, *Words for Pictures: Seven Papers on Renaissance Art and Criticism* (New Haven: Yale University Press, 2003), 98–116 (also with text and translation of the poem).

27. Pietro Scarpellini, *Perugino* (Milan: Electa, 1984), 114, cat. no. 144, fig. 239; *Pietro Perugino: Master of the Italian Renaissance*, ed. Joseph Antenucci Becherer, exh. cat., The Grand Rapids Art Museum (New York: Rizzoli International, 1997), 92–93, 290, fig. 31 and pl. 21. See also Matthias Winner, "Zum Nachleben des Laokoon in der Renaissance," *Jahrbuch der Berliner Museen* 16 (1974): 83–121.

28. Baxandall, *Words for Pictures*, 103–15.

29. David Coffin, *The Villa in the Life of Renaissance Rome* (Princeton: Princeton University Press, 1979); idem, *Gardens and Gardening in Papal Rome* (Princeton: Princeton University Press, 1991); Kathleen Wren Christian, "The De' Rossi Collection of Ancient Sculptures, Leo X, and Raphael," *Journal of the Warburg and Courtauld Institutes* 65 (2002): 132–200; idem, "From Ancestral Cults to Art: The Santacroce Collection of Antiquities," *Senso delle rovine e riuso dell'antico*, ed. Salvatore Settis, *Annali della Scuola Normale Superiore di Pisa*, ser. 4, quaderni 14, Classe di Lettere e Filosophia (2002): 255–72; idem, "The Della Valle Statue Court Rediscovered," *The Burlington Magazine* 145 (2003): 847–50; idem, "Raphael's 'Philemon' and the Collecting of Antiquities in Rome," *The Burlington Magazine* 146 (2004): 760–63; idem, *Empire without End: Antiquities Collections in Renaissance Rome, c.1350–1527* (New Haven: Yale University Press, 2010). With regard to Roman collections, see also Marjon van der Meulen, "Cardinal Cesi's Antique Sculpture Garden: Notes on a Painting by Hendrik van Clef III," *Burlington Magazine* 116 (1974): 16–24; Elisabeth Blair MacDougall, "Imitation and Invention: Language and Decoration in Roman Renaissance Gardens," *Journal of Garden History* 5 (1985): 119–34; *The Architecture of Western Gardens: A Design History from the Renaissance to the Present*, ed. M. Moser and G. Teyssot (Cambridge, MA: MIT Press, 1991), 25–108; Anna Maria Riccomini, "A Garden of Statues and Marbles: The Soderini Collection in the Mausoleum of Augustus," *Journal of the Warburg and Courtauld Institutes* 58 (1995): 265–84; Henning Wrede, "Römische Antikenprogramme des 16. Jahrhunderts," in *Der Statuenhof*, 83–115. The literary study of Comito,

The Idea of the Garden in the Renaissance, provides a useful frame of reference for the history of the garden in Renaissance Rome.

30. André Chastel, "Vasari et la légende Médicéene: L'école du jardin de Saint Marc," *Studi Vasariani* (Florence: Sansoni, 1952), 159–67; Caroline Elam, "Lorenzo de Medici's Sculpture Garden," *Kunsthistorisches Institut in Florenz: Mitteilungen* 36 (1992): 40–48; *Il giardino di San Marco: Maestri e compagni del giovane Michelangelo*, ed. Paola Barocchi, exh. cat., Firenze Casa Buonarroti, 30 giugno–19 ottobre 1992 (Cinisello Balsamo: Silvana, 1992).

31. See above, n. 30.

32. John Gere, "I disegni di Federico Zuccari sulla vita giovanile di suo fratello Taddeo," in *Per Taddeo e Federico Zuccari nelle Marche*, exh. cat., Sant'Angelo in Vado, Palazzo Fagnani, 18 settembre–7 novembre 1993, ed. Bonita Cleri (Sant'Angelo in Vado: Grafica Vadese, 1993), 49–55, fig. 17.

33. Gere, "I disegni," 50–51.

34. Irving Lavin, "*Ex uno lapide:* The Renaissance Sculptor's Tour de Force," in *Der Statuenhof*, fig. 28; L.D. Ettlinger, "*Exemplum Doloris*: Reflections on the Laocoön Group," in *De Artibus Opuscula XL: Essays in Honor of Erwin Panofsky*, ed. Millard Meiss, 2 vols. (New York: New York University Press, 1961), 1:121–26; 2, pls. 36–37. See also John Moffitt, "A Christianization of Pagan Antiquity: Giovanni Andrea Gilio da Fabriano, Antonio Possevino, and the Laocoön of Domenico Theotocopouli, 'El Greco'," *Paragone* 35 (1984): 44–60; Helmut Rumple, "Laokoon und die 'Grenzen des Fortschritts': Antikenrezeption und Neuzeitverständnis von der Hochrenaissance bis in die 'Postmoderne'," *Saeculum* 40 (1989): 80–92; Federico Revilla, "El simbolismo cristiano del 'Laocoonte' del 'Greco'," *Boletin del Seminario de Estudios de Arte y Arqueologia* 57 (1991): 387–93; Maria Berbara, "El Laocoonte y el tema del sacrificio entre el Renacimiento y la Contrarreforma," *Goya* (1999): 112–24; *Le Laocoon: Histoire et reception*, passim.

35. Harold E. Wethey, *The Paintings of Titian: Complete Edition* 1. *The Religious Paintings* (London: Phaidon, 1969), 126–28, fig. 72.

36. Dieter Blume, "Antike und Christentum," *Natur und Antike in der Renaissance*, 85–129, and passim; and Barkan, *Unearthing the Past*.

37. Ettlinger, "Exemplum Doloris," passim.

38. Ettlinger, "Exemplum Doloris," 126, citing Giovanni Andrea Gilio and Antonio Possevino.

39. See Joachim Rees, "Ethos und Pathos: Der Apoll vom Belvedere und die Laokoon-Gruppe im Spektrum von Kunsttheorie und Antikenrezeption im 18. Jahrhundert," *Wettstreit der Künste: Malerei und Skulptur von Dürer bis Daumier*, ed. E. Mai and K. Wettengl, exh. cat., Haus der Kunst, München/Wallraf-Richartz-Museum-Fondation Corbond, 2002 (Munich-Cologne: Edition Minerva, 2002), 152–69; and Wünsche, *Il torso del Belvedere*, passim and esp. 21–29, 66–87.

40. See, for example, Roberto Weiss, *The Renaissance Discovery of Classical Antiquity* (Oxford: Blackwell, 1969); Francis Haskell and Nicholas Penny, *Taste and the Antique* (New Haven: Yale University Press, 1981); Phyllis Pray Bober and Ruth Rubenstein, *Renaissance Artists and Antique Sculpture: A Handbook of Sources* (London: Harvey Miller, 1986); Alain Schnapp, *The Discovery of the Past*, trans. I. Kinnes and G. Varndell (New York: Harry N. Abrams, 1997); *The Rediscovery of Antiquity: The Role of the Artist. Acta Hyperborea* 10, ed. J. Fejfer, T. Fischer-Hansen and A. Rathje (Copenhagen: Museum Tusculanum Press, 2003). Payne, Kuttner and Smick, *Antiquity and Its Interpreters*, is rather conventional in its outlook. For an alternate view of chronology and chronicity in the Renaissance, see Alexander Nagel and Christopher Wood, "Interventions: Towards a New Model of Renaissance Anachronism," *The Art Bulletin* 87 (2005): 403–32; "What Counted as 'Antiquity' in the Renaissance," *Renaissance Medievalisms*, ed. Konrad Eisenbichler (Toronto: Centre for Reformation and Renaissance Studies, 2009), 53–74; *Anachronic Renaissance* (New York: Zone Books, 2010).

41. Arnold Nesslerath, *Raphael's School of Athens* (Vatican City: Edizioni Musei Vaticani, 1997); Ralph E. Lieberman, "The Architectural Background," in *Raphael's "School of Athens,"* ed. Marcia Hall (Cambridge: Cambridge University Press, 1997), 64–84, esp. 70–71.

42. James Ackerman, "The Belvedere as a Classical Villa," *Journal of the Warburg and Courtauld Institutes* 14 (1951): 70–91; repr. with postscript in idem, *Distance Points: Essays in Theory and Renaissance Art and Architecture* (Cambridge, MA: MIT Press, 1991), 325–59.

43. On the restoration of the Laocoon, see Orietta Rossi Pinelli, "Chirurgia della memoria: Scultura antica e restauri storici," in *Memoria dell'antico nell'arte italiana* 3. *Dalla tradizione all'archeologia,* ed. Salvatore Settis (Turin: Einaudi, 1986), 183–250; Settis, *Laocoonte,* 3–11.

44. Jean Seznec, *The Survival of the Pagan Gods: The Mythological Tradition and Its Place in Renaissance Humanism and Art,* trans. B. Sessions (New York: Harper & Row, 1961).

45. BAV, Vat. lat. 10377, fol. 98v., cited by Nesselrath, "Il Cortile delle Statue," in *Der Statuenhof,* 1. See the remarks of Christiane Denker Nesselrath on the accessibility of the sculpture collection to the public via Bramante's spiral staircase: *Bramante's Spiral Staircase* (Vatican City: Edizioni Musei Vaticani, 1997), 16–17.

46. At a considerable remove from the interpretation posited here is the phenomenon of the incorporation of ancient fragments in religious statuary. See W. Amelung, "Di statue antiche trasformate in figure di santi," *Mittheilungen des Kaiserlich Deutschen Archaeologischen Instituts: Roemische Abtheilung* 12 (1897): 71–74; Irving Lavin, "An Ancient Statue of the Empress Helen Reidentified (?)," *Art Bulletin* 49 (1967): 58. From the ample literature on reception, see, for example, Haskell and Penny, *Taste and the Antique*; Alexander Potts, *Flesh and the Ideal: Winckelmann and the Origins of Art History* (New Haven: Yale University Press, 1994); Horst Althaus, *Laokoon: Stoff und Form* (Tübingen: Francke, 2000).

47. E.H. Gombrich, "The Belvedere Garden as a Grove of Venus," in *Symbolic Images: Studies in the Art of the Renaissance* (Chicago: University of Chicago Press, 1985), 104–8.

48. Casimiro De Biaggi, "Sacro Monte di Varallo," *Bollettino storico per la provincia di Novara* 75 (1984): 239–52.

EPILOGUE

IN A RECENT ATTEMPT to frame in broad terms the methodological parameters of the study of landscape, James Elkins has sketched a variety of modes of thinking about the garden in the form of seven rubrics: the garden as a representation of history, as a representation of nature, as a representation of painting and fiction, as the meeting place of various disciplines, as a set of polarities, as a narrative of human life and as an open-ended site of desire.[1] Clearly these rubrics embrace a large amount of intellectual territory and themselves stand on a number of different intellectual planes. The concept of representation (of history, of nature, of painting and fiction), embedded in humanistic discourse in a certain sense is hardly commensurate with the notion of the garden as a meeting place of various disciplines or as a set of polarities that have a decidedly sociological or anthropological bent. Nonetheless, the recurrent use of the term "representation" alongside that of "narrative" (of human life) and "site" (of desire) suggests a dominant predisposition and theme. Representation, narrative and site position the designed landscape decisively as an object. They lend it the character of an autonomous form on the order of cultural products, such as paintings, buildings and works of music. They enable it to be read as a text. A classic expression of this predisposition is a way of thinking about historical landscape that has developed in recent years — epitomized, for example, by the work of Simon Schama — as "a vast mnemonic system for the retention of group history and ideals," or an archive of texts — mythic, cultic, ritual and literary.[2] Schama treats landscape as if it were an object of memory to be acted upon by consciousness.

As I have attempted to analyze historical landscape in the four foregoing studies, I have preferred to think in terms of the

image of the circuit, that is to say, the course or pathway along which a body of energy may flow. In the case of the Norman pavilions of the twelfth century, the relevant circuit was defined by the extraordinary ambition and means of the Norman rulers that propelled them forcibly onto a new plane of political status. They transformed themselves from mere princes to kings — to the consternation and resistance of many who surrounded them – and raised their sights to create an environment as both a setting and a performance that would substantiate and enhance this status. Thus they pillaged the princely cultures of Mediterranean for ideas, from gilded muqarnas to fountain pavilions, that would serve their needs, and they caused these forms to enter into a new kind of dialogue with one another that reiterated and stressed the themes of leadership and magnificence, leaping over traditional distinctions such as that between the ecclesiastical and the secular. No other princely culture of the Middle Ages constructed itself like this.

The case of Petrarch betokened the discovery of an environment, the landscape, in which a new kind of work could be undertaken, the enterprise of secular learning. That environment had actually been there all along, but its potential to encapsulate and give shape to an experience was, with Petrarch, newly exploited. This development had implications in turn in the visual arts, where it was taken up, ramified and elaborated in the context of other sets of content.

The case of Hesdin exposed a particular kind of mechanism in Burgundian culture in the fifteenth century that intertwined cloth, wool, weaving and industry, whose centrality to the society as a whole was as real as it was problematic. Thus it erupted as an anxiety and a pleasure in a circuit that had the character of a conversation fraught with claims and counter-claims of power and possession and that ran through media as diverse as political emblems and rituals, religious paintings and landscape.

Finally, in the *Cortile delle statue* the circuitry had to do with the visual traditions of Christianity, with their abundance of established forms and conventions for rendering Christian subjects that coalesced into a kind of matrix or guide precisely because of their formulaic construction of bodily movement, a guide then used to construe a body of material — the sculpture of antiquity — literally as it emerged from the ground, thus enabling its aesthetic redemption in the landscape.

One of the consequences of adhering to the image of a circuit has been drawing texts and images out of their isolation. In the foregoing analyses, texts and pictures have been treated as if they were interpenetrating and interlocking and were deployed virtually simultaneously in order to draw out of their interrelationship something that not a single one of them alone could offer. These works have been conceived of as individual points or nodes in a larger composition, or ductus, which emerges in the relationships among them. One might think of them, therefore, as fragments, even though they may appear to be whole, because of their embeddedness in a larger configuration at the moment of their creation.

Nonetheless, texts and pictures functioned in different ways in these studies.[3] In the case of Norman Sicily, the inscriptions on the ceiling of the Cappella Palatina gave access to the performative dimension of the nave of the chapel as a royal space, whose painted images in turn provided the specific inflection of content. This was a space constructed not as the scaffolding for a gallery of images of the (Christian) past but as an exuberant and living celebration of an existence on earth provisioned by the power of the king, made present to all those who inhabited it. Its direct analogue was in the pavilions erected by the Norman kings in the gardens that they built surrounding the city of Palermo.

In the case of Petrarch word and image began with the poet's own hand. Words were clearly Petrarch's primary medium, but when he turned to images, as he did occasionally in the context of the book he put pressure on the visual to perform in a way that it otherwise did not. The performance had to do with the author making himself present in the work.

At Hesdin, words came in the form of stories drawn from ancient myth and religion that clothed a program that was profoundly political in nature. These stories then took material form in a set of objects and rituals that stood in a relationship with one another as statement and response. The extraordinary ancient figures like the Laocoon that came to light to the amazement of all in Rome in the sixteenth century did not come equipped with a mechanism for articulating the ebb and flow of their inner lives. But the desire to grasp this mechanism was intense, and the words of the churchman and poet Jacopo Sadoleto revealed the process by which it was constructed: by the aesthetic sensibility imbued with the fervor of religious renewal. One might easily imagine this effort as the starting point for the formation of narrative that embraced the larger group of sculptures as whole in the *Cortile delle statue*.

But in the end what is telling about these cases is that they have caused to come together an assembly of disparate material traces of the past, which have not been interrogated simultaneously and whose coherence and flow have not been perceived or argued: the Norman garden pavilions and the images on the ceiling of the Cappella Palatina, Petrarch's sketch and the other products of his pen in poetry and prose, the park at Hesdin and the Ghent altarpiece, and the Descent from the Cross by Perugino and Filippino Lippi and the Laocoon. To my mind these associations get to the very heart of the concept of the connectivity for which I have argued: movement within movement.

Notes

1. Elkins, "On the Conceptual Analysis of Gardens."

2. The work in question is Simon Schama's *Landscape and Memory* (New York: Vintage, 1996). The citation is from David Lowenthal, "Geography, Experience and Imagination: Towards a Geographical Epistomology," *Annals of the Association of American Geographers* 51 (1961): 260.

3. See also *Elective Affinities: Testing Word and Image Relationships,* ed. Catriona MacLeod, Véronique Plesch and Charlotte Schoell-Glass (Amsterdam: Rodopi, 2009).

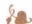

BIBLIOGRAPHY

Aberth, John. *An Environmental History of the Middle Ages: The Crucible of Nature*. London: Routledge, 2012.

Abulafia, David. *Italy, Sicily and the Mediterranean*. London: Variorum, 1987.

—. "The Crown and the Economy under Roger II and His Successors." *Dumbarton Oaks Papers* 37 (1983): 1–14.

—. *The Two Italies: Economic Relations between the Norman Kingdom of Sicily and the Northern Communes*. Cambridge: Cambridge University Press, 1977.

Ackerman, James. "The Belvedere as a Classical Villa." *Journal of the Warburg and Courtauld Institutes* 14 (1951): 70–91. Repr. with postscript in idem, *Distance Points: Essays in Theory and Renaissance Art and Architecture*. Cambridge, MA: MIT Press, 1991, 325–59.

—. *The Cortile del Belvedere*. Vatican City: Biblioteca Apostolica Vaticana, 1954.

Ahmad, Aziz. *A History of Islamic Sicily*. Edinburgh: Edinburgh University Press, 1975.

Akehurst, F.R.P., and Judith M. Davis, eds. *A Handbook of the Troubadours*. Berkeley: University of California Press, 1995.

Al-Gailani, 'Abd Al-Rahman. "Early Medieval Islamic Court Life: The Evidence of the Literary Sources." *Image and Meaning in Islamic Art*. Robert Hillenbrand, ed. London: Altajir Trust, 2005, 98–108.

Alberti, Leandro. *Descrittione di tutta Italia*. Bologna: Anslemo Giaccarelli, 1550.

Ali, Sammer M. *Arabic Literary Salons in the Islamic Middle Ages: Poetry, Public Performances and the Presentation of the Past*. Notre Dame: University of Notre Dame, 2010.

Althaus, Horst. *Laokoon: Stoff und Form*. Tübingen: Francke, 2000.

Amelung, W. "Di statue antiche trasformate in figure di santi." *Mittheilungen des Kaiserlich Deutschen Archaeologischen Instituts: Roemische Abtheilung* 12 (1897): 71–74.

Anastasi, Letizia. *L'arte nel parco normanno di Palermo: Favara*. Palermo: Scuola tipografica ospizio di beneficenza, 1935.

Andreae, Bernard. *Plinius und der Laokoon*. Trierer Winckelmannsprogramme 8 (1986). Günter Grimm, ed. Mainz am Rhein: Philipp von Zabern, 1987.

Anselmi, Alessandra. "Theaters for the Canonization of Saints." *St. Peter's in the Vatican*. William Tronzo, ed. New York: Cambridge University Press, 2005, 244–69.

Armstrong, A.J. "The Golden Age of Burgundy: Dukes That Outdid Kings." *The Courts of Europe: Politics, Patronage and Royalty 1400–1800*. A.G. Dickens, ed. London: Thames and Hudson, 1977, 55–75.

Arnade, Peter. *Realms of Ritual: Burgundian Ceremony and Civic Life in Late Medieval Ghent*. Ithaca, NY: Cornell University Press, 1996.

Arnold, Ellen F. *Negotiating the Landscape: Environment and Monastic Identity in the Medieval Ardennes*. Philadelphia: University of Pennsylvania Press, 2012.

Ascoli, Albert Russell. "Petrarch's Middle Age: Memory, Imagination, History and the 'Ascent of Mount Ventoux'." *Stanford Italian Review* 10 (1991): 5–43.

Ashbee, Jeremy A. "'The Chamber called Gloriette': Living at Leisure in Thirteenth- and Fourteenth-Century Castles." *Journal of the British Archaeological Association* 157 (2004): 17–40.

Asperen de Boer, J.R.J. van. "A Scientifc Reexamination of the Ghent Altarpiece." *Oud Holland* 93 (1979): 141–215.

Aurell, Martin. *Le chevalier lettré: Savoir et conduite de l'aristocratie aux XIIe et XIIIe siècles*. Paris: Fayard, 2011.

Aurigemma, Maria Giulia. *Il cielo stellato di Ruggero II: Il soffitto dipinto della Cattedrale di Cefalù*. Milan: Silvana, 2004.

Austin, J.L. *How To Do Things With Words*. Cambridge, MA: Harvard University Press, 1962.

Bakhtin, Mikhail. *Rabelais and His World*. Helene Iswolsky, trans. Cambridge, MA: MIT Press, 1965.

Barkan, Leonard. *The Gods Made Flesh: Metamorphosis and the Pursuit of Paganism*. New Haven: Yale University Press, 1986.

—. *Unearthing the Past: Archaeology and Aeshtetics in the Making of Renaissance Culture*. New Haven: Yale University Press, 1999.

Barnes, Carl F., Jr. *The Portfolio of Villard de Honnecourt: Paris, Bibliothèque Nationale de France MS Fr 19093*. Burlington VT: Ashgate, 2009.

Barocchi, Paola, ed. *Il giardino di San Marco: Maestri e compagni del giovane Michelangelo*. Exh. cat. Firenze Casa Buonarroti, 30 giugno–19 ottobre 1992. Cinisello Balsamo: Silvana, 1992.

Barral i Altet, Xavier. "Fontaines et vasques provenant de cloîtres méridionaux: Problèmes de typologie et d'attribution." *Les cahiers de Saint Michel de Cuxa* 7 (1976): 123–25.

Bauman, Johanna. "Tradition and Transformation: The Pleasure Garden in Piero de' Crescenzi's *Liber Ruralium Commodorum*." *Studies in the History of Gardens and Designed Landscapes* 22 (2002): 99–141.

Baxandall, Michael. "Art, Society, and the Bouguer Principle." *Representations* 12 (1985): 32–43.

—. *Words for Pictures: Seven Papers on Renaissance Art and Criticism*. New Haven: Yale University Press, 2003.

Bayless, Martha. *Parody in the Middle Ages: The Latin Tradition*. Ann Arbor: University of Michigan Press, 1996.

Beard, Mary. *The Parthenon*. Cambridge, MA: Harvard University Press, 2003.

Beaune, Colette. "Le Langage symbolique des jardins médiévaux." Centre de l'Enluminure et de l'Image Médiévale, Abbaye de Noirlac. *Jardins du Moyen Age*. Paris: Le Léopard d'Or, 1995, 63–75.

Becherer, Joseph Antenucci. *Pietro Perugino: Master of the Italian Renaissance*. Exh. cat. Grand Rapids Art Museum. New York: Rizzoli, 1997.

Bechmann, Roland. *Villard de Honnecourt: La Pensée technique au XIIIe siècle et sa communication*. Paris: Picard, 1991.

Bedini, Silvio. "The Role of Automata in the History of Technology." *Technology and Culture* 5 (1964): 24–42.

Bellafiore, Giuseppe. *Architettura in Sicilia nelle età islamica e normanna, 827–1194*. Palermo: Arnaldo Lombardi, 1990.

——. *La Zisa di Palermo*. Palermo: Flaccovio, 2008.

——. *Parchi e giardini della Palermo normanna*. Palermo: Flaccovio, 1996.

Bellafiore, Susanna. *La Cuba di Palermo*. Palermo: Greco, 1984.

Belozerskaya, Marina. *Rethinking the Renaissance: Burgundian Arts across Europe*. New York: Cambridge University Press, 2002.

Belting, Hans. *Bild-Anthropologie: Entwürfe für eine Bildwissenschaft*. Munich: W. Fink, 2001.

——. "Remarks on Communal Paintings in the Fourteenth Century in Siena and Pisa." *Studium Artium Orientalis et Occidentalis* 2.1 (1985): 11–16.

——. "The New Role of Narrative in Public Painting of the Trecento: *Historia* and Allegory." *Pictorial Narrative in Antiquity and the Middle Ages*. M.S. Simpson and Herbert L. Kessler, eds. *Studies in the History of Art of the National Gallery of Art* 16 (1985): 151–68.

Beneš, Mirka, and Michael G. Leo, eds. *Cleo in the Garden: Twenty-First Century Studies in Historical Methods and Theoretical Perspectives*. Washington, DC: Dumbarton Oaks, 2011.

Berbara, Maria. "El Laoconte y el tema del sacrificio entre el Renacimiento y la Contrarreforma." *Goya* (1999): 112–24.

Berger, Robert W., and Thomas Hedin. *Diplomatic Tours in the Gardens of Versailles under Louis XIV.* Philadelphia: University of Pennsylvania Press, 2008.

Bergson, Henri. *Laughter: An Essay on the Meaning of the Comic*. C. Brereton and F. Rothwell, trans. New York: Macmillan, 1911.

Bertone, Giorgio. *Lo sguardo escluso: L'idea di paesaggio nella letteratura occidentale*. Novara: Interlinea SRL, 2000.

Bettini, Maurizio. "Tra Plinio e sant'Agostino: Francesco Petrarca sulle arti figurative." *Memoria dell'antico nell'arte italiana* 1: *L'uso dei classici*. Salvatore Settis, ed. Turin: Giulio Einaudi, 1984, 221–67.

Bevilaqua, Mirko. "Il 'giardino' come struttura ideologico-formale del *Decameron*." *Rassegna della Letteratura Italiana* 80 (1976): 70–79.

Bieber, Margarete. *Laocoon: The Influence of the Group since Its Rediscovery*. Detroit: Wayne State University Press, 1967.

Billanovich, Giuseppe. *Petrarca e il primo umanesimo*. Padua: Antenore, 1996.

Blaauw, Sible de. *Cultus et Decor: Liturgia e architettura nella Roma tardoantica e medievale. Basilica Salvatoris, Sanctae Mariae, Sancti Petri*. Vatican City: Biblioteca Apostolica Vaticana, 1994.

Blair, Sheila, and Jonathan M. Bloom, eds. *Images of Paradise in Islamic Art*. Dartmouth College, Hood Museum of Art, 1991; Austin: University of Texas Press, 1991.

Bloch, Howard. *The Scandal of the Fabliaux*. Chicago: University of Chicago Press, 1986.

Blockmans, Wim, Till-Holger Bochert, Nele Gabriëls, Johan Oosterman and Anne van Oosterwijk, eds. *Staging the Court of Burgundy: Proceedings of the Conference, "The Splendour of Burgundy."* London: Harvey Miller, 2013.

Bloom, James J. "Performance as Paradigm in the Visual Culture of the Burgundian Court." *Staging the Court of Burgundy*, 143–47.

Bloom, Jonathan. *Arts of the City Victorious: Islamic Art and Architecture in Fatimid North Africa and Egypt*. New Haven: Yale University Press, with The Institute of Ismaili Studies, 2007.

—. "The Introduction of Muqarnas into Egypt." *Muqarnas* 5 (1988): 21–28.

Blume, Dieter. "Antike und Christentum." *Natur und Antike in der Renaissance*. Exh. cat. Liebighaus, Museum alter Plastik, Frankfurt am Main, 5. Dezember 1985 bis 2. März 1986. Frankfurt am Main: Liebighaus, 1986, 85–129.

Bober, Phyllis Pray, and Ruth Rubenstein. *Renaissance Artists and Antique Sculpture: A Handbook of Sources*. London: Harvey Miller, 1986.

Boccaccio, Giovanni. *Decameron, Filocolo, Ameto, Fiammetta*. Enrico Bianchi, Carlo Salinari and Natalino Sapegno, eds. Milan: Riccardo Ricciardi, 1952.

Boethius, Axel. *The Golden House of Nero: Some Aspects of Roman Architecture*. Ann Arbor: University of Michigan Press, 1960.

Bologna, Corrado. "Petrarca petroso." *L'Io lirico: Francesco Petrarca. Radiografia dei* Rerum vulgarium fragmenta. Giovannella Desideri, Annalisa Landolfi and Sabina Marinetti, eds. *Critica del testo* 6 (2003): 367–420.

Bousquet, Jacques. "Problèmes d'origines des cloîtres romans: Histoire et stylistique. De l'époque carolingienne à Aurillac, Conques et Moissac." *Les Cahiers de Saint-Michel de Cuxa* 7 (1976): 7–33.

Bouton, Jean de la Croix. "Un poème à Philippe le Bon sur la Toison d'Or." *Annales de Bourgogne* 42 (1970): 5–29.

Braida, Silvana. "Il castello di Fawara: Studi di restauro." *Architetti di Sicilia* 5/6 (1965): 23–28.

Bredekamp, Horst, Michael Diers and Charlotte Schoell-Glass, eds. *Aby Warburg: Akten des internationalen Symposions, Hamburg 1990*. Weinheim: VCH, 1991.

Bremmer, Jan, and Herman Roodenburg, eds. *A Cultural History of Humour from Antiquity to the Present Day*. Cambridge: Polity Press, 1997.

Brenk, Beat, ed. *La Cappella Palatina a Palermo*. Mirabilia Italiae 15. Modena: Franco Cosimo Panini, 2010.

Bresc, Henri. "Les jardins de Palerme, 1290–1460." *Mélanges de l'École Française de Rome. Moyen Age* 84 (1972): 55–127.

—. "Les jardins royaux de Palerme." *Mélanges de l'École Française de Rome. Moyen Age* 106 (1994): 239–58.

Brett, Gerard. "The Automata in the Byzantine Throne of Solomon." *Speculum* 29 (1954): 477–87.

Brilliant, Richard. *My Laocoön: Alternative Claims in the Interpretation of Artworks*. Berkeley: University of California Press, 2000.

Brink, Joel. "Simone Martini, Francesco Petrarca and the Humanistic Program of the Virgil Frontispiece." *Mediaevalia: A Journal of Mediaeval Studies* 3 (1977): 83–117.

Brosius, Christiane. *Kunst als Denkraum: Zum Bildungsbegriff von Aby Warburg*. Pfaffenweiler: Centaurus-Verlagsgesellschaft, 1997.

Brubaker, Leslie, and Kalliroe Linardou, eds. *Eat, Drink, and Be Merry (Luke 12:19): Food and Wine in Byzantium. Papers of the 37th Annual Spring Symposium for Byzantine Studies, in Honour of A.A.M. Bryer*. Burlington, VT: Ashgate, 2007.

Bruce, James Douglas. "Human Automata in Classical Tradition and Medieval Romance." *Modern Philology* 10 (1912–13): 511–26.

Brummer, Hans Henrik. "On the Julian Program of the Cortile delle Statue in the Vatican Belvedere." *Il Cortile delle Statue: Der Statuenhof des Belvedere im Vatikan. Akten des Internationalen Kongresses zu Ehren von Richard Krautheimer, Rom, 21.–23. Okt 1992*. Matthias Winner, Bernard Andreae and Carlo Pietrangeli, eds. Mainz am Rhein: Philipp von Zabern, 1998, 67–76.

—. *The Statue Court in the Vatican Belvedere*. Stockholm: Almquist & Wiksell, 1970.

Brunet, Michel. "Le parc d'attractions des ducs de Bougogne à Hesdin." *Gazette des Beaux Arts* 78 (1971): 331–42.

Bugslag, James. "'Contrefais al vif': Nature, Ideas and Representation in the Lion Drawings of Villard de Honnecourt." *Word & Image* 17 (2001): 360–78.

Burckhardt, Jacob. *Die Cultur der Renaissance in Italien: Ein Versuch.* Basel: Schweighauser, 1860. As *The Civilization of the Renaissance in Italy.* S.G.C. Middlemore, trans. London: George G. Harrap, 1929.

Bynum, Caroline. "Wonder." *American Historical Review* 102 (1997): 1–26.

Calkins, Robert G. "Piero de' Crescenzi and the Medieval Garden." *Medieval Gardens.* Elisabeth MacDougall, ed. Washington, DC: Dumbarton Oaks, 1986, 155–73.

Callu, Florence, and François Avril. *Boccace en France: De l'humanisme à l'érotisme.* Paris: Bibliothèque Nationale, 1975.

Calvin, John, and Jacopo Sadoleto. *A Reformation Debate: Sadoleto's Letter to the Genevans and Calvin's Reply.* John C. Olin, ed. and trans. New York: Harper & Row, 1966.

Camille, Michael. *Image on the Edge: The Margins of Medieval Art.* Cambridge, MA: Harvard University Press, 1992.

—. "'Labouring for the Lord': The Ploughman and the Social Order in the Luttrell Psalter." *Art History* 10 (1987): 423–54.

Camos, Rosanna Gorris, ed. *Les Montagnes de l'esprit: Imaginaire et histoire de la montagne à la Renaissance. Actes du Colloque International Saint-Vincent. Vallée d'Aoste. les 22–23 novembre 2002.* Aosta: Musumeci Éditeur, 2005.

Capone, Paola, Paola Lanzara and Massimo Venturi Ferriolo, eds. *Pensare al giardino.* Milan: Angelo Guerini, 1992.

Cardini, Franco. "Il giardino del cavaliere, il giardino del mercante: La cultura del giardino nella Toscana tre-quattrocentesca." *Mélanges de l'École Française de Rome. Moyen Age, Temps Modernes* 106.1 (1994): 259–73.

—. "Il giardino monastico nelle 'Sententiae' di Bernardo di Clarivaux." *Il giardino storico: Protezione e restauro.* Pier Fausto Bagatti Valsecchi, ed. Florence: Regione Toscana, Giunta Regionale, 1987, 92–95.

—. "L'acqua come simbolo nel giardino toscano tardomedievale." *Mélanges de l'École Française de Rome. Moyen Age* 104 (1992): 545–53.

Caronia, Giuseppe. *La Zisa di Palermo: Storia e restauro.* Rome: Laterza, 1987.

—, and Vittorio Noto. *La Cuba di Palermo.* Palermo: Giada, 1988.

Carruthers, Mary. "Rhetorical *Ductus*, or Moving through a Composition." *Acting on the Past: Historical Performance Across the Disciplines.* Mark Franko

and Annette Richards, eds. Hanover, NH: Wesleyan University Press, 2000, 99–117.

Cartellieri, Otto. *The Court of Burgundy: Studies in the History of Civilization.* New York: Haskell House, 1970.

Catterson, Lynn. "Michelangelo's Laocoön." *Artibus et Historiae* 26 (2005): 29–56.

Caxton, William. *The Historie of Jason* published by William Caxton in 1477, as reproduced in W.J.B. Crotch, *The Prologues and Epilogues of William Caxton.* London: Early English Text Society, 1928.

Cellauro, Louis. "Le case di campagna e i giardini di Petrarca a Valchiusa (Vaucluse) e ad Arquà." Exh. cat. *Andrea Palladio e la villa veneta da Petrarca a Carlo Scarpa.* Guido Beltramini and Howard Burns, eds. Padua: Marsilio, 2005.

Centre de l'Enluminure et de l'Image Médiévale, Abbaye de Noirlac. *Jardins du Moyen Age.* Paris: Le Léopard d'Or, 1995.

Cestelli Guidi, Benedetta, and Nicholas Mann, eds. *Photographs at the Frontier: Aby Warburg in America 1895–1896.* London: Merrell Holberton Publishers in association with the Warburg Institute, London, 1998.

Chargeat, Marguerite. "Le Parc d'Hesdin: Création monumentale du XIIIe siècle. Ses origines arabes. Son influence sur les miniatures de l'épître d'Othéa." *Bulletin de la Société de l'Histoire de l'Art Français* 1950 (1951): 94–106.

Chastel, André. "Vasari et la légende Médicéene: L'école du jardin de Saint Marc." *Studi Vasariani.* Florence: Sansoni, 1952, 159–67.

Chatelet, Albert. *Hubert et Jan van Eyck: Créateurs de l'Agneau Mystique.* Dijon: Éditions Faton, 2011.

Chiovenda, Lucia. "Die Zeichnungen Petrarcas." *Archivum Romanicum* 17 (1933): 1–61.

Christian, Kathleen Wren. *Empire without End: Antiquities Collections in Renaissance Rome, c.1350–1527.* New Haven: Yale University Press, 2010.

—. "From Ancestral Cults to Art: The Santacroce Collection of Antiquities." *Senso delle rovine e riuso dell'antico.* Salvatore Settis, ed. *Annali della Scuola Normale Superiore di Pisa* ser. 4.14. Classe di Lettere e Filosofia (2002): 255–72.

—. "Raphael's 'Philemon' and the Collecting of Antiquities in Rome." *The Burlington Magazine* 146 (2004): 760–63.

—. "The De' Rossi Collection of Ancient Sculptures, Leo X, and Raphael." *Journal of the Warburg and Courtauld Institutes* 65 (2002): 132–200.

—. "The Della Valle Statue Court Rediscovered." *The Burlington Magazine* 145 (2003): 847–50.

Clap, S. *Fontaine-de-Vaucluse: Le temps retrouvé.* Marguerittes: Equinoxe, 1992.

Clarke, John R. *Looking at Laughter: Humor, Power, and Transgression in Roman Visual Culture 100 B.C.–A.D. 250.* Berkeley: University of California Press, 2007.

Classen, Albrecht, ed. *Laughter in the Middle Ages: Epistemology of a Fundamental Human Behavior, Its Meaning and Consequences.* Berlin: Walter de Gruyter, 2010.

Cléty, Anne Élisabeth. *Les machines extraordinaires d'Hesdin. Sucellus: Dossiers Archéologiques, Historiques et Culturels du Nord-Pas-de-Calais* 44 (1997).

Cobby, Anne Elizabeth. *The Old French Fabliaux: An Annotated Bibliography.* Woodbridge: Tamesis, 2009.

Coccetti, Fabio. "Dal labirinto al giardino: La topografia testuale del *Decameron.*" *Rassegna della Letteratura Italiana* 94 (1990): 76–85.

Cockshaw, Pierre. "Les voeux du Faisan: Examen des différentes versions du texte." *L'ordre de la Toison d'Or, de Philippe le Bon à Philippe le Beau (1430–1505): Idéal ou reflet d'une société?* Pierre Cockshaw and Christiane Van den Bergen-Pantens, ed. Turnhout: Brepols, 1996, 115–17.

Coffin, David R. *Gardens and Gardening in Papal Rome.* Princeton: Princeton University Press, 1991.

———. *Magnificent Buildings, Splendid Gardens.* Princeton: Princeton University Press, 2008.

———. *The Villa in the Life of Renaissance Rome.* Princeton: Princeton University Press, 1979.

Cohen, M.R., and I.E. Drabbin. *A Source Book in Greek Science.* Cambridge, MA: Harvard University Press, 1958.

Comito, Terry. *The Idea of the Garden in the Renaissance.* New Brunswick, NJ: Rutgers University Press, 1978.

Conan, Michel, ed. *Gardens and Imagination: Cultural History and Agency.* Washington, DC: Dumbarton Oaks, 2008.

———. *Landscape Design and the Experience of Motion.* Washington, DC: Dumbarton Oaks, 2003.

———. *Performance and Appropriation: Profane Rituals in Gardens and Landscapes.* Washington, DC: Dumbarton Oaks, 2007.

———. *Sacred Gardens and Landscapes: Ritual and Agency.* Washington, DC: Dumbarton Oaks, 2007.

Conrad of Hildesheim. "Letter to Hartbert of Hildesheim." *MGH SS* 21 (1925), 194. English trans. in Ronald G. Musto, *Medieval Naples: A Documentary History, 400–1400.* New York: Italica Press, 2013, 119–23.

Cooke, Thomas D. *The Old French and Chaucerian Fabliaux: A Study of Their Comic Climax.* Columbia: University of Missouri Press, 1978.

—, and Benjamin L. Honeycutt, eds. *The Humor of the Fabliaux: A Collection of Critical Essays*. Columbia: University of Missouri Press, 1974.

Cosgrove, Denis. *Geography and Vision: Seeing, Imagining and Representing the World*. London: I.B. Tauris, 2008.

—. "Prospect, Perspective and the Evolution of the Landscape Idea." *Transactions of the Institute of British Geographers* n.s 10 (1985): 45–62.

—. *The Palladian Landscape: Geographical Change and Its Cultural Representation in Sixteenth-Century Italy*. Leicester: Leicester University Press, 1993.

—, and Stephen Daniels, eds. *Iconography of Landscape: Essays on the Symbolic Representation, Design, and Use of Past Environments*. Cambridge: Cambridge University Press, 1988.

Creighton, Oliver H. *Designs upon the Land: Landscapes of the Middle Ages*. London: Boydell, 2009.

Cross, Tom Peete. "Observations on the Pèlerinage Charlemagne." *Modern Philology* 25 (1927–28): 331–54.

Curran, Brian. "Teaching, and Thinking About, the High Renaissance: With Some Observations on Its Relationship to Classical Antiquity." *Rethinking the High Renaissance: The Culture of Visual Arts in Early Sixteenth-Century Rome*. Jill Burke, ed. Burlington, VT: Ashgate, 2012, 27–55.

Curtius, E.R. *European Literature and the Latin Middle Ages*. Willard R. Trask, trans. Bollingen Series 36. Princeton: Princeton University Press, 1973.

Dal Poggetto, Maria Grazia Ciardi Dupré and Vittore Branca. "Boccaccio 'visualizzato' dal Boccaccio. 1: Il corpus dei disegni e cod. Parigino It. 482." *Studi sul Boccaccio* 22 (1994): 197–234.

Daltrop, G. *Die Laokoongruppe im Vatikan: Ein Kapitel aus der römischen Museumsgeschichte und der Antiken-Erkundung*. Constance: Universitätsverlag Konstanz, 1982.

—. "Zur Aufstellung antiker Statuen in der Villetta di Belvedere des Vatikans." *Boreas: Münstersche Beiträge zur Archäologie* 6 (1983): 217–32.

De Biaggi, Casimiro. "Sacro Monte di Varallo." *Bollettino storico per la provincia di Novara* 75 (1984): 239–52.

Décultot, Élisabeth, Jacques LeRider and François Queyrel, eds. *Le Laocoon: Histoire et reception*. Paris: Presses Universitaires de France, 2003.

Degenhart, Bernhard, and Annegrit Schmitt. *Corpus der italienischen Zeichnungen 1300–1450*. 1: *Süd- und Mittelitalien*. Berlin: Mann, 1968.

Del Re, Giuseppe. *Cronisti e scrittori sincroni napoletani editi e inediti: Cronisti e scrittori sincroni della dominazione normanna nel regno di Puglia e Sicilia*. 1: *Normanni*. Aalen: Scientia Verlag, 1975 [rep. of Naples, 1845].

DeLue, Rachael, and James Elkins, eds. *Landscape Theory*. New York: Routledge, 2008.

Delumeau, Jean. *History of Paradise: The Garden of Eden in Myth and Tradition*. New York: Continuum, 1995.

Demus, Otto. *The Mosaics of Norman Sicily*. London: Routledge & Kegan Paul, 1950.

Dhanens, Elisabeth. *Van Eyck: The Ghent Altarpiece*. London: Allen Lane, 1973.

Didi-Huberman, Georges. *L'image survivante: Histoire de l'art et temps des fantômes selon Aby Warburg*. Paris: Éditions de Minuit, 2002.

Di Giovanni, Vincenzo. "Il castello e la chiesa della Favara de S. Filippo a Mare Dolce in Palermo." *Archivio Storico Siciliano* 22 (1897): 301–74.

Di Piazza, Maria. *Palermo: Città d'acqua. Aspetti storici e naturalistici dell'aquedotto*. Palermo: Gulotta, 2008.

Di Stefano, Guido. *Monumenti della Sicilia normanna*. 2nd ed. Wolfgang Krönig, rev. Palermo: S.F. Flaccovio, 1979.

Donato, Maria Monica, Chiara Frugoni and Alessio Monciatti. *Pietro e Ambrogio Lorenzetti*. Chiara Frugoni, ed. Florence: Le Lettere, 2002.

Douglas, Richard M. *Jacopo Sadoleto 1477–1547: Humanist and Reformer*. Cambridge, MA: Harvard University Press, 1959.

Doutrepont, Georges. "Jason et Gédéon, patrons de la Toison d'Or." *Mélanges Godefroid Kurth 2: Mémoires littéraires, philologiques et archéologiques*. Paris: Honoré Champion, 1908, 191–208.

—. "Les historiens du banquet des voeux du Faisan." *Mélanges d'histoire offerts à Charles Moeller*. Louvain: Bureau du Recueil, 1914, 1:654–70.

Drachman, A.G. *The Mechanical Technology of Greek and Roman Antiquity: A Study of Literary Sources*. Madison: University of Wisconsin Press, 1963.

Ducepp-Lamarre, François. "The Ducal Residence at Hesdin and Its Place in Courtly Arts under Philip the Bold and His Son (1384–1419)." *Art from the Court of Burgundy 1364–1419: Musée des Beaux-Arts de Dijon, May 28–September 15, 2004; The Cleveland Museum of Art, October 24, 2004–January 9, 2005*. Paris: Réunion des musées nationaux, 2004/Cleveland: The Cleveland Museum of Art, 2004, 160–61.

Duits, Rembrandt. *Gold Brocade and Renaissance Painting: A Study in Material Culture*. London: Pindar Press, 2008.

Dunlop, Anne. "Allegory, Painting and Petrarch." *Word & Image* 24 (2008): 77–91.

Duperray, Eve. *L'or des mots: Une lecture de Pétrarque et du mythe littéraire de Vaucluse des origines à l'orée du XXe siècle. Histoire de Pétrarchisme en France*. Paris: Publications de la Sorbonne, 1997.

Durliat, Marcel. "Les cloîtres historiés dans la France méridionale à l'époque

romane." *Les Cahiers de Saint-Michel de Cuxa* 7 (1976): 61–74.

Durling, Robert. "The Ascent of Mt. Ventoux and the Crisis of Allegory." *Italian Quarterly* 18 (1974): 7–28.

Eamon, William. "Technology as Magic in the Late Middle Ages and the Renaissance." *Janus: Revue internationale de l'histoire des sciences, de la médecine, de la pharmaire, et de la technique* 70 (1983): 171–212.

Eichberger, D.H. "The *Tableau Vivant*: An Ephemeral Art Form in Burgundian Civic Festivities." *Parergon: Bulletin of the Australian and New Zealand Association for Medieval and Renaissance Studies* n.s. 6a (1988): 37–60.

Elam, Caroline. "Lorenzo de Medici's Sculpture Garden." *Kunsthistorisches Institut in Florenz. Mitteilungen* 36 (1992): 40–48.

Elkins, James. "On the Conceptual Analysis of Gardens." *Journal of Garden History* 13 (1993): 189–98; rev. in idem, *Our Beautiful, Dry and Distant Texts: Art History Writing*. University Park: Pennsylvania State University Press, 1997, 254–71; and in *Landscape Theory*, ed. DeLue and Elkins, 69–86.

Epstein, Stephen A. *The Medieval Discovery of Nature*. Cambridge: Cambridge University Press, 2012.

Ettlinger, L.D. "*Exemplum Doloris*: Reflections on the Laocoön Group." *De Artibus Opuscula XL: Essays in Honor of Erwin Panofsky*. Millard Meiss, ed. 2 vols. New York: New York University Press, 1961, 1:121–26.

Farmer, Sharon. "Aristocratic Power and the 'Natural' Landscape: The Garden Park at Hesdin, c.1291–1302." *Speculum* 88 (2013): 644–80.

Fehlmann, Marc. "Casts and Connoisseurs: The Early Reception of the Elgin Marbles." *Apollo* 165 (June 2007): 44–51.

Fejfer, J., T. Fischer-Hansen and A. Rathje, eds. *The Rediscovery of Antiquity: The Role of the Artist. Acta Hyperborea* 10. Copenhagen: Museum Tusculanum Press, 2003.

Feldges-Henning, Ursula. "The Pictorial Programme of the Sala della Pace: A New Interpretation." *Journal of the Warburg and Courtauld Institutes* 35 (1972): 145–62.

Feo, Michele. *Le cipolle di Certaldo e il disegno di Valchiusa*. Pontedera: Bandecchi & Vivaldi, 2004.

—, ed. *Petrarca nel tempo: Tradizione lettori e immagini delle opere. Catalogo della mostra, Arezzo, Sottochiesa di San Francesco, 22 novembre 2003 – 27 gennaio 2004*. Pontedera: Edizioni Bandecchi e Vivaldi, 2003.

Fillastre, Guillaume. *Le premier (–second) volume de la Toison d'Or*. Paris: Francoys Regnault, 1516/17.

Fiorilla, Maurizio. *Marginalia figurati nei codici di Petrarca*. Florence: Leo S. Olschki, 2005.

Fliegel, Stephen N. "The Cleveland Table Fountain and Gothic Automata." *Cleveland Studies in the History of Art* 7 (2002): 6–49.

Francis, M., and R.T. Hester Jr., eds. *The Meaning of Gardens: Idea, Place and Action*. Cambridge, MA: MIT Press, 1989.

Franke, Birgit. "Alttestamentliche Tapisserie und Zeremoniell am burgundischen Hof." *Zeremoniell als höfische Ästhetik in Spätmittelalter und Früher Neuzeit*. Tübingen: Max Niemeyer, 1995, 332–52.

—. "Gesellschaftsspiele mit Automaten-'Merveilles' in Hesdin." *Marburger Jahrbuch für Kunstwissenschaft* 24 (1997): 135–58.

Franzoni, Claudia. "'Rimembranze d'infinite cose': Le collezioni rinascimentali di antichità." *Memoria dell'antico nell'arte italiana*. 1: *L'uso dei classici*. Salvatore Settis, ed. Turin: Einaudi, 1984, 304–60.

Frasso, Giuseppe. *Itinerari con Petrarca*. Padua: Antenore, 1974.

Freccero, John. "The Fig Tree and the Laurel: Petrarch's Poetics." *Diacritics* 5 (1975): 34–40.

Frommel, Christof Luitpold. "I tre progetti bramanteschi per il Cortile del Belvedere." *Der Statuenhof*, 17–65.

Frugoni, Chiara. *A Distant City: Images of Urban Experience in the Medieval World*. William McCuaig, trans. Princeton: Princeton University Press, 1991.

Frühe, Ursula. *Das Paradies ein Garten – der Garten ein Paradies: Studien zur Literatur des Mittelalters unter Berücksichtigung der bildenden Kunst und Architektur*. Frankfurt am Main: Lang, 2002.

Galvez, Marisa. *Songbook: How Lyrics Became Poetry in Medieval Europe*. Chicago: University of Chicago Press, 2012.

Gaunt, Simon, and Sarah Kay, eds. *The Troubadours: An Introduction*. Cambridge: Cambridge University Press, 1999.

Geese, Uwe. "Antike als Programm: Der Statuenhof des Belvedere im Vatican." *Natur und Antike in der Renaissance*. Exh. cat. Liebighaus, Museum alter Plastik, Frankfurt am Main, 5. Dezember 1985 bis 2. März 1986. Frankfurt am Main: Liebighaus, 1986, 24–50.

Gere, John. "I disegni di Federico Zuccari sulla vita giovanile di suo fratello Taddeo." *Per Taddeo e Federico Zuccari nelle Marche*. Exh. cat. Sant'Angelo in Vado, Palazzo Fagnani, 18 settembre–7 novembre 1993. Bonita Cleri, ed. Sant'Angelo in Vado: Grafica Vadese, 1993, 49–55.

Giannetto, Raffaella Fabiani. *Medici Gardens: From Making to Design*. Philadelphia: University of Pennsylvania Press, 2008.

—. "Writing the Garden in the Age of Humanism: Petrarch and Boccaccio." *Studies in the History of Gardens and Designed Landscapes* 23 (2003): 231–57.

Giusti, Maria Adriana, ed. *I giardini dei monaci*. Lucca: M. Pacini Fazzi, 1991.

Goehring, Margaret L. "The Representation and Meaning of Luxurious Textiles in Franco-Flemish Manuscript Illumination." *Weaving, Veiling, and Dressing: Textiles and Their Metaphors in the Late Middle Ages*. Medieval Church Studies 12. Kathryn M. Rudy and Barbara Baert, eds. Turnhout: Brepols, 2007, 121–55.

—. "The Significance of Cloth-of-Gold Borders in Burgundian and Post-Burgundian Manuscript Illumination in the Low Countries." *Oud Holland* 119 (2006): 22–41.

Goldin, Frederick, trans. and intro. *Lyrics of the Troubadours and Trouvères: An Anthology and a History*. Gloucester MA: Peter Smith, 1983.

Goldschmidt, Adolf. "Die Favara des Königs Roger von Sizilien." *Jahrbuch des königlich preussischen Kunstsammlungen* 16 (1895): 199–215.

—. "Die normannischen Königspaläste in Palermo." *Zeitschrift für Bauwesen* 48 (1898): 541–90.

Gombrich, E.H. *Aby Warburg: An Intellectual Biography*. 2nd ed. Chicago: University of Chicago Press, 1986.

—. "The Belvedere Garden as a Grove of Venus." *Symbolic Images: Studies in the Art of the Renaissance*. Chicago: University of Chicago Press, 1985, 104–8.

Goodgal, Dana. "The Iconography of the Ghent Altarpiece." Ph.D. diss., University of Pennsylvania, 1981.

Gramit, David. "The Music Paintings of the Cappella Palatina in Palermo." *Imago Musicae: International Yearbook of Musical Iconography* 2 (1985): 9–49.

Greene, Thomas M. *The Light in Troy: Imitation and Discovery in Renaissance Poetry*. New Haven: Yale University Press, 1982.

Greenstein, Jack M. "The Vision of Peace: Meaning and Representation in Ambrogio Lorenzetti's *Sala della Pace* Cityscapes." *Art History* 11 (1988): 492–510.

Grimm, Reinhold. *Paradisus coelestis, paradisus terrestris: Zur Auslegungsgeschichte d. Paradieses im Abendland bis zum 1200*. Munich: Fink, 1977.

Grube, Ernst J., and Jeremy Johns. *The Painted Ceilings of the Cappella Palatina*. Genoa: Bruschettini Foundation for Islamic and Asian Art, and New York: East-West Foundation, 2005.

Gurevich, Aaron. *Medieval Popular Culture: Problems of Belief and Perception*. János M. Bak and Paul A. Hollingsworth, trans. Cambridge: Cambridge University Press, 1988.

Guthrie, Shirley. *Arab Social Life in the Middle Ages: An Illustrated Study.* London: Saqi Books, 1995.

Haggh, Barbara. "Between Council and Crusade: The Ceremonial of the Golden Fleece in the Fifteenth Century." *Staging the Court of Burgundy,* 51–58.

—. "The Mystic Lamb and the Golden Fleece: Impressions of the Ghent Altarpiece in Burgundian Music and Culture." *Revue belge de musicologie* 61 (2007): 5–59.

Hahnloser, Hans. *Villard de Honnecourt: Kritische Gesamtausgabe des Bauhüttenbuches ms. fr 19093 der Pariser Nationalbibliothek.* 2nd ed. Graz: Akademische Druck, 1972.

Hanawalt, Barbara A., and Michael Kobialka, eds. *Medieval Practices of Space.* Minneapolis: University of Minnesota Press, 2000.

Hanaway, William L., Jr. "Paradise on Earth: The Terrestrial Garden in Persian Literature." *The Islamic Garden.* Elisabeth B. MacDougall and Richard Ettinghausen, eds. *Dumbarton Oaks Colloquium in the History of Landscape Architecture* 4. Washington, DC: Dumbarton Oaks, 1976, 41–67.

Hardwick, Paul, ed. *The Playful Middle Ages: Meanings of Play and Plays of Meanings. Essays in Memory of Elaine C. Block.* Turnhout: Brepols, 2011.

Harvey, John. *Mediaeval Gardens.* London: B.T. Batsford, 1990.

Harvey, Ruth. "Courtly Culture in Medieval Occitania." *The Troubadours: An Introduction.* Simon Gaunt and Sarah Kay, eds. Cambridge: Cambridge University Press, 1999, 8–27.

Haskell, Francis, and Nicholas Penny. *Taste and the Antique.* New Haven: Yale University Press, 1981.

Heck, Thomas F., ed. *Picturing Performance: The Iconography of the Performing Arts in Concept and Practice.* Rochester, NY: University of Rochester Press, 1999.

Henisch, Bridget Ann. *The Medieval Calendar Year.* University Park: Pennsylvania State University Press, 1999.

Hennebo, Dieter. *Gärten des Mittelalters.* Hamburg: Broschek Verlag, 1962.

Hertl, Michael, and Renate Hertl. *Laokoon: Ausdruck des Schmerzes durch zwei Jahrtausende.* Munich: K. Thiemig, 1968.

Herzner, Volker. *Jan van Eyck und der Genter Altar.* Worms: Wernersche Verlagsgesellschaft, 1995.

—. "Response to Hugo van der Velden." *Simiolus* 35 (2011): 127–30.

Hesberg, Henner v. "Mechanische Kunstwerke und ihre Bedeutung für die höfische Kunst des frühen Hellenismus." *Marburger Winckelmann-Program* (1987): 47–72.

Hess-Lüttich, Ernest W.B., Jürgen E. Müller and Aart van Zoest, eds. *Signs & Space = Raum & Zeichen: An International Conference on the Semiotics of Space and Culture in Amsterdam*. Tübingen: G. Narr, 1998.

Hill, David. "Eleventh-Century Labors of the Months in Prose and Pictures." *Landscape History* 20 (1998): 29–39.

Hillenbrand, Robert. "*La Dolce Vita* in Early Islamic Syria: The Evidence of the Later Umayyad Palaces." *Art History* 5 (1982): 1–35.

Hillier, Bill, and Julienne Hanson. *The Social Logic of Space*. Cambridge: Cambridge University Press, 1984.

Hofmann-Randall, Christina. "Die Herkunft und Tradierung des Burgundischen Hofzeremoniells." *Zeremoniell also höfische Ästhetik*, 150–56.

Hommel, Luc. *L'Histoire du Noble Ordre de la Toison d'Or*. Brussels: Éditions Universitaires, 1947.

Horn, Walter, and Ernst Born. *The Plan of St. Gall*. 3 vols. Berkeley: University of California Press, 1979.

Houghton, L.B.T. "Simone Martini's Frontispiece to Petrarch's Vergil." *Paragone* 53 (2002): 54–76.

Hourihane, Colum. *Time in the Medieval World: Occupations of the Months and Signs of the Zodiac in the Index of Christian Art*. Princeton: Index of Christian Art, Department of Art and Archaeology, Princeton University, in association with Pennsylvania State University Press, 2007.

Howe, John, and Michael Wolfe, eds. *Inventing Medieval Landscapes. Sense of Place in Western Europe*, Gainesville: University Press of Florida, 2002.

Huizinga, Johan. *Homo Ludens: A Study of the Play-Element in Culture*. Boston: Beacon Press, 1955.

—. *The Autumn of the Middle Ages*. Rodney J. Payton and Ulrich Mammetzsch, trans. Chicago: University of Chicago Press, 1996.

Hunt, John Dixon. *A World of Gardens*. London: Reaktion Books, 2012.

—. *Greater Perfections: The Practice of Garden Theory*. Philadelphia: University of Pennsylvania Press, 2000.

—. *The Afterlife of Gardens*. Philadelphia: University of Pennsylvania Press, 2004.

—. *The Figure in the Landscape: Poetry, Painting, and Gardening during the Eighteenth Century*. Baltimore: The Johns Hopkins University Press, 1989.

—, ed. *Garden History: Issues, Approaches, Methods*. Washington, DC: Dumbarton Oaks, 1992.

Hurlbut, Jesse D. "Immobiliers et cérémonies urbain: Les Joyeuses Entrées Françaises à la fin du moyen age." *Civic Ritual and Drama*. Alexandra F. Johnston and Wim N.M. Hüsken, eds. Amsterdam: Rodopi, 1997, 125–42.

Ibn Jubayr. *The Travels of Ibn Jubayr*. R.J.C. Broadhurst, trans. London: J. Cape, 1957.

Ingrassia, G.F. *Informatione del pestifero, et contagioso morbo, il quale affligge et have afflitto questa città di Palermo, & molte altre città, et terre di questo Regno di Sicilia, nel anno 1575 et 1576*. Palermo: Giouan Mattheo Mayda, 1576.

Iser, Wolfgang. *The Fictive and the Imaginary: Charting Literary Anthropology*. Baltimore: The Johns Hopkins University Press, 1993.

Jenkins, Ian. *Archaeologists and Aesthetes: In the Sculpture Galleries of the British Museum 1800–1939*. London: British Museum Press, 1992.

John of Salisbury. *Policraticus*, book VII. Joseph B. Pike, trans. *Frivolities of Courtiers and Footprints of Philosophers, Being a Translation of the First, Second, and Third Books and Selections from the Seventh and Eighth Books of the* Policraticus *of John of Salisbury*. Minneapolis: University of Minnesota Press, 1938.

—. *Policraticus I–IV*. K.S.B. Keats-Rohan, ed. *Corpus Christianorum Continuatio Mediaevalis* 118. Turnhout: Brepols, 1993.

—. *Policraticus: Of the Frivolities of Courtiers and the Footprints of Philosophers*. Cary J. Nederman, trans. Cambridge: Cambridge University Press, 1990.

Johns, Jeremy. "Iscrizioni arabe nella Cappella Palatina," and "Le pitture del soffitto della Cappella Palatina." Brenk, *La Cappella Palatina a Palermo: Saggi*, 353–407.

—. "The Bible, the Qur'ān and the Royal Eunuchs in the Cappella Palatina." *Die Cappella Palatina in Palermo: Geschichte, Kunst, Funktionen. Forschungsergebnisse der Restaurierung Hg. im Auftrag der Stiftung Würth*. Thomas Dittelbach, ed. Künzelsau: Swiridoff, 2011, 199–216, 413–24, 560–70.

Jolly, Penny Howell. "More on the van Eyck Question: Philip the Good, Isabelle of Portugal and the Ghent Altarpiece." *Oud Holland* 101 (1987): 237–53.

Kapitaikin, Lev. "'The Daughter of al-Andalus': Interrelations between Norman Sicily and the Muslim West." *Al Masaq: Islam and the Medieval Mediterranean* 25 (2013): 113–34.

Keck, Gabrielle, Susan Marti and Till Holger-Borchert, eds. *Charles the Bold 1433–1477: Splendour of Burgundy*. Exh. cat. Brussels: Mercatorfonds, 2009.

Kermode, Jenny. *Medieval Merchants: York, Beverly and Hull in the Later Middle Ages*. New York: Cambridge University Press, 1998.

Kern, E.G. "The Gardens in the *Decameron* Cornice." *PMLA* 66 (1951): 503–23.

Kinoshita, Sharon. "*Le Voyage de Charlemagne:* Mediterranean Palaces in the Medieval French Imaginary." *Olifant* 25 (2006): 255–70.

Kirkham, Victoria, and Armando Maggi, eds. *Petrarch: A Critical Guide to the Complete Works*. Chicago: University of Chicago Press, 2009.

Kitzinger, Ernst. *I mosaici del periodo normanno in Sicilia. 6: La Cattedrale di Cefalù, La Cattedrale di Palermo e il Museo Diocesano. Mosaici Profani*. Palermo: Istituto Siciliano di Studi Bizantini e Neoellenici, 2000.

Kjeldsen, Jens E. "Talking to the Eye: Visuality in Ancient Rhetoric." *Word & Image* 19 (2003): 133–37.

Knipp, David. "Die almoravidischen Ursprünge der Holzdecke über dem Mittelschiff der Cappella Palatina in Palermo." *Die Cappella Palatina in Palermo*, 217–28, 425–32, 571–78.

——. "Image, Presence, and Ambivalence: The Byzantine Tradition of the Painted Ceiling in the Cappella Palatina, Palermo." *Visualisierungen von Herrschaft*. Franz Bauer, ed. *BYZAS* 5 (2006): 283–328.

——. "The Torre Pisana in Palermo: A Maghribi Concept and Its Byzantinization." *Wissen über Grenzen: Arabisches Wissen und lateinisches Mittelalter*. Andreas Speer and Lydia Wegener, eds. Berlin: Walter de Gruyter, 2006, 745–74.

Koortbojian, Michael. "Pliny's Laocoön?." *Antiquity and Its Interpreters*. Alina Payne, Ann Kuttner and Rebekah Smick, eds. Cambridge: Cambridge University Press, 2000, 199–216.

Koslin, Desirée, and Janet E. Snyder. *Encountering Medieval Textiles and Dress: Objects, Texts, Images*. New York: Palgrave, 2002.

Krönig, Wolfgang. "Die Rettung der 'Zisa' des normannischen Königsschlosses in Palermo." *Kunstchronik* 5 (1973): 133–51.

——. *Il Castello di Caronia in Sicilia: Un complesso normanno del XII secolo*. Rome: Edizioni dell'Elefante, 1977.

——. "Il palazzo reale della Zisa a Palermo: Nuovi osservazioni." *Commentari* 26 (1975): 229–47.

Kruft, Hanno-Walter. "Metamorphosen des Laokoon: Ein Beitrag zur Geschichte des Geschmacks." *Pantheon* 42 (1984): 3–11.

Kunze, Max. *The Pergamon Altar: Its Rediscovery, History and Reconstruction*. Mainz: Philipp von Zabern, 1995.

L'eau dans la société médiévale: Function, enjeux, images. Mélanges de l'École Française de Rome 104.2 (1992).

La Toison d'Or: Cinq Siècles d'Art et d'Histoire, Musée Communal des Beaux Arts, 14 Juillet–30 Septembre 1962. Bruges: Lanno-Tielt, 1962.

Laborde, Léon Emmanuel. *Les Ducs de Bourgogne: Études sur les letters, les arts et l'industrie pendant le XVe siècle* 2.1. Paris: Plon Frères, 1849.

Lafontaine-Martel, Agathe. *Fête noble en Bourgogne au XVe siècle: Le Banquet du Faisan (1454). Aspects politiques, sociaux et culturels*. Montreal: Vrin, 1984.

Lamberti S. Audomari Canonici. *Liber Floridus: Codex autographus Bibliotecae Universitatis in commemorationem diei natalis*. Alberto Derolez, ed. Ghent: Story-Scientia, 1968.

Landsberg, Sylvia. *The Medieval Garden*. Toronto: University of Toronto Press, 2003.

Lang, Karen. *Chaos and Cosmos: On the Image in Aesthetics and Art History*. Ithaca, NY: Cornell University Press, 2006.

Laocoonte: Alle origini dei Musei Vaticani. Rome: "L'Erma" di Bretschneider, 2006.

Lavin, Irving. "An Ancient Statue of the Empress Helen Reidentified (?)." *Art Bulletin* 49 (1967): 58.

—. "*Ex uno lapide:* The Renaissance Sculptor's Tour de Force." *Der Statuenhof*, fig. 28.

Lecat, Jean-Philippe. *Le Siècle de la Toison d'Or*. Paris: Flammarion, 1986.

Leclerq, Jean. "Le cloître est-il un paradis?" *Le message des moines à notre temps: Mélanges offerts à Don Alexis, Abbé de Boquen*. Cardinal Fumasoni Biondi, ed. Paris: A. Fayard, 1958, 141–59.

Lefebvre, Henri. *The Production of Space*. Donald Nicholson-Smith, trans. Oxford: Blackwell, 1991.

Legler, Rolf. *Der Kreuzgang: Ein Bautypus des Mittelalters*. Frankfurt am Main: Peter Lang, 1989.

Lehmann, Paul. *Die Parodie im Mittelalter*. Stuttgart: Anton Hiersemann, 1963.

Le Jardin médiéval: Colloque, concert et exposition mai–septembre 1988. Les Cahiers de l'Abbaye de Saint-Arnoult. Warluis: Adama, 1990.

Lejeune, Rita. "La Sicile et la littérature française du XIe au XIIe siècle." *Dai trovatori arabo-siculi alla poesia d'oggi: Atti del Congresso internazionale di poesia e di filologia per il VII centenario della poesia e della lingua italiana (Palermo, 6–10 giugno 1951)*. Palermo: Palumbo, 1953, 85–106.

Leslie, Michael, John Dixon Hunt et al., eds. *A Cultural History of Gardens*. 6 vols. London: Bloomsbury, 2013.

Lestocquoy, J. "Les origins d'Hesdin-le-vieux." *Revue du Nord* 32 (1950): 94–104.

Levinson, Stephen C. *The Body in Space: Cultural Differences in the Use of Body-Schema for Spatial Thinking and Gesture*. Nijmegen: Cognitive Anthropology Research Group, Max Planck Institute for Psycholinguistics, 1996.

Lieberman, Ralph E. "The Architectural Background." *Raphael's "School of Athens."* Marcia Hall, ed. Cambridge: Cambridge University Press, 1997, 64–84.

Littlewood, Antony, Henry Maguire and Joachim Wolschke-Bulmahn, eds. *Byzantine Garden Culture*. Washington, DC: Dumbarton Oaks Research Library and Collection, 2002.

Liverani, Paolo. "Il Cortile delle statue in Belvedere." *Il torso del Belvedere: Da Aiace a Rodin*. Raimund Wünsche, ed. Vatican City: Direzione Generale Monumenti, Musei e Gallerie Pontificie, 1998, 13–19.

Lloyd, T.H. *The English Wool Trade in the Middle Ages*. Cambridge: Cambridge University Press, 1977.

Low, Setha M., and Denise Lawrence-Zuñiga, eds. *The Anthropology of Space and Place: Locating Culture*. Oxford: Blackwell Publishing, 2003.

Lowenthal, David. "Geography, Experience and Imagination: Towards a Geographical Epistemology." *Annals of the Association of American Geographers* 51 (1961): 241–60.

MacDonald, William. *The Architecture of the Roman Empire*. 1: *An Introductory Study*. Rev. ed. New Haven: Yale University Press, 1982.

MacDougall, Elisabeth Blair. *Fountains, Statues and Flowers: Studies in Italian Gardens of the Sixteenth and Seventeenth Centuries*. Washington, DC: Dumbarton Oaks, 1994.

—. "Imitation and Invention: Language and Decoration in Roman Renaissance Gardens." *Journal of Garden History* 5 (1985): 119–34.

MacLeod, Catriona, Véronique Plesch and Charlotte Schoell-Glass, eds. *Elective Affinities: Testing Word and Image Relationships*. Amsterdam: Rodopi, 2009.

Maguire, Eunice Dauterman, and Henry Maguire. *Other Icons: Art and Power in Byzantine Secular Culture*. Princeton: Princeton University Press, 2007.

Maguire, Henry. "A Description of the Aretai Palace and Its Garden." *Journal of Garden History* 10 (1990): 209–13.

—. *Earth and Ocean: The Terrestrial World in Early Byzantine Art*. University Park: Pennsylvania State University Press, 1987.

—. *Nectar and Illusion: Nature in Byzantine Art and Literature*. New York: Oxford University Press, 2012.

—. "Paradise Withdrawn." In Littlewood, Maguire and Wolschke-Bulmahn, *Byzantine Garden Culture*, 23–35.

Mallette, Karla. *The Kingdom of Sicily: A Literary History, 1100–1250*. Philadelphia: University of Pennsylvania Press, 2005.

—. "Translating Sicily." *Medieval Encounters* 9 (2003): 140–63.

Maragoni, Gian Pietro. *Sadoleto e il Laocoonte: Di un modo di descrivere l'arte*. Parma: Zara, 1986.

Maraussen, Lars. *The Architecture of Space / The Space of Architecture*. Copenhagen: The Danish Architectural Press, 2008.

Marçais, Georges. "Salsabil et Sadirwan." *Études d'orientalisme dédiées à la mémoire de Lévi-Provençal*. Paris: G.-P. Maisonneuve et Larose, 1962, 2:639–48.

Mariani, Maria Stella Calò. "Utilità e diletto: L'acqua e le residenze regie dell'Italia meridionale fra XII e XIII secolo." *Mélanges de l'École Française de Rome. Moyen Age, Temps Modernes* 104.2 (1992): 343–72.

Martens, Pieter. "La destruction de Thérouanne et d'Hesdin par Charles Quint en 1553." *La fortresse à l'épreuve du temps: Destruction, dissolution, dénaturation, XIe–XXe siècle*. Gabriel Blieck, Philippe Contamine, Christian Corvisier, Nicolas Faucherre and Jean Mesqui, eds. Paris: Éditions du CTHS, 2007, 63–117.

Martinelli, B. "Del Petrarca e il Ventoso." *Studi in onore di Alberto Chiari* 2. Brescia: Paideia, 1973, 768–834.

Massetti, Marco. "In the Gardens of Norman Palermo, Sicily (Twelfth Century A.D.)." *Anthropozoologica* 44 (2009): 7–34.

Maurach, G. "Sadoletos 'Laokoon': Text, Übersetzung, Kommentar." *Würzburger Jahrbücher für die Altertumswissenschaft* n.s 18 (1992): 245–65.

Mazzotta, Giuseppe. *The Worlds of Petrarch*. Durham: Duke University Press, 1993.

McClung, William Alexander. *The Architecture of Paradise: Survivals of Eden and Jerusalem*. Berkeley: University of California Press, 1983.

McDannell, Colleen, and Bernhard Lang. *Heaven: A History*. New Haven: Yale University Press, 1988.

McLean, Teresa. *Medieval English Gardens*. New York: Viking Press, 1980.

Meier, Hans-Rudolf. "'…das ird'sche Paradies, das sich den Blicken öffnet': Die Gartenpaläste der Normannenkönige in Palermo." *Die Gartenkunst* 6 (1994): 1–18.

—. *Die normannischen Königspaläste in Palermo: Studien zur hochmittelatlerlichen Residenzbaukunst*. Worms: Wernersche Verlagsgesellschaft, 1994.

Meiss, Millard. *French Painting in the Time of Jean de Berry: The Late Fourteenth Century and the Patronage of the Duke*. London: Phaidon, 1969.

—, with S.O.D. Smith and E.H. Beatson. *French Painting in the Time of Jean de Berry: The Limbourgs and Their Contemporaries*. New York: Braziller, 1974.

Metcalfe, Alex. *The Muslims of Medieval Italy*. Edinburgh: Edinburgh University Press, 2007.

Meulen, Marjon van der. "Cardinal Cesi's Antique Sculpture Garden: Notes on a Painting by Hendrik van Clef III." *The Burlington Magazine* 116 (1974): 16–24.

Meyvaert, Paul. "The Medieval Monastic Claustrum." *Gesta* 12 (1973): 53–59.

—. "The Medieval Monastic Garden." In MacDougall, *Medieval Gardens*, 23–53.

Michaelis, A. "Geschichte des Statuenhofes im Vatikanischen Belvedere." *Jahrbuch des Deutschen Archäologischen Institutes* 5 (1890): 5–72.

Michaud, Philippe-Alain. *Aby Warburg and the Image in Motion.* Sophie Hawkes, trans. New York: Zone Books, 2004.

Michaud-Fréjaville, Françoise. "Images et réalités du jardin médiéval." *Jardins du Moyen Age.* Centre de l'Enluminure et de l'Image Médiévale, Abbaye de Noirlac. Paris: Le Léopard d'Or, 1995, 39–62.

Mitchell, W.J.T., ed. *Landscape and Power.* Chicago: University of Chicago Press, 1994.

Moffitt, John. "A Christianization of Pagan Antiquity: Giovanni Andrea Gilio da Fabriano, Antonio Possevino, and the Laocoön of Domenico Theotocopouli, 'El Greco'." *Paragone* 35 (1984): 44–60.

Monnas, Lisa. "Contemplate What Has Been Done: Silk Fabrics in Paintings by Jan van Eyck." *Hali* 60 (1991): 103–28.

—. *Merchants, Princes and Painters: Silk Fabrics in Italian and Northern Paintings 1300–1550.* New Haven: Yale University Press, 2008.

—. "Silk Textiles in the Paintings of Jan van Eyck." *Investigating Jan van Eyck.* Susan Foister, Sue Jones and Delphine Cool, eds. Turnhout: Brepols, 2000, 147–62.

Monneret de Villard, Ugo. *Le pitture musulmane al soffitto della Cappella Palatina in Palermo.* Rome: La Libreria dello Stato, 1950.

Montanari, Massimo. "Convivi e banchetti." *Strumenti, tempi e luoghi di communicazione nel mezzogiorno normanno-svevo: Atti delle undecime giornate normanno-sveve, Bari, 26–29 ottobre 1993.* Giosuè Musca and Vito Sivo, eds. Bari: Centro di studi normanno-svevi, Università degli Studi di Bari, 1995, 323–44.

Moore, Sally F., and Barbara G. Myerhoff, eds. *Secular Ritual.* Amsterdam: Van Gorcum, Assen, 1977.

Moreau, Alain. *Le mythe de Jason et Médée: Le va-nu-pied et la sorcière.* Paris: Belles Lettres, 1994.

Moser, M., and G. Teyssot. *The Architecture of Western Gardens: A Design History from the Renaissance to the Present.* Cambridge, MA: MIT Press, 1991.

Munro, John H.A. *Textiles, Towns and Trade: Essays in the Economic History of Late-Medieval England and the Low Countries.* Aldershott, Hampshire: Variorum, 1994.

—. *Wool, Cloth, and Gold: The Struggle for Bullion in Anglo-Burgundian Trade 1340–1428.* Brussels: Éditions de l'Université de Bruxelles, 1972.

Muscatine, Charles. *The Old French Fabliaux.* New Haven: Yale University Press, 1986.

Nagel, Alexander, and Christopher Wood. *Anachronic Renaissance.* New York: Zone Books, 2010.

—. "Interventions: Towards a New Model of Renaissance Anachronism." *The Art Bulletin* 87 (2005): 403–32.

—. "What Counted as 'Antiquity' in the Renaissance." *Renaissance Medievalisms*. Konrad Eisenbichler, ed. Toronto: Centre for Reformation and Renaissance Studies, 2009, 53–74.

Necipoğlu, Gülru. "The Concept of Islamic Art: Inherited Discourse and New Approaches" *Journal of Art Historiography* (http://arthistoriography.wordpress.com/number-6-june-2012-2): 6-GN/1.

Nef, Anneliese. *Conquérir et gouverner la Sicile islamique au XIe et XIIe siècles*. Rome: École Française de Rome, 2011.

Nelson, Robert S, ed. *Visuality Before and Beyond the Renaissance: Seeing as Others Saw*. Cambridge: Cambridge University Press, 2000.

Nesselrath, Arnold. "Il Cortile delle Statue: Luogo e storia." *Der Statuenhof*, 1–16.

—. *Raphael's School of Athens*. Vatican City: Edizioni Musei Vaticani, 1997.

Nesselrath, Christiane Denker. *Bramante's Spiral Staircase*. Vatican City: Edizioni Musei Vaticani, 1997.

Nevile, Jennifer. "Dance and the Garden: Moving and Static Choreography in Renaissance Europe." *Renaissance Quarterly* 52 (1999): 805–36.

Nicholas, David. "In the Pit of the Burgundian Theater State: Urban Traditions and Princely Ambitions in Ghent, 1360–1420." *City and Spectacle in Medieval Europe*. Barbara A. Hanawalt and Kathryn L. Reyerson, eds. Minneapolis: University of Minnesota Press, 1994, 271–95.

Nicklies, Charles E. "Cosmology and the Labors of the Months at Piacenza: The Crypt Mosaic at San Savino." *Gesta* 34 (1995): 108–25.

Nicolson, Marjorie Hope. *Mountain Gloom and Mountain Glory: The Development of the Aesthetics of the Infinite*. New York: W.W. Norton, 1959.

Nolhac, Pierre de. *Pétrarque et l'humanisme*. Paris: Librairie Honoré Champion, 1965.

O'Connell, Michael. "Authority and the Truth of Experience in Petrarch's 'Ascent of Mount Ventoux'." *Philological Quarterly* 62 (1983): 507–20.

Oschema, Klaus. "Liquid Splendour – Table Fountains and Wine-Fountains at the Burgundian Courts." *Staging the Court of Burgundy*, 133–40.

Pächt, Otto. "Early Italian Nature Studies and the Early Calendar Landscape." *Journal of the Warburg and Courtauld Institutes* 13 (1950): 13–47.

—. *Van Eyck and the Founders of Early Netherlandish Painting*. Maria Schmidt Dengler, ed. David Britt, trans. London: Harvey Miller, 1994.

Panofsky, Erwin. *Early Netherlandish Painting: Its Origins and Character*. New York: Icon Editions: 1971.

Paolini, Maria Grazia. "Considerazioni su edifici civili di età normanna a Palermo." *Atti della Accademia di Scienze, Lettere e Arti di Palermo* 33 (1974): 299–346.

Papapetros, Spyros. *On the Animation of the Inorganic: Art, Architecture, and the Extension of Life.* Chicago: University of Chicago Press, 2012.

——. "The Eternal Seesaw: Oscillations in Warburg's Revival." *Oxford Art Journal* 26 (2003): 169–76.

Paravicini, Werner, Torsten Hiltman and Frank Viltart, eds. *La cour de Bourgogne et l'Europe: Le rayonnement et les limites d'un modèle culturel. Actes du colloque internationale tenu à Paris les 9, 10 e 11 octobre 2007.* Ostfildern: Jan Thorbecke Verlag, 2013.

Parker, Andrew, and Eve Kosofsky Sedgwick, eds. *Performativity and Performance.* New York: Routledge, 1995.

Pateman Trevor. "How To Do Things With Images: An Essay on the Pragmatics of Advertising." *Theory and Society* 9 (1980): 603–22.

Paul, Martine. "Turf Seats in French Gardens of the Middle Ages (12th–16th Centuries)." *Journal of Garden History* 5 (1985): 3–14.

Pearcy, Roy J. *Logic and Humor in the Old French Fabliaux: An Essay in Applied Narratology.* Cambridge: D.S. Brewer, 2007.

Pearsall, Derek, and Elizabeth Salter. *Landscapes and Seasons of the Medieval World.* Toronto: University of Toronto Press, 1973.

Pearson, Michael Parker, and Colin Richards, eds. *Architecture and Order: Approaches to Social Space.* London: Routledge, 1994.

Pellegrin, E. "Manuscrits de Pétrarque dans les bibliothèques de France: Censimento dei codici Petrarcheschi, II." *Italia medioevale e umanistica* 6 (1963–64): 271–364.

Perkinson, Stephen. "Engin and Artifice: Describing Creative Agency at the Court of France, ca. 1420." *Gesta* 41 (2002): 51–67.

Pesez, Jean-Marie. "Sicile arabe et Sicile normande: Chateaux arabes et arabo-normands." *Mélanges de l'École Française de Rome. Moyen Age* 10 (1998): 561–76.

Petit, Charles. "Vieil-Hesdin: L'exploration archéologique d'une Ville disparue." *Revue du Nord* 59 (1977): 545–72.

Petrarch, Francesco. *Canzoniere.* Ugo Dotti, ed. 8th ed. Milan: Feltrinelli, 2008.

——. *De vita solitaria. Buch I: Kritische Textausgabe und Ideengeschichte Kommentar von K.A.E. Enenkel.* Leiden: E.J. Brill, 1990.

——. *De vita solitaria.* Guido Martellotti, ed. Antonietta Bufano, Italian trans. Turin: Einaudi, 1977.

——. *Le familiari.* Ugo Dotti, ed. 3 vols. Rome: Archivio Guido Izzo, 1991.

———. *Letters on Familiar Matters*. Aldo S. Bernardo, trans. 3 vols. New York: Italica Press, 2005.

———. *Petrarch at Vaucluse: Letters in Verse and Prose*. Ernst Hatch Wilkins, ed. and trans. Chicago: University of Chicago Press, 1958.

———. *Pétrarque, De vita solitaria/La vie solitaire, 1346–1366*. Christophe Carraud, ed. Nicholas Mann, intro. Grenoble: Éditions Million, 1999.

———. *The Life of Solitude by Francis Petrarch*. Jacob Zeitlin, trans. Westport, CT: Hyperion, 1978.

Petrie, Jennifer. *Petrarch: The Augustan Poets, the Italian Tradition and the Canzoniere*. Dublin: Irish Academic Press, 1983.

Petrucci, Armando. *La scrittura di Francesco Petrarca*. Vatican City: Biblioteca Apostolica Vaticana, 1967.

Petrus de Crescentiis. *Pier de' Crescenzi (1233–1321): Studi e documenti*. Tommaso Alfonsi, Roberto Bozzelli et al., eds. Bologna: Licinio Cappelli Editore, 1933.

———. *Pier de' Crescenzi. Ruralia commoda: Das Wissen des vollkommenen Landwirts um 1300*. Erster Teil: Einleitung mit Buch I–III. Will Richter and Reinhilt Richter-Bergmeier, eds. Heidelberg: C. Winter, 1995.

Petrus de Ebulo. *Liber ad honorem Augusti sive de rebus Siculis. Codex 120 II der Burgerbibliothek Bern. Eine Bilderchronik der Stauferzeit*. Theo Kölzer and Marlis Stähli, eds. Gereon Becht-Jördens, trans. Sigmaringen: Jan Thorbecke Verlag, 1994.

Philip, Lotte Brand. *The Ghent Altarpiece and the Art of Jan van Eyck*. Princeton: Princeton University Press, 1971.

Pigeaud, Mathilde. "La découverte du Laocoon et le poème de Jacques Sadolet." *Thesauramata philologica Iosepho Orozio Oblata*. M.R. Herrera, S. García-Jalón and M.A.M. Casquero, eds. *Helmantica* 46 (1995): 463–86.

Pinelli, Orietta Rossi. "Chirurgia della memoria: Scultura antica e restauri storici." *Memoria dell'antico nell'arte italiana*. 3: *Dalla tradizione all'archeologia*. Salvatore Settis, ed. Turin: Einaudi, 1986, 183–250.

Piponnier, Françoise. "À la recherché des jardins perdus: Vestiges et traces archéologiques des jardins médiévaux," *Mélanges de l'École Française de Rome. Moyen Age* 106 (1994): 229–38.

Pirrone, Gianni. *L'isola del Sole: Architettura dei giardini di Sicilia*. Milan: Electa, 1994.

———, Michele Buffa, Eliana Mauro and Ettore Sessa, eds. *Palermo, detto Paradiso di Sicilia: Ville e Giardini, XII–XIX secolo*. Palermo: Centro Studi di Storia e Arte Giardini, 1989.

Post, Paul. "Ein verschollenes Jagdbild des Jan van Eyck." *Jahrbuch des preussischen Kunstsammlungen* 52 (1931): 120–32.

Potts, Alexander. *Flesh and the Ideal: Winckelmann and the Origins of Art History.* New Haven: Yale University Press, 1994.

Power, Eileen, and M.M. Postan, eds. *Studies in English Trade in the Fifteenth Century.* London: Routledge, 1933.

Prevenier, Walter, and Wim Blockmans. *The Burgundian Netherlands.* Cambridge: Cambridge University Press: 1986.

Price, Derek J. DeSolla. "Automata and the Origins of Mechanism and Mechanistic Philosophy." *Technology and Culture* 5 (1964): 9–23.

Purtle, Carol. *The Marian Paintings of Jan van Eyck.* Princeton: Princeton University Press, 1982.

Queruel, Danielle. "Le jardin d'Hesdin et les jardins de la cour de Bourgogne." *Le jardin médiéval: Les Cahiers de l'abbaye de Saint-Arnoult* 3 (1990): 104–17.

Rampley, Matthew. "From Symbol to Allegory: Aby Warburg's Theory of Art." *The Art Bulletin* 79 (1997): 41–55.

Randall, Lilian M.C. *Images in the Margins of Gothic Manuscripts.* Berkeley: University of California Press, 1966.

Réau, Louis. *Iconographie de l'Art Chrétien.* 3 vols. Paris: Presses Universitaires de France, 1955–59.

Rees, Joachim. "Ethos und Pathos: Der Apoll vom Belvedere und die Laokoon-Gruppe im Spektrum von Kunsttheorie und Antikenrezeption im 18. Jahrhundert." *Wettstreit der Künste: Malerei und Skulptur von Dürer bis Daumier.* E. Mai and K. Wettengl, eds. Exh. cat. Haus der Kunst, München/Wallraf-Richartz-Museum-Fondation Corbond, 2002. Munich: Edition Minerva, 2002, 152–69.

Revilla, Federico. "El simbolismo cristiano del 'Laocoonte' del 'Greco'." *Boletin del Seminario de Estudios de Arte y Arqueologia* 57 (1991): 387–93.

Rey, Raymond. *L'art des cloîtres romans: Étude iconographique.* Toulouse: Édouard Privat, 1955.

Ricci, Lucia Battaglia. "Gardens in Italian Literature during the Thirteenth and Fourteenth Centuries." *The Italian Garden: Art, Design and Culture.* John Dixon Hunt, ed. New York: Cambridge University Press, 1996, 6–33.

Riccomini, Anna Maria. "A Garden of Statues and Marbles: The Soderini Collection in the Mausoleum of Augustus." *Journal of the Warburg and Courtauld Institutes* 58 (1995): 265–84.

Ridderbos, Bernhard, Anne van Buren and Henk van Veen. *Early Netherlandish Paintings: Rediscovery, Reception and Research.* Los Angeles: The J. Paul Getty Museum, 2005.

Ritter, Joachim. "Landschaft: Zur Funktion des Ästhetischen in der modernen Gesellschaft." *Subjektivität: Sechs Aufsätze.* Frankfurt am Main: Suhrkamp Verlag, 1974, 141–63.

Rizzitano, Umberto. *Storia e cultura nella sicilia saracena.* Palermo: S.F. Flaccovio, 1975.

Robbins, Jill. "Petrarch Reading Augustine: 'The Ascent of Mont Ventoux'." *Philological Quarterly* 64 (1985): 533–53.

Robertson, D.W. "The Doctrine of Charity in Medieval Literary Gardens: A Topical Approach through Symbolism and Allegory." *Speculum* 26 (1951): 24–49.

Robinson, Cynthia. *In Praise of Song: The Making of Courtly Culture in Al-Andalus and Provence, 1005–1134.* Leiden: Brill, 2002.

Roblot-Delondre, Louise. "Un Jardin d'Amour de Philippe le Bon." *Revue archéologique* 1 (1911): 420–29.

Rosser-Owen, Miriam. "Mediterraneanism: How to Incorporate Islamic Art into an Emerging Field." *Journal of Art Historiography* (http://arthistoriography.wordpress.com/number-6-june-2012-2): 6-MRO/1.

Rothenberg, Jacob. *"Descensus ad Terram": The Acquisition and Reception of the Elgin Marbles.* New York: Garland Publishing, 1977.

Roy, B. "L'humor érotique au XVe siècle." *L'érotisme au moyen âge: Études présentées au Troisième Colloque de l'Institut d'études médiévales.* Montreal: Aurore, 1977, 155–64.

Ruggles, D. Fairchild. *Gardens, Landscapes, and Vision in the Palaces of Islamic Spain.* University Park: Pennsylvania State University Press, 2006.

—. *Islamic Gardens and Landscapes.* Philadelphia: University of Pennsylvania Press, 2008, 159–60.

—, and Elizabeth Kryder-Reid. "Vision in the Garden." *Journal of Garden History* 14 (1994): 1–2.

Rumple, Helmut. "Laokoon und die 'Grenzen des Fortschritts': Antikenrezeption und Neuzeitverständnis von der Hochrenaissance bis in die 'Postmoderne'." *Saeculum* 40 (1989): 80–92.

Salomone-Marino, S. "La Cuba di Palermo al 1571." *Archivio Storico Siciliano* n.s. 22 (1897): 547–50.

Santagata, Marco. *I frammenti dell'anima: Storia e racconto nel Canzoniere di Petrarca.* Bologna: Il Mulino, 1993.

Santini, Emilio. "La Sicilia nel *Decameron*." *Archivio Storico per la Sicilia* 6 (1940): 239–52.

Sauerländer, Willibald. "Art antique et sculpture autour de 1200." *Art de France* 1 (1961): 47–56.

Scafi, Alessandro. *Mapping Paradise: A History of Heaven on Earth*. Chicago: University of Chicago Press, 2006.

Scarpellini, Pietro. *Perugino*. Milan: Electa, 1984.

Scerrato, Umberto. "Arte Islamica in Italia." *Gli arabi in Italia*. Francesco Gabrieli and Umberto Scerrato, eds. Milan: Garzanti, 1993, 307–42.

Schälzle, Christoph. "*Immo vivo:* Laokoon in Literatur und Kunst. Interdisziplinäre Tagung an der Universität Bonn 30. November bis 2. Dezember 2006." *Kunstchronik* 12 (2007): 551–58.

Schama, Simon. *Landscape and Memory*. New York: Vintage, 1996.

Schmidt, Peter. *Aby M. Warburg und die Ikonologie, mit einem Anhang unbekannter Quellen zur Geschichte der Internationalen Gesellschaft für Ikonographische Studien von Dieter Wuttke*. Bamberg: Stefan Wendel Verlag, 1987.

Schnapp, Alain. *The Discovery of the Past*. I. Kinnes and G. Varndell, trans. New York: Harry N. Abrams, 1997.

Schoell-Glass, Charlotte. *Aby Warburg and Anti-Semitism: Political Perspectives on Images and Culture*. Samuel Pakucs-Willcocks, trans. Detroit: Wayne State University Press, 2008.

Searle, John R. *Expression and Meaning: Studies in the Theory of Speech Acts*. Cambridge: Cambridge University Press, 1979.

—. *Speech Acts: An Essay in the Philosophy of Language*. London: Cambridge University Press, 1969.

—, with Daniel Vanderveken. *Foundations of Illocutionary Logic*. Cambridge: Cambridge University Press, 1985.

Seidel, Linda. "Adam and Eve: Shameless First Couple of the Ghent Altarpiece." *Different Visions: A Journal of New Perspectives on Medieval Art* 1 (2008): 1–18.

—. "Visual Representation as Instructional Text: Jan van Eyck and *The Ghent Altarpiece*." *Making Knowledge in Early Modern Europe: Practices, Objects, and Texts, 1400–1800*. Pamela H. Smith and Benjamin Schmidt, eds. Chicago: University of Chicago Press, 2007, 45–67.

Settis, Salvatore. "Des ruines au musée: La destinée de la sculpture classique." *Annales: Économies, sociétés, civilizations* 48 (1993): 1347–80.

—. *Laocoonte: Fama e stile*. Rome: Donzelli Editore, 1999.

Seznec, Jean. *The Survival of the Pagan Gods: The Mythological Tradition and Its Place in Renaissance Humanism and Art*. B. Sessions, trans. New York: Harper & Row, 1961.

Shalem, Avinoam. "What Do We Mean When We Say 'Islamic Art'? A Plea for a Critical Rewriting of the History of the Arts of Islam." *Journal of*

Art Historiography (http://arthistoriography.wordpress.com/number-6-june-2012-2): 6-AS/1.

Sheppard, Eric, and Robert B. McMaster, eds. *Scale and Geographic Inquiry: Nature, Society, and Method*. Oxford: Blackwell, 2004.

Sherwood, Merriam. "Magic and Mechanics in Medieval Fiction." *Studies in Philology* 44 (1947): 567–92.

Sibley, David, Peter Jackson, David Atkinson and Neil Washbourne, eds. *Cultural Geography: A Critical Dictionary of Key Concepts*. London: I.B. Tauris, 2005.

Sinding-Larsen, Staale. "*Plura ordinantur ad unum*: Some Perspectives Regarding the 'Arab-Islamic' Ceiling of the Cappella Palatina at Palermo (1132–43)." *Acta ad archaeologiam et atrium historiam pertinentia* 7 (1989): 55–96.

Siragusa, G.B. "Di una probabile rappresentazione dell'Aula Regia del palazzo reale di Palermo." *Rendiconti Accademia dei Lincei* 15 (1906): 226–34.

Skinner, Quentin. "Ambrogio Lorenzetti: The Artist as Political Philosopher." *Malerei und Stadtkultur in der Dantezeit: Die Argumentation der Bilder*. Hans Belting and Dieter Blume, eds. Munich: Hirmer, 1989, 85–103.

Smith, Jeffrey Chipps. "The Artistic Patronage of Philip the Good, Duke of Burgundy." PhD dissertation, Columbia University, 1979.

—. "'Venit Nobis Pacificus Dominus': Philip the Good's Triumphal Entry into Ghent in 1458." *"All the World's a Stage…": Art and Pageantry in the Renaissance and Baroque*. Barbara Wisch and Susan Scott Munshower, eds. University Park: Pennsylvania State University Press, 1990, 1:258–90.

Smith, Nathaniel B. "In Search of the Ideal Landscape: From 'Locus Amoenus' To 'Parc du Champ Joli' in the 'Roman de la Rose'." *Viator* 11 (1980): 224–43.

Smith, W. *The Golden Fleece, wherein is related the Riches of English Wools in its manufacturers*. London: I. Grismond, 1656.

Sörrensen, Wolfgang. "Gärten und Pflanzen im Klosterplan." Studien zum St. Galler Klosterplan. = *Mitteilungen zur vaterländischen Geschichte herausgegeben vom Historishcen Verein des Kantons St. Gallen* 42. St. Gall: Fehr, 1962.

St. Clair, William. *Lord Elgin and the Marbles*. Oxford: Oxford University Press, 1998.

Staacke, Ursula. *Un palazzo normanno a Palermo: La Zisa. La cultura musulmana negli edifice dei re*. Palermo: Arti Grafiche Siciliane, 1991.

Starn, Randolph. *Ambrogio Lorenzetti: Palazzo Pubblico a Siena*. Turin: Società Editrice Internazionale, 1996.

—. "The Republican Regime of the 'Room of Peace' in Siena, 1338–40." *Representations* (1987): 1–32.

—, and Loren Partridge. *Arts of Power: Three Halls of State in Italy, 1300–1600*. Berkeley: University of California Press, 1992.

Stokstad, Marilyn, and Jerry Stannard. *Gardens of the Middle Ages*. Exh. cat. Lawrence, KS: Spencer Museum of Art, 1983.

Stuip, R.E.V., and C.Vellekoop, eds. *Tuinen in de Middeleeuwen*. Hilversum: Uitgeverij Verloren, 1992.

Summers, David. *Real Spaces: World Art History and the Rise of Western Modernism*. London: Phaidon, 2003.

Swan, Claudia. "*Ad vivum, naer het leven,* from the life: Defining A Mode of Representation." *Word & Image* 11 (1995): 353–72.

Szafranska, Malgorzata. "Place, Time and Movement: A New Look at Renaissance Gardens." *Studies in the History of Gardens and Designed Landscapes* 26 (2006): 194–208.

Tabbaa, Yasser. "The Medieval Islamic Garden: Typology and Hydraulics." *Garden History: Issues, Approaches, Methods*. John Dixon Hunt, ed. Washington, DC: The Dumbarton Oaks Research Library and Collection, 1992, 313–16.

—. "The 'Salsabil' and 'Shadirwan' in Medieval Islamic Courtyards." *Environmental Design: Journal of the Islamic Environmental Research Centre* 1 (1986): 34–37.

Tanner, Marie. *The Last Descendant of Aeneas: The Hapsburgs and the Mythic Image of the Emperor*. New Haven: Yale University Press, 1993.

Thoenes, Christof. "Renaissance St. Peter's." *St. Peter's in the Vatican*. William Tronzo, ed. New York: Cambridge University Press, 2005, 64–92.

Thomasset, Claude, and Danièle James-Raoul, eds. *La montagne dans le texte médiéval: Entre mythe et réalité*. Paris: Presses de l'Université de Paris-Sorbonne, 2000.

Tolley, Thomas. "Jan van Eyck and the English." *England and the Continent in the Middle Ages: Studies in Memory of Andrew Martindale. Proceedings of the Harlaxton Symposium*, John Mitchell and Matthew Moran, eds. Stamford: Shaun Tyas, 2000, 267–97.

Tourneur, Victor. "Les origines de l'ordre de la Toison d'Or et la symbolique des insignes de celui-ci." *Bulletin de la Classe des letters et des sciences morales et politiques, Bruxelles, Académie royale de Belgique* 42 (1956): 300–323.

Trapp, J.B. "Petrarchan Places: An Essay in the Iconography of Commemoration." *Journal of the Warburg and Courtauld Institutes* 69 (2006): 1–50.

Trilling, James. "Daedalus and the Nightingale: Art and Technology in the Myth of the Byzantine Court." *Byzantine Court Culture from 829–1204*. Henry Maguire, ed. Cambridge, MA: Harvard University Press, 1997, 217–30.

Trizzino, Lucio. *SS. Trinità alla Zisa: Progetto di restauro*. Palermo: D. Flaccovio, 1979.

Tronzo, William. "Mixed Media/*Admirabiles mixturae*." *Immagine e ideologia: Studi in onore di Arturo Carlo Quintavalle*. Arturo Calzona, Roberto Campari and Massimo Mussini, eds. Milan: Electa, 2007, 207–12.

—. "Restoring Agency to the Discourse on Hybridity: The Cappella Palatina from Another Point of View." *Die Cappella Palatina in Palermo*, 229–37, 433–39, 579–85.

—. *The Cultures of His Kingdom: Roger II and the Cappella Palatina in Palermo*. Princeton: Princeton University Press, 1997.

—. "The Royal Gardens of Medieval Palermo: Landscape Experienced, Landscape as Metaphor." *Le vie del medioevo: Atti del convegno internazionale di studi, Parma 28 settembre–1 ottobre 1998. I convegni di Parma 1*. Arturo Carlo Quintavalle, ed. Milan: Electa, 2000, 362–73.

—, ed. *St. Peter's in the Vatican*. New York: Cambridge University Press, 2005.

—, ed. *The Fragment: An Incomplete History*. Los Angeles: Getty Research Institute, 2009.

Turel, Noa. "Living Pictures: Rereading 'au vif,' 1350–1550." *Gesta* 50 (2011): 163–82.

Turner, Victor. *The Anthropology of Performance*. New York: PAJ Publications, 1986.

Vachikan no runesansu bijutsu ten: Tensai geijutsukatachi no jidai = High Renaissance in the Vatican: The Age of Julius II and Leo X. Exh. cat. The National Museum of Western Art, Tokyo, 21 September–28 November, 1993. 2 vols. Tokyo: Kokuritsu Seiyo Bijutsukan, 1993.

van Buren, Anne Hagopian. "Images monumentales de la Toison d'Or: Aux murs du chateau de Hesdin et en tapisserie." *L'ordre de la Toison d'Or de Philippe le Bon à Philippe le Beau (1430–1505): Idéal ou reflet d'une société?* Pierre Cockshaw and Christiane Van den Bergen-Pantens, eds. Turnhout: Brepols, 1996, 226–33.

—. "Reality and Literary Romance in the Park of Hesdin." *Medieval Gardens*. Elisabeth MacDougall, ed. Washington, DC: Dumbarton Oaks, 1986, 115–34.

—. "The Model Role of the Golden Fleece." *The Art Bulletin* 61 (1979): 359–76.

—. "Un Jardin d'amour de Van Eyck dans une commande ducale." *La Revue du Louvre et des musées de France* 35 (1985): 185–92.

Vanderjagt, Arjo. "The Princely Culture of the Valois Dukes of Burgundy." *Princes and Princely Culture 1450–1650*. Martin Gosman, Alasdair MacDonald and Arjo Vanderjagt, eds. Leiden: Brill, 2003, 51–79.

Vasari, Giorgio. *Le vite dè più eccelenti pittori, scultori e architettori*. G. Milanesi, ed. Florence: G.C. Sansoni, 1906. Gaston de Vere, trans. New York: Alfred A. Knopf, 1996.

Vaughan, Richard. *Philip the Good: The Apogee of Burgundy*. Woodbridge, Suffolk: The Boydell Press, 2002.

—. *Valois Burgundy*. London: Allen Lane, 1975.

Veder, Robin. "Walking through Dumbarton Oaks: Early Twentieth-Century Bourgeois Bodily Techniques and Kinesthetic Experience of Landscape." *Journal of the Society of Architectural Historians* 72 (2013): 5–27.

Veemstra, Jan R. "'Le prince qui se veult faire de nouvel roy': The Literature and Ideology of Burgundian Self Determination." *Ideology of Burgundy: The Promotion of National Consciousness 1364–1565*. D'Arcy J.D. Boulton and Jan R. Veemstra, eds. Leiden: Brill, 2006, 195–221.

Velden, Hugo van der. "The Quatrain of the Ghent Altarpiece." *Simiolus* 35 (2011): 5–39.

Walker, Alicia. *The Emperor and the World: Exotic Elements and the Imaging of Middle Byzantine Imperial Power, Ninth to Thirteenth Centuries CE*. New York: Cambridge University Press, 2012.

Waller, Marguerite R. *Petrarch's Poetics and Literary History*. Amherst: University of Massachusetts Press, 1980.

Wamberg, Jacob. *Landscape as World Picture: Tracing Cultural Evolution in Images*. Gaye Kynoch, trans. 2 vols. Aarhus: Aarhus University Press, 2009.

Warnke, Martin. *Political Landscape: The Art History of Nature*. David McLintock, trans. Cambridge, MA: Harvard University Press, 1995.

Webb, Ruth. "The Aesthetics of Sacred Space: Narrative, Metaphor, and Motion in *Ekphraseis* of Church Buildings." *Dumbarton Oaks Papers* 53 (1999): 59–74.

Webster, James Carson. *The Labors of the Months in Antique and Mediaeval Art to the End of the Twelfth Century*. Evanston, IL: Northwestern University, 1938.

Weiss, Allen S. *The Wind and the Source: In the Shadow of Mount Ventoux*. Albany: State University of New York Press, 2005.

Weiss, Roberto. *The Renaissance Discovery of Classical Antiquity*. Oxford: Blackwell, 1969.

Wescher, W. "Fashions and Textiles at the Court of Burgundy." *CIBA Review* 51 (1946): 1830–68.

Wethey, Harold E. *The Paintings of Titian: Complete Edition*. 1: *The Religious Paintings*. London: Phaidon, 1969.

Wilkins, Ernst Hatch. *Studies in the Life and Works of Petrarch.* Cambridge, MA: The Mediaeval Academy of America, 1955.

Winner, Matthias, Bernard Andreae and Carlo Pietrangeli, eds. *Il Cortile delle Statue: Der Statuenhof des Belvedere im Vatikan. Akten des Internationalen Kongresses zu Ehren von Richard Krautheimer, Rom, 21.–23. Okt 1992.* Mainz am Rhein: Philipp von Zabern, 1998.

Winner, Matthias. "Einleitung: 'Il Cortile delle Statue nel Belvedere'." *Der Statuenhof,* ix–xi.

—. "Zum Nachleben des Laokoon in der Renaissance." *Jahrbuch der Berliner Museen* 16 (1974): 83–121.

Wirth, Jean. *Les marges à drôleries des manuscrits gothiques, 1250–1350.* Geneva: Librairie Droz, 2008.

Wrede, Henning. "Römische Antikenprogramme des 16. Jahrhunderts." *Der Statuenhof,* 83–115.

Wuttke, Dieter. *Aby M. Warburgs Methode als Anregung und Aufgabe, mit einem Briefwechsel zum Kunstverständnis.* 4th ed. Wiesbaden: Otto Harrasowitz, 1990.

—. *Dazwischen: Kulturwissenschaft auf Warburgs Spuren.* Baden-Baden: Valentin Koerner, 1996.

Wyss, Robert L. "The Dukes of Burgundy and the Encouragement of Textiles in the Netherlands." *Connoisseur* 194 (1977): 164–71.

Zak, Gur. *Petrarch's Humanism and the Care of the Self.* Cambridge: Cambridge University Press, 2010.

Zitzlsperger, Philipp, ed. *Kleidung im Bild: Zur Ikonologie dargestellter Gewandung.* Emsdetten: Edition Immorder, 2010.

INDEX

A

Abulafia, David 35
Ackerman, James 165
Adam and Eve 6, 8, 10, 11, 21, 119, 120, 122, 126, 139
Addison, Joseph 99
Adrian VI, pope 172
Aeneas 154, 171
Alberti, Leandro 40
Alexander of Telese 50, 51, 54, 64
Alexander the Great 99
Alexandria 50, 54
al-Madinah. *See* Palermo.
Anchises 167
Andrew, St. 114, 138
Anthony, St. 115, 116
Apollo 4, 6
Apostles 113
Apulia 50
Aquinas, Thomas, *Summa theologica* 55
Arabic world 106
Aristotle, *Metaphysics* 55; *Rhetoric* 55
Arras 102
Arthurian legend 113
Assisi, S. Francesco 11
Athens, Parthenon 146–47, 164, 175
Augustine, *Confessions* 80
Augustus, emperor 154

B

Babylon 50, 54
Bacchus 4, 6
Bakhtin, Mikhail 108
Baxandall, Michael 157
Bayless, Martha 109
Beaucaire 51
Beaufort, Henry Cardinal 117
Bellafiore, Giuseppe 39, 69
Berlin, Pergamonmuseum 145
Bible: Genesis 2:9–17 7, 3:23–24 10; Genesis, book of 6, 7, 10; Judges 6:37–40 113
Billanovich, Giuseppe 79
Boccaccio, Giovanni 11, 25, 70; *Decameron* 25, 40; *De montibus, silvis, fontibus, lacubus, fluminibus, stagnis, seu paludibus, de nominibus maris* 70, 71
Boeotia 111
Borglum, Gutzon 99
Borluut, Elisabeth 116
Boulogne 102
Bramante 147–48, 181; New St. Peter's 165
Bresc, Henri 35, 48
Broederlam, Melchior 104, 112
Brummer, Hans Henrik 148
Bullion and Partition Ordinances 124
Buontalenti, Bernardo 106
Burckhardt, Jakob, *Die Cultur der Renaissance in Italien: Ein Versuch* 79
Burgundy 98; automata 108; competition with England 124; court 107; culture 100, 184; dukes of 103; feasts 108; Hapsburgs 102; knightly ideal 121; political/cultural evolution 113; rule of Flanders 123; state 121; topography 117; trade with England 124; Valois dukes of 102, 123; wool trade 121–29
Bynum, Caroline 54, 55
Byzantine style 42
Byzantium 102; automata 107

C

Cairo 41, 61
Calabria 50
Calais 124

calendrical sequences 85–88
Calvin, John 155, 177
Camille, Michael 109
Campania 50
Canche, river 102
Canosa 50
Canova, Antonio 145
Carruthers, Mary 3
Caxton, William 110, 126; *Historie of Jason* 106
Chanson de Girart de Roussillon 110
Charlemagne 110
Charles the Bold 112
Charles V, emperor 102
Christ 41, 42, 45, 113, 119, 126, 141; crucified 156, 157; Deposition 161; Passion 161
Christian, Kathleen 159
Cicero 4
Clement VII, pope 152
Cleopatra 154
Coffin, David 159
Coignet, Renaud 103
Colard le Voleur 105
Colchis 110, 111
Collezione Torta 39
Commodus, emperor 154
Company of the Staple 124
Conrad, bishop of Hildesheim 110
Constantinople 41, 50, 54, 56; imperial palace 110
Cortile delle statue. *See* Vatican, *Cortile delle statue*.
Counter Reformation 164
Creusa 112
Cumaean Sibyl 154, 166

D

Dante 11; *Purgatory* 80
de Caus, Salomon 106
de' Crescenzi, Piero 3

de Fredis, Felice 150
Deinokrates 99
della Porta, Tommaso 161
Demosthenes 78
Dhanens, Elisabeth 122, 123
Dido 152, 154
Dijon, Chartreuse de Champmol 129; Musée des Beaux Arts 103
Dionigi da Borgo San Sepolcro 79
Duveen, Joseph 145

E

Eden, Garden of 6–12, 21–22, 92
Egypt 40
Elysian Fields 154, 167
England, wool trade 124–25
Ettlinger, L.D. 164
Euripides 112
Eve 6, 8, 10, 11, 21. *See also* Adam and Eve.

F

fabliaux 109
Federigo of Sicily, king 25
Feldges, Uta 82
Fez, mosque 43
Flood, biblical 10
Florence, Galleria dell'Accademia 157, 158; Palazzo Pitti 152; San Marco 159; Santissima Annunziata 157
Francis of Assisi, Averna 80
Frederick II, emperor 102
Frugoni, Chiara 82, 83

G

Geneva 155
Germain, Jehan 113
Ghent 116, 123, 124; cathedral of St. Bavo (church of John the Baptist) 116
Ghent Altarpiece 100, 114–21, 122,

126, 186; Adoration of the Lamb 123; arrangement 117
Giambologna 99
Gideon 113
God the Father, 119
Golden Fleece 110–13
Goldschmidt, Adolf 40
Gombrich, Ernst 168
Gramit, David 44
Guissin, Master 103
Gurevich, Aaron 109

H

Harvard Hannibal Master 7, 8
Helicon 4
Henry II, king 51
Henry VI, emperor 39, 52, 69
Hercules 154
Hercules and Antaeus 152, 170
Hermes 114
Heron of Alexandria 99, 106
Hesdin 1, 11, 98, 99–142, 184, 186; description 102; destroyed by Charles V 102; li Marés 102; li paveillon dou Marés 102; li petit Paradis 102; origins and history 102; room of Jason and Medea 108, 114, 127; room of the hermit 104, 127
Hitchcock, Alfred, *North by Northwest* 99
Hugo le Fort 110
Huizinga, Johan 109
Hypnerotomachia Poliphili 11

I

Ibn Jubayr 25, 51, 52
Ingrassia, G.F. 36
Innocent VIII, pope 147
Isabella of Portugal 112
Islamic world 40

J

Jacopo da Verona 74
Jason 111
Jason and the Argonauts 103, 108–13, 125
John of Salisbury 54; *Policraticus* 55
Johns, Jeremy 45
John the Baptist 116, 119, 122, 123
Joseph of Arimathea 157
Julius II, pope 144, 147, 152–56, 159, 170, 178

K

Kemonia, river 26

L

Lambert of Saint-Omer 8
Lamb of God 119, 123
landscape studies 1, 3, 14
Laocoon 150–59, 161–64, 170, 183, 190
Laura 74, 76. *See also* Petrarch, Francesco.
Lehmann, Paul 109
Lentini, Rocco 30, 34
Leo X, pope 152, 159, 178
Lille 100, 102, 113, 123; Feast of the Pheasant 100
Limbourg Brothers, *Très riches heures* 51, 85–86, 89
Lippi, Filippino 157, 158, 190
Liutprand of Cremona 107
locus amoenus 6
London, British Museum 143, 144, 145, 146; Duveen installation 145, 147
Lord Elgin 144
Lorenzetti, Ambrogio 81–92, 96–97
Louis IX of France 102

M

Mallette, Karla 48
Mantua 71, 74
Manuscripts and drawings: Berlin, Kupferstichkabinett, 79.D.2, vol. 1 148, 160, 174; Staatliche Museum drawings 112; Bern, Burgerbibliothek cod. 120 II, 38, 60, 69; Brussels, Royal Library, MS 9231 111; MS 9511 138; Chantilly, Musée Condé, MS 65 86, 87, 89, 92; Florence, Uffizi, Gab. Disegni 161; Lille, Département du Nord archive 102; Lisbon, Museu Nacional de Arte Antigua, inv. no. 1072 175; Oxford, Fitzwilliam MS 268 112; marginalia of illuminated manuscripts 109; Palermo, Biblioteca Comunale, Miscellanea Qq C83 36; Paris, BNF, MS fr. 247 8; MS lat. 6802 68, 69, 70; St. Gall, Codex Sangallensis 1092 9; Vienna, Albertina, Inv. 48r 151; Österreichische Nationalbibliothek MS 2649 75
Mary, Virgin 119
Medea 106, 108, 110, 112, 126
Mediterranean 102
Meier, Hans Rudolf 40
Mesopotamia 40
Michaelis, A. 153
Michelangelo 151, 174, 175
Monreale 28
Moresca 172
Mount Athos 99
Mount Rushmore 99
Mount Sinai 80
Mount Ventoux 5, 19, 79, 80
Munro, John H.A. 124
music, depictions of 44

N

Naples 11, 26, 65; Hohenstaufen 102
Nelli, Franceso 4
Nero, Domus aurea 108
Nesselrath, Arnold 153, 154, 156
Nicholas V, pope 147
Normans 25, 26, 29, 37, 40, 41, 48, 51, 53, 54, 55, 56, 190
North Africa 40, 61

O

Occitania 51, 66
Old Testament 56. *See also* Bible.
Order of the Garter 113
Order of the Golden Fleece 112, 116, 121, 125, 138, 141; annual chapter 114; chapter in Lille in 1431, 113; founding 124, 127
Ordinance of Charles the Bold 112

P

Pächt, Otto 122
Palermo 1, 11; al-'Aziz. *See* Palermo, Zisa; Biblioteca Comunale 35; Cappella Palatina 41–46, 49–56, 63–67, 189, 190; Cassaro 27; Conca d'Oro 39; Corso Calatafimi 25; Corso Vittorio Emmanuele 25; Cuba 25–41; Cubula 27; Favara 27, 37; Galca 27; Maredolce 27; Norman 26, 102, 188; *Palatium novum* 26, 52; Palermitan plain 39; Scibene 27; *viridarium Genoard* 27, 38, 39, 69; Zisa 28–41, 46, 47, 48, 49, 51, 52, 53, 55
Palestine 50, 54
Papireto, river 26
Parthenon 144, 146, 147
Paul III, pope 144, 152
Pèlerinage Charlemagne 110
Pelias 111
Pergamon 145, 147

Perugino 157, 158; *Descent from the Cross* 190
Peter of Eboli 38, 39, 52; *Liber ad honorem augusti* 69
Peter, St. 166
Petrarch, Francesco 4–6, 11–12, 69–81, 188, 190; *Canzone* 126 74; *De vita solitaria* 77; *Familiares* 74; *Trionfi* 73, 77
Philip the Bold 104, 112, 123, 129
Philip the Good 100, 103, 106, 112, 113, 116, 117, 121, 125, 126; Breviary of 138; entry into Ghent 100; marriage 124
Phoenicia 50
Pico della Mirandola, Giovanni Francesco 172
Pliny 152; art theory 153; *Historia naturalis* 69
Polykleitos 152
Pratolino 99

Q
Qur'ān 45, 52, 63

R
Randall, Lilian M.C. 109
Raphael, *School of Athens* 165
Restituta, Sta. 25, 26
Robert II, count of Artois 102
Roger I of Sicily 26
Roger II of Sicily 26, 29, 41, 50, 51, 53, 54
Roman de la Rose 11
Rome 1, 11; 12th-century 56; 16th-century archaeology 152; antiquities collections 159, 190; Baths of Titus 153; Castel Sant'Angelo 165; palace of Titus 152; S. Ambrogio al Corso 162; use of ancient sculpture 165
Ruggieri dell'Oria, admiral 26

Ruiz, Juan 39

S
Sadoleto, Jacopo 143, 155, 157, 159, 186
Sangallo, Antonio da, the Elder 151; Giuliano da 151, 152
Schama, Simon 183
sculpture: Antinous 152; Apollo 152, 153, 154, 161, 163, 164, 166, 175; Ariadne 152; Belvedere Torso 164; Cleopatra or Dido 152, 164; Commodus, emperor 152; Hercules 152; Hercules and Antaeus 152, 170; Hercules and Hylas 152; Hercules and Telephos 152; Hermes or Meleager, 152; Nile 152, 171; Tiber 152; Tigris 152; Venus ex balneo, 152; Venus Felix 152, 173; Vesta 152; Zitella 152
Sherwood, Merriam 110
Sicily, Arab 43
Siena, Palazzo Pubblico 11, 82–84, 88, 89, 92; Sala dei Nove 82
Skinner, Quentin 82
Sluter, Claus 129
Smith, Jeffrey Chipps 117
Sorgue, river 4, 69, 70, 71, 77
Spain 40
Staacke, Ursula 31
St. Gall, monastery plan 8
Starn, Randolph 82
Stoic thought 164
Syria 50

T
Tabbaa, Yasser 48
Ternoise, river 102
Titian 162, 173; *Resurrection* in Brescia 162
Tolley, Thomas 122, 123

Trent, Castello del Buonconsiglio 11
Très riches heures of the Duc de Berry 11, 85–92. *See also* Limbourg Brothers.
Tripoli 50, 54
Trivulzio, Cesare 151, 159, 176 n. 15
Troy 154
Tunis, crusade of Louis ix 102

V

van Buren, Anne Hagopian 100, 103, 112
van der Weyden, Roger 129
van Eyck, Hubert 117; Jan 103, 104, 115–20, 122, 123, 141
Varallo, Sacro Monte di 168
Vasari, Giorgio 152
Vatican 143; Cortile del Belvedere 144, 147, 153, 165; *Cortile delle statue* 143–68; *Cortile Ottagono* 143; New St. Peter's 161; Old St. Peter's 147; papal properties 147
Vaucluse 1, 4, 69, 77, 79, 80, 93; oratory of St. Victor 71
Venus 154

Versailles, Musée du Chateau 103
Vijd, Joos 116, 117
Villard de Honnecourt 47, 107
Virgil 74, 81, 94, 154; *Aen.* vi, 258 154; bones in Naples legend 110; Frontispiece 94 n. 10; Virgilian tradition 157

W

Warburg, Aby 3, 16, 17
Warnke, Martin 88
William Durandus 9
William i, king 29, 41, 53
William ii, king 28, 29, 41, 51, 53
Winckelmann, Johann Joachim 158
Winner, Matthias 153
Wirth, Jean 109
wool trade 121–29. *See also* Burgundy, England.
Wrede, Henning 159

Y

Ypres 123

Z

Zuccari, Federico 160, 168; Taddeo 160, 161

This Book Was Completed on October 31, 2013
At Italica Press in New York, NY. It Was
Set in Adobe Bembo and Bembo Expert.
This Print Edition Was Produced
On 70-lb White Paper
in the USA and
Worldwide

www.ingramcontent.com/pod-product-compliance
Lightning Source LLC
Chambersburg PA
CBHW040107180526
45172CB00009B/1257